ITALIAN CHIC

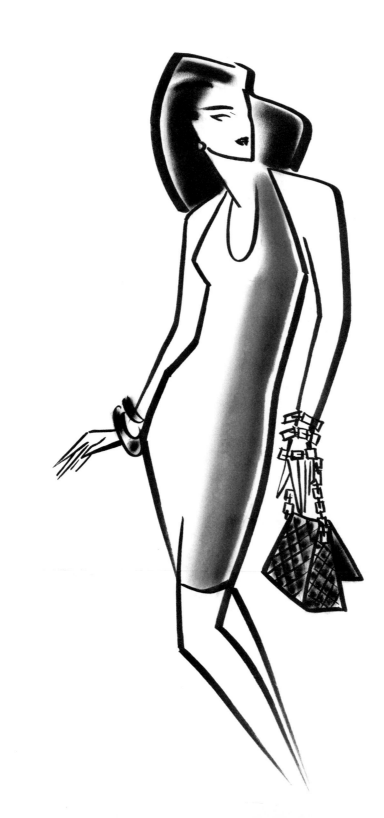

ITALIAN CHIC

THE ITALIAN APPROACH TO AFFORDABLE ELEGANCE

SUSAN SOMMERS

ILLUSTRATIONS BY PIERRE POULARD

VILLARD BOOKS
NEW YORK 1992

VILLARD BOOKS is a registered trademark
of Random House, Inc.

Library of Congress Cataloging-
in-Publication Data
Sommers, Susan.
Italian chic: the Italian approach to
affordable elegance/Susan Sommers.
p. cm.
ISBN 0-679-40457-0
1. Clothing and dress. 2. Fashion—
United States. 3. Fashion—Italy.
I. Title.
TT507.S687 1992
646'.34—dc20 91-51043

9 8 7 6 5 4 3 2
First Edition

FOR LOUISE

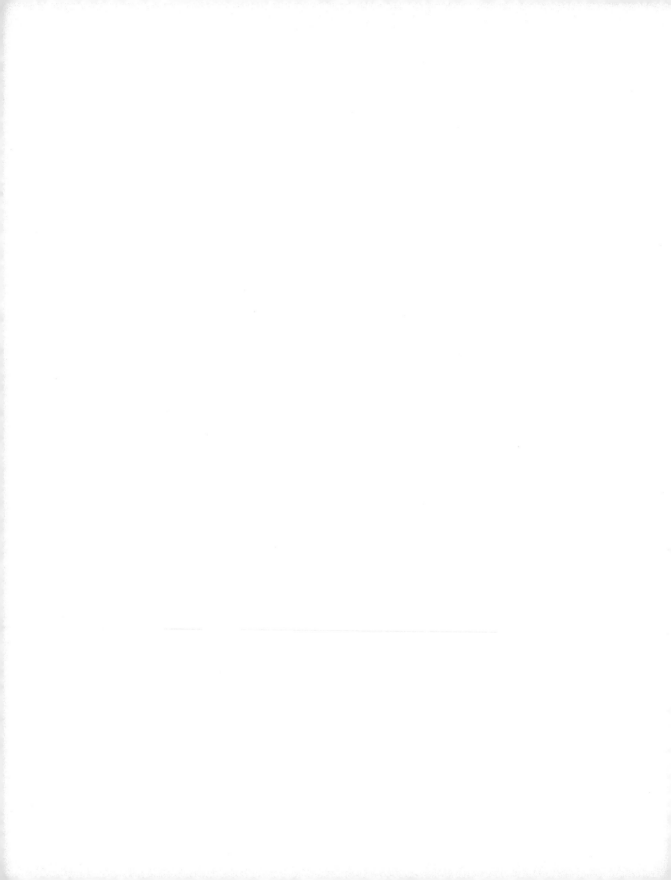

ACKNOWLEDGMENTS

WHEN THE "STUFF" of a book is the actual style of living people, first finding and getting to them, then establishing a rapport—especially when they are thousands of miles away—can be daunting and as much or more work than capturing them on paper. My deepest appreciation to all already quoted in the book who gave freely of their time and expertise to be interviewed and in some cases photographed. Included in this list are those of the world's top fashion and accessories designers who understood the value of a book of this nature, as well as their public relations staffs who fit me into already jammed schedules.

Heartfelt thanks to those behind-the-scenes people whose input was indispensable in other ways—whether it was sharing their fashion, style, or cultural viewpoints on social and professional contacts, allowing themselves to be photographed for the book, or helping me set up appointments—including Pierfilippo Pieri, Giampiero Paoletti, Adrienne Vittadini, Gabriella Mariotti, Meryll Shaw, Micela Moro, Glynis Costin, Benedetta Barzini, Sabrina Tehilim, the staff at Italian *Vogue,* Enrico Lepri and his assistant Rosa at Alitalia, Helene Cadario of Benetton, Martha Moreno, Angelo Bucarelli, Rosanna Prezioso, Donatella Bugnazzi and her husband, Susanna Avesani, Daniela Cioncolini, Sunny Ham and her daughter Maria, Gentry's Patrizia Pagan de Paganis, Giulia Pavoni, Stefania Conti, Cecilia Fanfani, and Mara Vassallo.

Grazie to Pierre Poulard for his brilliant illustrations, and to photographers Bruno Casolaro, Luca Lionello, Giovanni Cozzi, Marco Host-Ivessich, and Keith Trumbo, whose images say what words cannot.

Again, as before, I was sustained by the support of my editor, Diane Reverand, and my agent, Connie Clausen, who believe in my vision of style.

CONTENTS

PIERRE POULARD

INTRODUCTION

FROM THE FIRST MOMENT I slipped into an Italian designer outfit —a draped black handkerchief linen dress rimmed in jet beads by Gianni Versace that I found in a boutique in Montecatini twelve years ago—I have been in love with Italian fashion. Until then I had always appreciated it, of course, but to wear it—to touch it—turns one into a convert. It is so simply yet exquisitely designed, so well made, and best, so comfortable. To me that sums up Italian chic: it looks wonderful . . . it feels wonderful— both the fabric and the fit—and it whispers quality, never shouts it. Italian style is somewhat like the finest Italian food—it's not overdone or tricky, but you do have to try it to appreciate its subtleties. Italian style, like cooking, is marvelously adaptable to American life. You don't even have to use pure Italian ingredients, only its principles.

While style in all things is a daily preoccupation in Italy, Italians hate to look as if they have tried at all. The fashion effect is rather casual, "in motion" as Barbara Stratyner, a member of the faculty at Parsons School of Design in Manhattan, told me. And it is fashion that moves, flutters, drapes. The sheer ease of it sets it apart, from French style for one (although Chanel is quite the rage in Italy right now). If you are familiar with my last book, *French Chic: How to Dress Like a Frenchwoman,* you will know the emphasis the French place on whimsy and formality, on effect rather than comfort, which results in a completely different— although fabulous in its own way—sort of chic from the Italian version.

Although I had traveled extensively in Italy through the years and felt a kinship with the Italian spirit, I decided that I needed a Nineties perspective to do this book. I planned my trip with little more than a list of contacts and a fistful of faxes

confirming interviews with the country's leading designers. Interviewing Valentino in his fantastic Roman *accademia,* which houses his suite of offices and workrooms, Gianfranco Ferre in his spacious Milanese conference room, Dolce and Gabbana in their stark warehouse-looking space (part showroom/offices/boutique) during an informal fashion show, Laura Biagiotti in a heart-stopping centuries-old palazzo, Romeo Gigli over his Corso Como converted garage (he has since moved), Laudomia Pucci in the family's palatial Florentine office/residence, or the dozen or so other fashion heros and heroines responsible for some of the world's most coveted clothing changed my thinking a little—it will yours too, I promise. I also met with a multitude of stylish women and men, just like you and me, who shared their fashion secrets and formulas for your benefit, including achieving the look with a minimum of extras—practical advice in inflationary times.

Although united in their belief that quality comes first, Italians are by nature very individualistic in all things, not the least of which is style. Each area has its own look, although the differences may be slight. Since three of the major cities—Milan, Florence, and Rome—have their own unique looks that work well in America, I have showcased them. You will see exactly what they are and how to create them using many items you might already have in your closet. Milanese style is a big city, big business style, ideal for New York, Chicago, Detroit, Cleveland, San Francisco, and Washington, while Roman style is more laid-back and body revealing—leggings and pullovers, short skirts and blazers, a little sun dress—suited for Los Angeles and southern climes. Florence has a very small-town feel about it . . . it reminds me a lot of Boston. The style is a cross between Old English and Ralph Lauren . . . very classic and tailored, with lots of tweed. It is an approach that works on weekends, as well as in a less-formal office setting.

I hope *Italian Chic* can help you see fashion in a new way —through Italian eyes. The approach is basically that quality combined with style equal elegance, no matter what the current fashion climate. I would advise you to read the fashion formulas of each city, no matter where you live. Life in these United States is so mobile and changeable that there might be occasions for you to adopt a more businesslike demeanor even if your look is usually a casual one, or vice versa.

After using this guide for your basic look, you can make it work even more for your particular lifestyle by putting as much of your personality as you can in whatever you have on—a signature necklace or pin that you wear with everything, a striking embroidered antique vest you've had for years under a tweed blazer. The list is as long as your imagination!

PIERRE POULARD

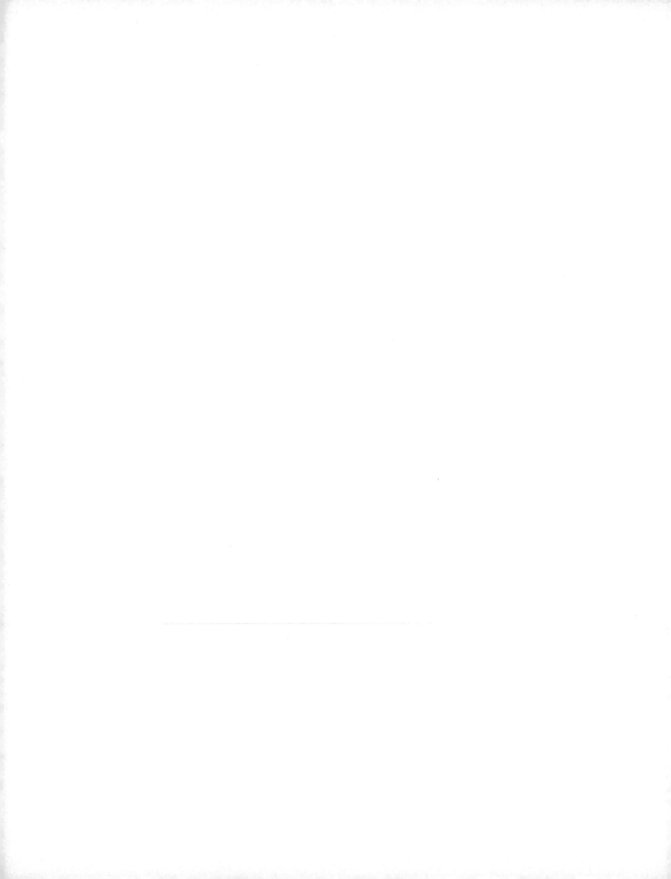

ITALIAN
CHIC

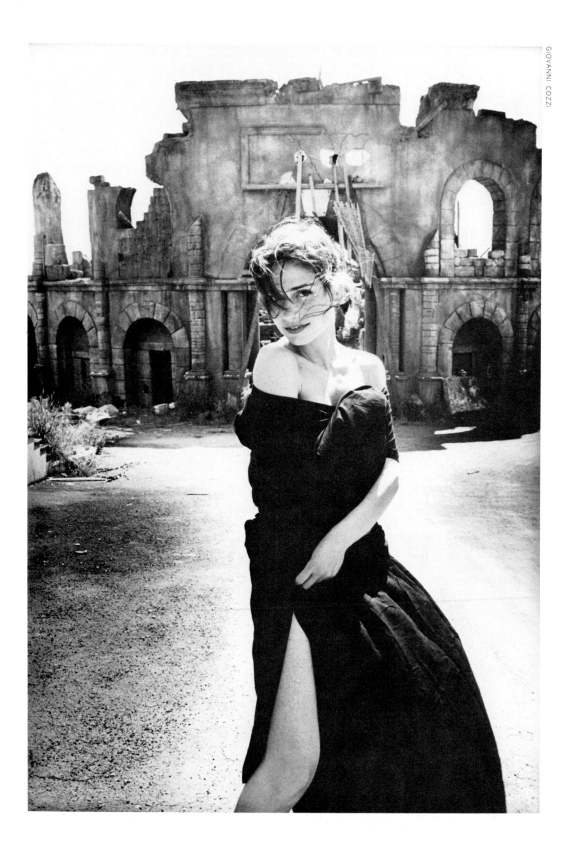

MADE IN ITALY

THE COMPONENTS OF CHIC

THE ART, THE ARCHITECTURE, THE COLORS OF THE ATMOSPHERE PROVIDE A BEAUTIFUL FRAME FOR EVEN THE SIMPLEST LOOK.

IN A COUNTRY that contains a majority of the world's most significant art treasures, that has a history in which esthetics have been essential to its development, and that is blessed with breathtaking and inspiring landscapes and colors, it is no surprise that an appreciation of beauty is almost innate among its inhabitants. And that appreciation extends to every area of life in Italy, especially fashion. In fact, being well dressed is practically a national priority.

"It's in the Italian chromosomes to have style," states Milan-based psychologist, Manuela Shapiro. Whether or not this statement is fact is not important. The truth is that Italy exudes a chic that is the perfect fusion of art and industry, history and style.

WHAT DO AN EASY-FITTING Armani jacket, pressed Levi 501 jeans that fall to exactly one inch below the anklebone, an exuberant Pucci print, iridescent silk Gigli pants with a Renaissance-looking taffeta shirt, tailored leather loafers, a pair of hot pink leather gloves, an embroidered chenille Fendi shawl rimmed with handmade velvet roses, a baby's silk shirt with a hand-pleated front, a black body-hugging *La Dolce Vita*–looking sheath, a yellow cashmere cardigan knotted over the shoulders of a crisp white cotton shirt, giant gold earrings worn with a multitude of gold chain necklaces and bracelets, and gold rings on three out of five fingers have in common?

They are *all* elements of Italian chic!

Italian chic, like the Italian character, is richly diverse. Rather than one specific look, there is a multitude of them. These looks follow regional lines, in much the same way as Italian social and culinary patterns do. What you might see on the streets of Bologna will be quite different from Perugia, for instance.

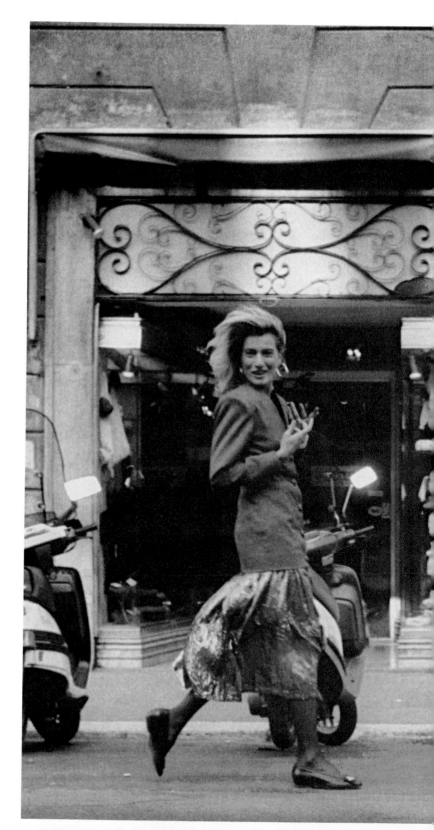

THE LOOK IS MORE ORNAMENTED
IN ROME, WHERE ALMOST
ANYTHING GOES. OVERSIZED
EARRINGS ARE DEFINITELY THE
ORDER OF THE DAY.

This isn't surprising when you consider that Italy has only been united for a little more than one hundred years. Before that, it was composed of independent states that were constantly at war with one another. These regions are still fiercely territorial. The North and South almost consider themselves different countries, a fact that Sophia Loren made very clear when she told Barbara Walters during an interview that she wasn't Italian, she was Neapolitan.

Traveling down from Venice you can see at a glance that the mood and the fashion get more extravagant the farther south you go. These dissimilarities are influenced as much by nature as the personalities of the people. Climate, temperature, geography, and the quality of light are all important factors.

In a city like Milan, for example, where skies are gray and foggy, the light translucent, and the buildings earth-toned, the fashion style tends to be understated and the color palette somber and neutral. The look is in perfect harmony with the weather. Even the serious and businesslike outlook of the Milanese works with the weather. What a contrast to Rome, which is only an hour away by plane! There the light is bright, the weather balmy, the colors vibrant, and exaggeration is the Roman way of life.

Although splendidly diverse, Italian style has several elements in common that make it distinctive from all others. These elements of style are so taken for granted by the average Italian that they are practically subliminal. Although Italians seem unaware of them, they are really the components that give Italian chic its very special character:

HIGH QUALITY: The look of a garment counts, but its quality counts more. Quality is the backbone of Italian style and so expected that Italians don't even look for it. No matter what their income, Italians would expect nothing less. Quality is a combination of material, detailing, and technical innovations. From infancy on, Italians are exposed to beautiful things—baby clothes are as intricate and exquisite as haute couture—so they grow up expecting the best.

The tailoring is superb. Historically, when clothes were made by hand at home or by tailors (known as *sartos*), this was certainly the case. This artisanal tradition continues even now that garments are mass manufactured. There is a balance between craftsmanship and industry of which the Italians are justifiably

proud. Due to the extraordinary wealth of fabric-related industries, the fabric as well as the fabrication is impeccable. The cloth feels good . . . it's just the right weight for the garment.

STREAMLINED: Italian fashion is cut along clean and spare lines with a particularly Italian approach. The material determines the shape of the clothing rather than the other way around, making the fit natural and fluid. The overall effect is an easy chic. Since the Italian woman usually buys pieces, rather than a total look, her personality is evident as soon as you see her.

In the North, Italian chic is a combination of spareness and sensuality. A typical "uniform" seen on the streets of Milan is classic, composed of streamlined parts—an unconstructed single-button blazer in a muted plaid that flows from the shoulders over the body, gently enfolding but not encasing it; easy pleated trousers in a muted check that works with but doesn't match the jacket; a cream silk shirt; a soft paisley silk and cashmere shawl thrown over the shoulder; a pouchy leather shoulder bag and tailored leather flat shoes.

LUXURIOUS FEELING: These are clothes you want to touch and feel—the materials and fabrics are so sumptuous and sensuous. While the Milanese uniform might, at first glance, seem very casual, look again: the jacket is probably cashmere with hand-stitched lapels; the colors of the entire ensemble are a sophisticated symphony of shades within the same family that blur beautifully, soothingly into each other; the shirt is silk crepe de chine. In addition, several accessories, like an ornate, art-deco lapel pin, large gold and semiprecious stone earrings, an oversized sports watch on a crocodile strap with two or three gold link bracelets, and an alligator belt, add to the overall elegance of the ensemble. The other characteristics that make this chic so unique —its subtle and sophisticated textural and color mixes, marvelous craftsmanship and detailing, elegant accessories—might be quiet when taken individually, but scream luxury when combined.

TIMELESSNESS: Just like its art, there is a certain immortality to Italian fashion. Changes do take place, after all; that is the nature of fashion. But these changes are extremely subtle. This is a

culture that has always looked into its past for inspiration. Italian designers are masters at taking classic shapes and reinterpreting them to make a connection between the past and the present that works for the future as well. The result is wear-for-years clothing.

The Italian woman enjoys her classics. Investing in timeless pieces is one of the ways she economizes, and you can, too. She then combines these items in new ways to refresh them, adding new accessories and accents.

The Italian woman also develops her own style early on, certainly by her twenties, and remains faithful to it. In this way, if she stays the same weight, she has a wardrobe that she's built over the years that works as a base.

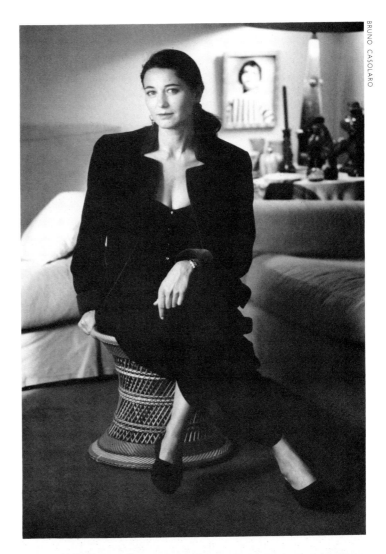

BRUNO CASOLARO

A FUSION OF FASHION STYLES THAT ADD UP TO AN EXTREMELY ELEGANT, EXTRAORDINARILY WELL-BRED AND REFINED LOOK IS ONE COMPONENT OF ITALIAN CHIC. HERE MILANESE INTERIOR DESIGNER BARBARA FRUA SHOWS ONE OF THE MANY WAYS SHE WEARS A FAVORITE VELVET JACKET.

CHIC ORIGINS

HISTORICALLY, Italians appear to have always been interested in the way they look and the way things look. Many of their ancient crafts are still practiced, as are age-old beliefs. Clothing was and continues to be the visible sign of social traditions and cultural values.

Since 2000 B.C., Italy has seen many different civilizations flourish in her boundaries, most notably Greek, Etruscan, then ancient Roman. The ruins and remnants of these civilizations are still very much in evidence in modern Italy, as is their legacy of art and style. The Etruscans in particular were highly advanced artisans whose designs, particularly in gold, are still widely copied. While their fashion style was simple, their cloth was relatively sophisticated, and they were masters at dyeing techniques and the creation of elaborate prints.

Along with attention to the arts, the notion that clothes made the man prevailed throughout antiquity. For example, the way a Roman dressed, as well as the color of the border on his toga, indicated his status. Thousands of years later, a form of improvisational theater called the commedia dell'arte, which was popular in the sixteenth to eighteenth centuries, reaffirmed the attitudes inspired by certain dress and appearance. Actors in the commedia troupe were skilled in disguise and transformation. They tried to become someone else during the course of the performance through recognizable masks and costumes that immediately typecast the character being played.

For hundreds of years, Italy had traditional costumes specific to each republic/city-state. In the nineteenth and first half of the twentieth centuries, Italian fashion was mostly inspired by French models. In fact, the Italian aristocracy and upper class often had French clothes copied in Italy. Even Italian designers as late as the 1940s blended French ideas with Italian culture.

Not until the Fifties did Italy begin to export its own recognizable look. At this time, Florence was the capital of Italian high fashion. The center moved, however, to Rome in the Sixties.

Ready-to-wear moved to the forefront of fashion in the Seventies, and when it did, Milan, an industrial center situated near many of the great fabric houses, ascended as capital of the new chic. Clothing with the pedigree and craftsmanship of the

haute couture, yet industrially produced, soon became another art form for which Italy was renowned.

THE TASTE OF ITALY

"THE WAY YOU LOOK is 50 percent of the way people think you are," maintains Patricia Pontremoli, editor in chief of Italian *Cosmopolitan,* affirming the importance of looking good in Italian culture.

If you are physically beautiful, so much the better, but beauty or wealth alone, without style and good taste, are not enough. One could say this is a tremendously superficial attitude. But developing their inborn elegance to its fullest, dressing stylishly, showing the world that they think they are worth it, is an integral part of Italian society and an approach that underscores every aspect of life. It's called *la bella figura.*

LA BELLA FIGURA

This quintessentially Italian attitude—*la bella figura*—means looking good. It sounds simple, doesn't it? A people tremendously concerned with style believes in dressing well for every occasion. While *la bella figura* involves an unspoken style code consisting of strict rules, it also involves self-esteem and actions as well as appearances. It seems to be taken more seriously in Milan and the northern part of the country—the South has a more relaxed approach to everything—but is nonetheless a national attitude.

"You should look the way you're supposed to look for who and what you are" is how journalist Ludina Barzini, whose father, Luigi Barzini, wrote *The Italians,* defines one part of *la bella figura.* "This is a very consumer-oriented country, and it's important to get your clothes right. People watch each other all the time . . . and judge each other."

Adds Manuela Shapiro, "There's a constant display of the position you've attained. You don't want to ever show the negative side to your nature. So you dress within a range of the limits chosen. And style to some is as important as brushing your teeth. You don't leave the house without looking perfect.

"Style and elegance are anchors to give strength," she continues, "so that people envy you, instead of you having to envy others." Shapiro believes that this empowering phenomenon came out of insecurity. "Italy was a poor and rural country before and during the war. Times were hard and there was a situation

of feeling inferior to the other powers in the war," she says, tracing the origins of this insecurity. "It's also a way of Italy invading the world with something different. In the past, we exported manual labor . . . now we export refined elegance."

A sense of dress in Italy is connected with modernity and social climbing, points out Giannino Malossi, author of the book *This Was Tomorrow.* "That's why everyone is so tense about fashion. It's status."

This focus on style is also a way of showing the world that you are always in control. Jill Stainforth, author of *A Survival Guide to Milan,* a Canadian married to an Italian and living in Milan, explains, "An Italian wants to appear right or best at all times." Even at the grocer's. "Dressing elegantly while doing the grocery shopping shows courtesy and respect for the grocer," says she. "It's important to dress right for an ongoing rapport."

Within this code, there's a great self- and social consciousness. Sloppiness is never acceptable, and a sense of rightness continually prevails. You go out dressed the way one is dressed when one goes out. You stay home alone dressed the way one is dressed to stay home alone. And this also means that dressing well is an indication of self-respect. From the cradle, children are educated to be continually elegant.

People have been known to go to extremes in order to *fare bella figura* (look good/save face). Some other rules of conduct according to the code include:

- Making up an answer to a question if you don't know it, because you never want to appear lacking.

- Bypassing shops that are out of your price range. This involves somehow knowing the price range of a shop before you enter it. This is to avoid embarrassment on your part—or the shopkeeper's—if it's too expensive.

- Not asking prices in a chic shop. If a garment interests you, ask if you can try it on and look at the price in the dressing room. If the price isn't indicated, ask it casually.

- Always wearing shoes that are almost new and very elegant when shopping.

DRESSING TO IMPRESS

DRESSING TO IMPRESS is a basic tenet of Italian life, to be expected perhaps when design and style are essential, as is going to great lengths to do the right thing. Italian women dress to be appreciated by everyone—although Italian men like to think it's strictly for them.

Men have much to say about fashion . . . about what they like and don't like. Two attractive men, independent of each other, who both begged for anonymity, mentioned that if a woman isn't tastefully dressed, no matter how gorgeous her face and body, they couldn't get involved with her. They explained that their sensibilities would be offended by bad taste.

Another underlying—and unspoken—reason, according to the *bella figura* code, would probably be that they are afraid *they* would be judged lacking because of their companion's lack of taste.

What Luigi Barzini wrote in *The Italians* more than thirty years ago is still true: "Men run the country, but women run men." Once you've spent enough time in Italy to become somewhat integrated into society, you see exactly how they do it!

Other Italian men state it differently. Here are a few of their comments about women . . . and fashion:

"Generally speaking, the Italian woman feels she has power . . . a feeling she inherited from her mother. For historical reasons, in Italy, women know unconsciously, viscerally, that they have power, like in ancient times. In addition, women are always looked at here . . . and that gives them a power. It's also natural in this culture to appreciate beauty. It's an ancient fact . . . not a superficial one. We're conditioned by our past.

"I think that the Italian woman is sort of obsessed with her image. Relationships here between men and women are connected to sex. Women understand this and think of themselves first as a woman, then as a person. Fashion underlines her role as a woman. She dresses to show herself as a woman . . . she lives up to the role." —GIUSEPPE PULLARA, political journalist

GIOVANNI COZZI

AT HEART A LITTLE SEXY, YET A LITTLE SOPHISTICATED, ITALIAN CHIC DIFFERS ALL OVER THE COUNTRY. ONE THING THAT NEVER CHANGES, THOUGH, IS THE NATURAL EARTHINESS OF ITALIAN WOMEN.

"It's in our culture to want to dress in a way we feel good about. Italian women have a strong temperament. They always want to emphasize sex . . . to be reassured that what they wear attracts." —ROBERTO SCHIO, entrepreneur

"Fashion is important to Italian men. They're interested in the way women look and dress. For the Italian male, the woman is still a premium object."
—LUIGI SETTEMBRINI, writer and marketing director

"I think Italian men love women in the good true sense. But we're spoiled by the way we're born. We've been trained since birth to appreciate beauty. Italy is a very beauty- and family-oriented country. Actually the family molds the looks of both Italian women and men. The root of many differences

certainly between Italians and Americans is that Italians never leave home.

"Italian women, however, are sweetly powerful, yet they're very liberated. But they do dress for men, although the style is different from North to South. They're also manipulative. Men, though, don't mind being manipulated. We know it's a game."

—DARIO MARIOTTI, managing director of New York City's
Mayfair Hotel

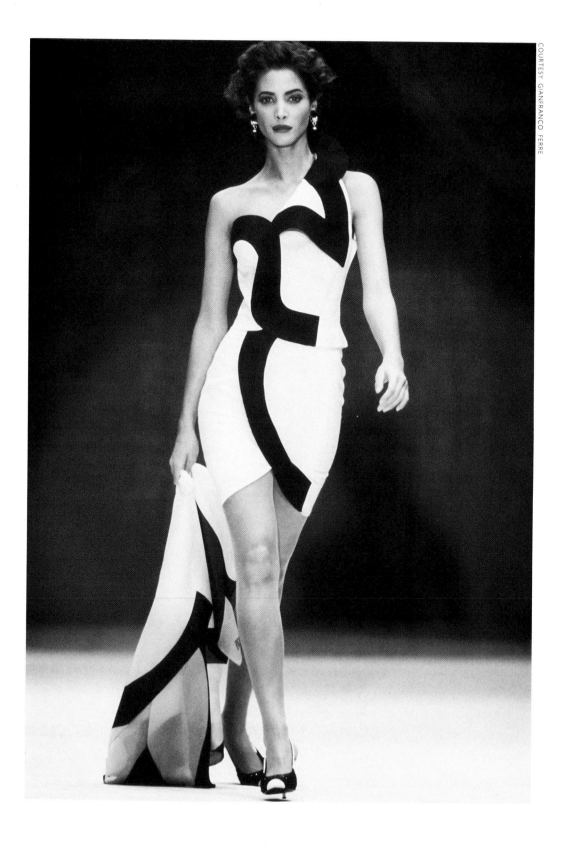

2

THE NAME OF THE GAME

WHAT'S THE ITALIAN WORD for "jacket"? Many well-dressed Italians would say "Armani." A jacket by any other name just wouldn't do! In Italy, names are everything and an article of clothing is almost always identified by its designer. An Armani jacket, for example, is considered the epitome of design. It identifies the wearer as a woman of taste. "She doesn't choose a designer name for reassurance," explains public relations maven Franco Savorelli. "That signature gives the Italian woman a guarantee of quality."

That signature also often costs a fortune, especially in America, one of the leading markets for Italian designer fashions, and especially during those times when the dollar is not very strong. To remain competitive in the marketplace, most designers are branching out to a number of subsidiary collections, each with a different attitude—sport, career, and so on—and each with a different and less costly price point. Although they generally suit more casual occasions, they usually share the same attention to value.

Whatever their price point, however, designers set the Italian fashion pace. They are the source of inspiration for the public (and some say for foreign designers as well). Magazines spread the word. Competitors, whether consciously or unconsciously, are influenced by the look. Garments become derivative of Armani or Ferre or any top name. Direct copies also abound. In Italy, they, like the originals, are usually of excellent quality, even those that are mass-produced and available in the small boutiques or the occasional department store, of which there are only a few.

For top-of-the-line copies—or adaptations, as they are often described—wealthy Italians sometimes visit a "sarta," or dressmaker. The rich especially will have a favorite designer gar-

EVENING ALLURE FROM GIANFRANCO FERRE'S COLLECTION.

ment copied, almost always in the designer's actual fabric, but frequently with a slight change to personalize it.

THE PLAYERS

THE ITALIAN DESIGN COMMUNITY can be divided into a few general categories. Each may contain certain crossovers because it's difficult to attach neat labels to a complicated group . . . for example:

THE DYNASTIES: The great families of design: the *Fendis, Ferragamos, Pradas, Benettons, Missonis.*

THE OLD GUARD: The acknowledged leaders whose names are synonymous with Italian chic: *Armani, Pucci* (a Sixties name that's become a Nineties phenomenon . . . could be considered a crossover because Emilio Pucci's children are now very involved in the company), *Gucci* (another crossover, but from the Dynasty category, because most of the family is no longer a part of the business, except for son Maurizio).

THE UPSTARTS: Their interpretation of Italian chic is a departure from the traditional: *Romeo Gigli, Dolce & Gabbana, Moschino.*

THE FRANCO-ITALIANS: Italians by birth, but French by affiliation . . . or outlook: *Ferre,* who also designs Christian Dior couture; *Valentino,* who's long shown his collections in Paris and incorporates Gallic elements in his style; *Versace,* whose new design style is more Parisian than the French.

THE INDEPENDENTS: They don't fit into neat categories—*Mariucca Mandelli for Krizia* (whose whimsical prints are truly original) and *Laura Biagiotti* (the queen of Italian cashmere), *Capucci* (an acknowledged iconoclast who's renowned in Rome and within Italian borders).

THE NEWCOMERS: They're not yet household names, but are starting to have a following: *Marina Spadafora* (a native Italian who was living in California for years), *Ciara Boni* (based in Florence and not available—yet—in America).

THE INDUSTRIALIST COMPLEX: Giant corporations that own, oversee, develop, and encourage well-known fashion names, like the *Genny Moda Group* that produces Genny (designed by Versace with the collaboration of Donatella Girombelli), Byblos (designed by Keith Varty and Alan Cleaver), Complice (designed by Dolce & Gabbana), Malisy, and a few other lines, as well as *GFT,* producer of Ciara Boni in Italy and certain secondary lines of Armani and Valentino in America.

DESIGNER MESSAGES

THEIR NAMES STAND FOR quality, integrity of design . . . and something far less tangible, too. And they may be attached not only to clothing at various price levels for women, men, and children, but accessories from A to Z, fragrance, even home furnishings. Designer style is extremely pervasive. In fact, it's even taken to the air. Giorgio Armani recently redesigned the Alitalia uniforms for flight attendants and ground hostesses. The looks he created are as chic as his collections, and based—to be expected—on his signature easy tailoring and neutral shade ranges. Why Armani? "Alitalia remains faithful to its aim of associating its image with the highest expressions of Italian style and culture," explains Ferruccio Pavolini, the airline's president.

Probably the best way to understand each designer's message and appeal is to try on the clothes, but this brief rundown should be a help. So here are the names mentioned before, in alphabetical order:

ARMANI

It all started in 1975 with an unstructured jacket that offered the ease of menswear plus a very fluid, somehow feminine feel, and the rest is fashion history . . . the rise of Giorgio Armani, that is, who is frequently referred to as the most influential designer in the world. Armani is the master of easy elegance for men and women. His legendary jacket remains a fashion classic and his name is now synonymous with a softer, more relaxed way of dressing that's refined, yet sensuous. "My style is about feeling good in clothes and about yourself—whether you're wearing a skirt, shorts, or a pair of trousers," he explains, adding, "Style is the correct balance of knowing who you are, what works for you, and how to develop your own character. Clothes become the expression of this balance."

His background as a menswear designer enabled him to

ALITALIA'S NEW ARMANI UNIFORM.

create a female fashion formula based on his belief that women were looking for a style of dressing that was a little like a man's, with plain, soft, flowing jackets they could move in freely and naturally. In the Seventies, he realized they wanted clothes that, like menswear, didn't appear dated the next year. Now, in the

COURTESY GIORGIO ARMANI

THE QUINTESSENTIAL
ARMANI SUIT.

Nineties, his approach has changed very little. "I think that a woman can dress like a man in the morning, and wear a dress in the afternoon," he maintains. His belief in the elegance of the uncomplicated is evident in his use of multitextured fabrics, layers of subdued colors (especially taupes and grays), and superb tailoring. It's been said that you can copy the Armani look, but never the fit.

Rather than changing drastically, his designs evolve naturally from those of past seasons, a philosophy he thinks women should apply to themselves. "Change has to be subtle," he cautions. "When a woman alters her look too much from season to season, she becomes a fashion victim." Interestingly enough, one of his biggest followings is in Hollywood, where he not only dresses the stars on and off the screen, but also the decisionmakers, moneymakers, and executive wannabes. An Armani suit, especially for a woman, is considered the height of power dressing.

BENETTON

In the strict sense Benetton is not a designer label, but rather a manufacturing and retailing phenomenon, with six thousand outlets in eighty countries. Benetton's eye-catching advertising promoting a "united world," arresting cookie-cutter stores all designed by the same Italian team for the last twenty-five-plus years, and brightly colored, young-spirited, easy-attitude clothing are acceptable to all age groups. "There's not a Benetton look," says Fabrizio Servente, director of product development. "It's a method of dressing that a person can personalize. There are lots of ways to combine the parts. Benetton's message is: up-to-date, not excessive, easy to understand, wear, and buy." A quality item that's affordable and simple to care for are additional attributes.

Color, which is a key element in the Benetton formula, is the foundation upon which the company was built. In 1965 Luciano Benetton began selling the brightly hued sweaters his sister Guiliana knitted as a hobby, bringing his brothers Gilberto and Carlo into the fledgling business. At that time, the knit color palette in Italy was extremely limited, and the array of dazzling shades in simple shapes was instantly appealing, especially to the younger customer. This success led to a revolutionary retail operation developed by Luciano: a direct commercial network with representatives and shops exclusively for the Benetton product. The first Benetton boutique was opened in Italy in 1968. The philosophy, even the look, was different than the traditional shop

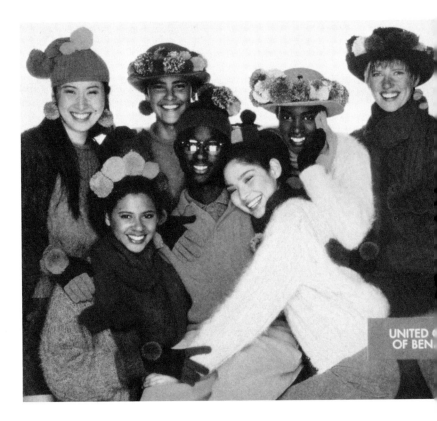

HIGH-SPIRITED AND YOUTHFUL
—THE FASHION AND IMAGE
FOR WHICH BENETTON IS
WORLD FAMOUS.

at that time: the space was open and inviting, with all merchandise displayed for self-selection.

Today, Benetton is far more than bright knits. In addition to the namesake sportswear line, it has diversified into perfume, cosmetics, all manner of accessories, including shoes and eyewear, a children's line, a bed-and-bath line, and the Sisley trademark, a more upscale ready-to-wear collection.

BIAGIOTTI

Often referred to as the "Queen of Cashmere" because of her love for this luxurious yarn and her distinctive use of it in her collections, Laura Biagiotti gravitates toward the classic and toward quality in her fibers, fabrications, and creations because of their longevity. "I like things that endure, lasting styles, natural colors," she says, adding that she usually dresses in white, a shade that is virtually timeless. She also draws upon culture, art, and archeology for design inspiration. "Although I'm a stylist, my hobbies are archeology and antiquing. I feel that culture has always influenced what I do," she explains. "Style is like a chain,

however. You can't invent it. You have to have a knowledge of many things and then find something new in them." Born in Rome to a "fashion family," she began working in the business in the Sixties. She feels that femininity, quality, and research combine to create her style. "I think that I have a design advantage because I'm a woman; I consider myself as a test," she adds.

Her approach, which she feels is typical of Italian style, is creations for everyday life. "French fashion is usually for great situations, while American style is more sportswear. Italian fashion, dating as far back as the Renaissance, is meant to add the extraordinary to real life."

Biagiotti presented her first collection in 1972. Now, twenty years later, she is an industry with a wealth of licenses in all fashion areas from fragrance to luggage, as well as items for the home.

BONI

Think of her label as the Ellen Tracy of Italy—lots of career-minded clothes, including a succession of curvy little suits. Based in Florence, Chiara Boni began designing feminine and sexy dresses for herself twenty years ago, then branched out. "I always try to do things that I can wear," she explains. "But my clothes are for any woman who's lively and has a sense of humor."

BYBLOS

The fashions are fun, casual, and young-spirited, even though the customer might be between "nineteen and ninety," explain the designers, Alan Cleaver and Keith Varty, two Brits who have been designing the collection, part of the Genny Group, since 1981. "When people think of Byblos, they think of pattern, including wonderful prints, shape, and color."

Certainly, the combination of Italian craftsmanship and English eccentricity creates quality sportswear with a playful air. Rather than offering a total look, the collection is made up of distinctive pieces that work together and separately as well. "We don't design outfits . . . we don't say what has to be worn with what."

The two do design items that are simple and easy to wear and mix. "We like to see our clothes mixed with other pieces, whether they be Byblos from years past, or different labels," they maintain. Creating collectible, lasting fashion is their goal. "We never want to make our clothing so overdesigned that it can't be kept for years," they state emphatically, adding that accessories

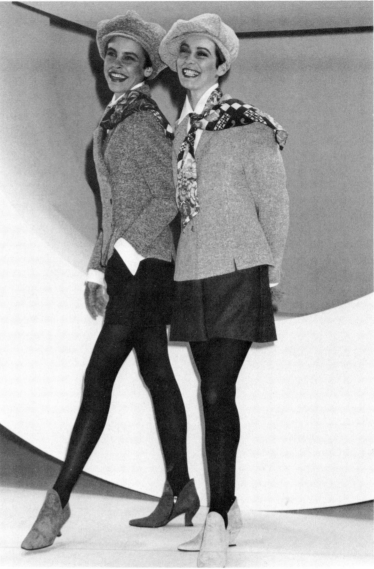

COURTESY BYBLOS

THE BYBLOS TRADEMARK—CLASSIC
ELEMENTS PRESENTED AND
ACCESSORIZED IN A
YOUTHFUL WAY.

are also a very important part of the fashion mix. "The clever woman works with them to update and change her look."

CAPUCCI

A name that conjures up wild inventiveness, fashion that's an art form, fabric that frames the body in extravagant shapes, Roberto Capucci is considered a true original. His forte is eveningwear unlike anyone else's and outside the boundaries of passing trends. "My idea of evolution is *not* to change each year," observes the

designer, whose basic designs build on each other from collection to collection, although each of them is marked by experimentation and the continuous reexamination of shapes and colors he's already experienced.

Capucci set up his first atelier in Rome in 1950. And Rome is where he's stayed for the last forty-plus years, except for a time in the Sixties when he worked in Paris. Although he's garnered numerous awards and honors throughout his career, he prefers to remain outside the fashion establishment, citing a need for independence and freedom. As for his inspiration, he claims, "I'm always designing . . . it's a need. It's almost as if I absorb the beauty of whatever I see, be it nature, art, music, decor, sculpture, and it influences my work." His only desire, he says, is to satisfy his own artistic sense to create something different and original that continually astonishes.

WEARABLE ART—SILK COCKTAIL
DRESSES—DESIGNED BY
ROBERTO CAPUCCI.

DOLCE & GABBANA

"She's a Sicilian type, strong, yet very feminine," says this design team, explaining their ideal woman. The image that comes to mind is that of Anna Magnani, the earthy Italian actress with the tragic aura. The clothes that have brought Domenico Dolce and Stephano Gabbana into the limelight celebrate the female body —especially the breasts and hips. Luxurious fabrics in curve-clinging shapes, including shirred stretch skirts, wrap front and revealing tops, and romantic fashions with the feel of lingerie are just a few of their signatures. "Our woman is in touch with her sensual side," they point out, adding that she takes care of her body and feels secure about herself. That's good, because these styles leave little to the imagination.

While the collections change each season, the philosophy stays the same. "We want to create clothing that makes a woman happy because she's pleasing herself, as well as whoever sees her," maintains Gabbano. "We're attempting to bring back something from our culture that was lost . . . a passion, perhaps. We're trying to translate emotions into clothes and help a woman express her inner self."

The two met in Milan, in 1980, when they both assisted the same designer, and started their own business two years later. Dolce was born into the fashion business. He learned the trade in his native Sicily, where his father had a small clothing factory. On the other hand, Gabbana, born in Venice, has a background in graphic design. They first worked as consultants to several companies, then created their own line, which they formally showed in 1985 during the Milan collections. Today their distinctive look is bought by the same women who buy Romeo Gigli and generally eschew a tailored, menswear approach for a sultrier, more body-conscious one. In addition to designing for men and women under their own name, Dolce & Gabbana design the Complice collection, which is part of the Genny Group.

FENDI

From luxurious leather goods to couture clothing and world-famous furs, Fendi is a family business that seems to know no boundaries. Run by five sisters—Paola, president of the group; Anna, creative director; Franca, liaison with the stores and clientele; Carla, head of press and advertising; and Alda, director of fur production—who transformed their parents' small leather and fur shop, opened in 1925, into a conglomerate, Fendi today

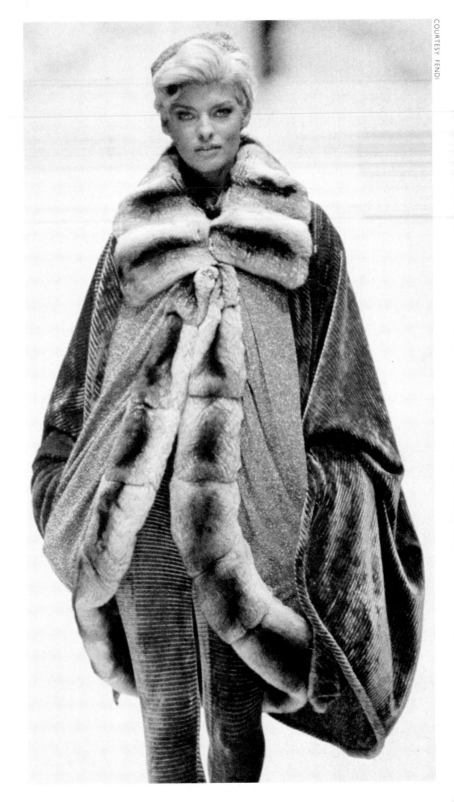

A SUMPTUOUS FENDI FUR.

consists of more than seventy-five boutiques and hundreds of points of sale around the world. "Fendi is a phenomenon spanning three generations," points out Carla Fendi. "So even though there's the tradition of great quality, there's always something new. We're continually searching for new materials and technological advances." While the company roots are in Rome, the sisters always had a great desire to create the avant-garde, she explains. "Rome is a city that promotes fantasy and creativity, although we never think of ourselves as doing typically Roman fashion," she maintains. One reason might be that since the mid-Sixties there has been a collaboration with designer Karl Lagerfeld, the talent behind today's Chanel label as well, although Carla is quick to point out that it's a joint effort.

And although each sister has a different personality, and thus point of view, all this does, says she, is lead to very lively meetings. Dedication to the company and the common goal results in very focused business decisions.

FERRAGAMO

Certainly the maestro of Italian shoe design, Ferragamo's name is also associated with a vast empire encompassing not only footwear but ready-to-wear and accessories. Refer to Chapter 7 for a more complete description.

FERRE

Spare lines in sumptuous, sensual fabrics with decorative details —extravagant buttons, eye-catching soutache scrolling—are Gianfranco Ferre signatures. He defines his customer as "an active, modern woman who knows tradition." Formally trained as an architect, this discipline is perhaps more evident in his highly organized approach to projects than it is in the dramatic and opulent outcomes, although there's a sense of underlying structure in his clean shapes, even when they're soft. His travels and the time he spent in the Orient and India after graduating from university have also remained enduring influences on his style. "But I always want to be modern," maintains Ferre. "I want clothes to be easy, but with the richest cultural background I can give them."

Ferre presented his first namesake women's collection in Milan in 1978, as well as a men's and women's sportswear line called Oaks, followed by a Ferre men's collection four years later. Today, he's garnered awards all over the globe and his name stands for an empire of lines and licensees in all areas of fashion

and accessories, as well as furniture. In addition to all he creates under the Ferre label, he also designs Christian Dior couture and ready-to-wear.

CASUAL EVENING ELEGANCE FROM
GIANFRANCO FERRE.

GENNY

A division of the vast Genny Moda Group, the Genny collection looks as if it were designed for a very feminine—and sexy—executive. The fabrics are luxurious, the lines figure-flattering, and the feeling is businesslike but not boring. That's probably because the professional at the helm is a woman with an international outlook who takes the message very personally. "The Genny style represents my style, my caprices. It's a combination of sensuality and severity," explains Donatella Girombelli, who collaborates with Gianni Versace to create the collection. She, along with her brother-in-law Sergio Girombelli, is also involved in the direction of the overall Genny Group, which was founded by her late husband in the early Sixties. "Genny tries to respect the personality of the wearer, because it should come first," she insists. "Therefore, there are work fashions for a woman's serious side and lighter, more frivolous looks for after office hours." These are clearly clothes with a dual aim—to please men as well as the women wearing them. "It's the package that counts," confirms Girombelli.

GIGLI

His designs can be recognized at a glance . . . so different are they from everyone else's. Romeo Gigli's fashion formula is based on soft, rounded lines rather than hard geometric ones, on sloped shoulders and draped shapes to elongate the body: gently wrapped skirts and tops, cocoon coats and flyaway jackets that envelop the body, hugging it in some places, hiding it in others. He tends to repeat forms, rendering them in different fabrics and colors, with different ornamentation. "My shapes recognize a woman's shape," he explains. "I don't like to cut fabrics, but rather wrap them around the body in an ethnic manner." Each collection is a cerebral mix of rich complex colors, astonishingly opulent materials, innovative and unexpected effects, recalling long-ago times and more exotic places.

A designer who took to it naturally, Gigli actually studied architecture. He began designing fashion in the Eighties, after developing a passion for lavish fabrics, extraordinary colors, and ethnic shapes as a result of extensive and prolonged traveling, especially in India and the Orient.

Gigli says that his vision of women comes from Italian art. "During the Renaissance, the women depicted in art were very

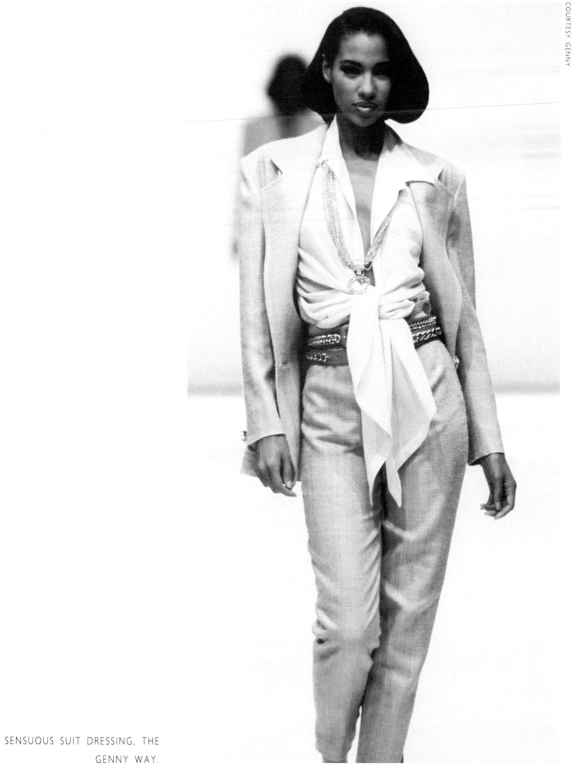

SENSUOUS SUIT DRESSING, THE
GENNY WAY.

ROMEO GIGLI'S OUTERWEAR WITH
A RENAISSANCE LOOK—AND FEEL.

sensual and sweet . . . pleasing to men." Certainly his knowledge of Italian culture and art, his around-the-world travels, and his architectural background are all apparent in the way he mixes Renaissance and rococo elements with ethnic and modern ones. Details may change in his collections from season to season, but their spirit and sensuality—and sometimes their strangeness— remain fixed.

His look, however, is meant to be personalized. "I never want to walk down the street and see someone duplicating the way a designer showed an outfit," he says with a shudder. "I design the jacket, the shirt, the pants separately and assemble them later," he explains, referring to the creative process. "I like every piece to have its own life, so a woman can play with them in any way she wants, to emphasize her personality."

GUCCI

One of this century's most famous names in leather and accessories, Gucci has changed significantly in the past few years under the guidance of grandson Maurizio Gucci, who hired American creative whiz Dawn Mello to overhaul the company. These days, the famous Gucci loafer is fabricated in a rainbow of mouth-watering hues, all the leathers are on everyone's most-wanted list, and the cashmeres and ready-to-wear are truly fashionable. Refer to Chapter 7 for a more complete description.

KRIZIA

Although she is sometimes referred to as Krizia, the name of the label's founder and designer is actually Mariuccia Mandelli. She calls her company Krizia because it refers to a character in one of Plato's dialogues who squanders money on women. Today, Mandelli's style can be described with the same adjectives it could when she gave up a teaching career in 1954 to become a designer, finally presenting to the international press at Florence's Palazzo Pitti in 1964. She caused a sensation. She is always contradictory: classic yet contemporary, wearable yet witty. In fact, the uproar created over the fact that she, a newcomer at the show, won the top prize resulted in the award's being abolished. "I think fashion should be a game, not a problem or a tragedy," explains Mandelli. "The woman I design for isn't afraid to show people who she is, but doesn't want to show off." She believes that a good stylist has a sense of what the streets can offer. "Because I'm a woman, I sense things . . . it's a natural response," she says about her talent. Inspired by art and architecture, including the harmonies

of both design and color within the Italian culture, Mandelli likens her fashion constructions to architecture, in a way. Since childhood she has wanted to be a designer. "I like to dress people the way I think they should look," she observes.

She has certainly taken the ball and run with it. In concert with her husband, Aldo Pinto, she began expanding the Krizia domain first with a sweater company, then with a children's collection, followed by a second women's-wear line—and the list goes on and on. Today, Mandelli creates more than twenty-eight collections a year including menswear and has about forty licenses. There are free-standing Krizia boutiques all over the world. Through a licensing agreement, Japan will have hundreds of outlets. In addition, Mandelli is a promoter of cultural events in her Spazio Krizia in Milan, a partner in a publishing house, and the owner of an exotic resort near Antigua, called K Club.

Certain themes run through her collections. Animal images and prints have been constant since the Sixties. In fact, since 1974 each collection has had an animal mascot. Inventive pleating is another recurring motif as is the use of surprising and inventive materials.

MISSONI

Quintessential Missoni is characterized by a rainbow of flame-stitch stripes in an assortment of unexpected colors on a slinky, silky, sexy knit pullover or sheath. Patterns are a trademark, as are unexpected color pairings and beautiful workmanship. One of the most instantly recognizable of all Italian designer styles, Missoni looks as right today as it did in its heyday, the Seventies. The company itself began modestly. In the early Fifties, just after their marriage, Rosita and Ottavio (Tai) Missoni set up shop: the business was knits, and the news was an innovative way of creating them that resulted in the now legendary look. Faithful followers like to mix up the combinations of patterns and colors so that the results are very personal.

After years of creating knits for different resources, the Missonis began designing under their own name in the Sixties. Very well received in Europe, they became media darlings in America by 1970, winning a wealth of awards and being exhibited in museums all over this country. Their fabrics have often been compared to works of modern art. In fact, in an art show in Milan they were presented as paintings. "We are artisans," explains Rosita Missoni. "Sometimes we achieve great results in the

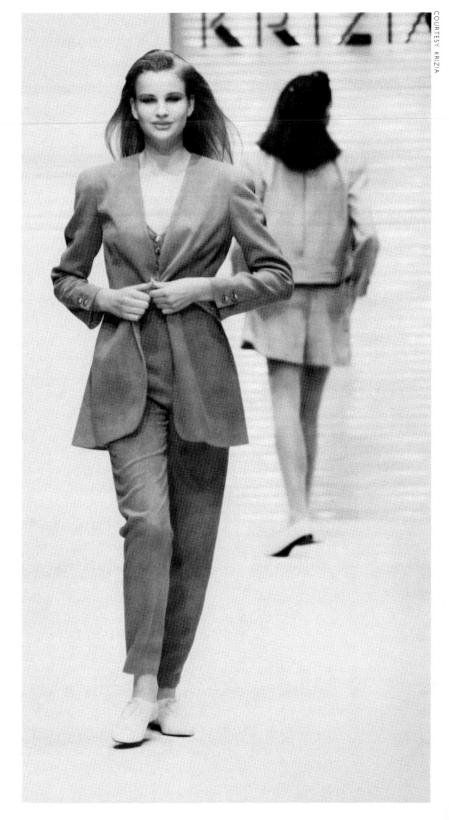

EASY KRIZIA:
THE FEMININE PANTSUIT.

field of applied art. But we don't think in terms of doing art."

The Missonis, like many other Italian designers, are quite diversified. In addition to namesake boutiques throughout the world and their men's and women's ready-to-wear, their licenses cover the range of accessories from beachwear to underwear. Today, their three children assist them in running the business.

MOSCHINO

A "dinner suit" with knives, forks, and spoons for buttons; an evening dress with stuffed teddy bears edging the neckline; a Chanel-inspired suit with tiny jackets making up the jacket pockets . . . the man behind this fashion madness is the industry's favorite bad boy, Franco Moschino. "I don't design for a woman. I do what I like," he insists, adding that "fortunately it sells!"

What he likes best is to have fun with fashion . . . and to poke fun at it too. After having worked first as an illustrator and then as a freelance designer, Franco Moschino started his own label in 1982, a time when clothing signified success, power, and status. "I started with this fun attitude as a reaction against what was going on," he explains, and for that reason he set himself as a revolutionary, a crusader for better values. As he sees it, his message is to be yourself and not let anyone else dictate your taste. "Don't forget that the real philosophy of fashion is to get dressed and be pleasant," he explains.

A designer who hates newness for the sake of newness, he nonetheless likes to play around with concepts that are novel, and credits his Italian heritage for influencing his vision. "Italians have been maestros of taste for centuries . . . the history, the visual art . . . it's everywhere in my work," he points out. His speciality is creating classic clothes adorned with surreal details so the outfit turns into a parody of itself. "My job is to provide solutions, suggestions," he says. "If there are people who are shocked, well, today I am convinced those people will never be saved."

When he started, price was less important than it is today, explains Moschino, adding that it is currently part of his design concept. His less expensive line, Cheap and Chic, embodies this belief . . . even though its prices are far from rock bottom. "Spending so much money for such a little thing as fashion is silly, though," says this world-famous designer, ever the provocateur. Asked what a woman should splurge on if she could only buy one thing, he responds, "a good bottle of Italian red wine."

PRADA A company renowned for its status and its costly leather goods and handbags—every image-conscious Milanese has at least one version of the Prada bag—Prada is also the label of choice for interesting and innovative shoes and luxurious, highly personal clothing, all designed by Miuccia Prada, granddaughter of the company's founder. Refer to Chapter 7 for a complete description.

PUCCI One of the most famous fabric and fashion designers of them all, Emilio Pucci is perhaps synonymous with the Sixties. His shocking color combinations—lime and brown, pink and pistachio, peach and geranium—fantastic patterns, slinky silk jerseys in sexy silhouettes have influenced fashion for more than thirty years. Yet this aristocratic designer, who lists Catherine the Great and the Medicis among his ancestors, is as sought after today as in the past. When queried about his fashion philosophy, his daughter Laudomia answers, "His thinking is very Renaissance. He puts a woman on a pedestal; makes her look as feminine as possible." For him, style is mostly a matter of uncluttered lines and simple elegance. While rooted in tradition, Pucci was from the start a fashion visionary. He began his design career in the Forties with a line of stylish skiwear. In the Fifties, he was the first to create an elegant and comfortable pair of women's trousers. He developed colors that had never been used before, and lists Capri as his inspiration. Other firsts include his now-famous silk jersey, followed by fabrications mixed with Lycra that allow movement, as well as the before-mentioned extraordinary prints and color mixes that are instantly recognizable and have changed the face of fashion forever. While his distribution is small in Italy, it's extensive—and becoming more so—in the United States. "America has always been the site of my father's biggest success," points out Laudomia.

SPADAFORA Her designs are young-spirited and sensual, and she is recognized for her inventive way with ready-to-wear, primarily knits. She has taken the family knitwear business, begun in 1925 by her grandfather Giuseppe, in new directions, coming out with her own label in 1983. Although born in Italy and currently based there, Marina Spadafora went to school in the United States and had a fashion studio for several years in Los Angeles. Her designs are usually comfortable, casual, sensual, and somewhat whimsical.

VALENTINO

One of the few designers to be known all over the world by his *first* name, Valentino Garavani has been an internationally famous fashion figure for over thirty years. His clothing is refined, luxurious, with a very feminine Franco-Italian feel, perhaps because of his years spent in Paris apprenticing with Jean Desses and Guy Laroche before opening his own atelier in Rome (he is one of the few designers based there, along with Laura Biagiotti, the Fendis, and Capucci). And his clothing looks expensive. All of these attributes probably explain why he has long been the darling of many of the world's richest, best-dressed, and most-celebrated women. Early on, Elizabeth Taylor, Sophia Loren, and Gina Lollobrigida wore his designs. Jacqueline Kennedy Onassis was a loyal fan, although during her stay in the White House she patriotically wore only American designers. The elegant Babe Paley and the Duchess of Windsor also wore Valentino.

Responsible for some twenty-five collections a year, from haute couture to wallcoverings, Valentino is more than a designer, he's an industry.

VERSACE

In recent years, Versace's designs seem more French than Italian, and more rocker than real life. His colors are dazzling, his styling sizzling, and his sexy silhouettes suitable for leading ladies who dare to show their stuff. Although he has become fashion's, as well as a bevy of film and pop stars' darling, his tailoring, as always, remains superb. "I hate women who are afraid," he has been quoted as saying. And it would seem that it takes real guts to wear some of his more body-revealing looks, which many rock stars find ideal. Lately, Versace has been designing costumes for the opera and the ballet, as well as concerts and videos. His inspiration can come from just about anything, which is why he likes to travel, to be out there. Since his mother was a dressmaker, he says he only has memories of fashion and playing with fabric. In fact, while he was growing up, he continually tried his ideas on his younger sister Donatella, who has remained his muse. When he got older, Versace entered the business, starting his own company in 1978 after six years as a freelance designer for various labels, among them Genny, Callaghan, and then Complice. Today, the Versace Group is strictly a family affair, although it is a tremendous venture including boutiques and design entries in all fashion and accessories areas, as well as fragrance.

His signatures, although theatrical, remain the same—soft draping, asymmetrical cuts, unusual fabric and color mixes, combinations of black and vivid hues. Of all the Italian designers, Versace is most often referred to as "modern." He says, "I am only interested in tomorrow; what's behind is just footwork."

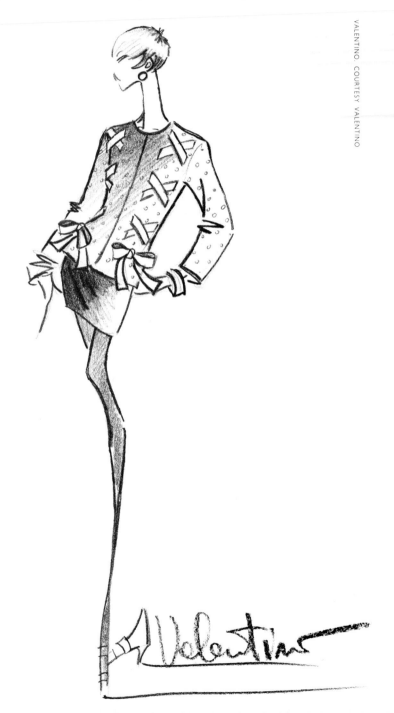

VALENTINO'S WITTY DAY-INTO-
EVENING SUIT

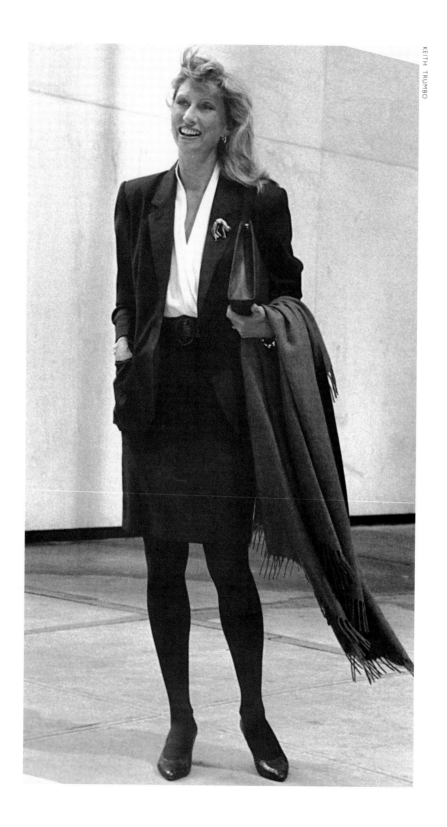

3

MILAN— BIG CITY SOPHISTI- CATION

IT IS THE CAPITAL OF CHIC with a small *c*. Fashion reigns supreme, but anything showy is described by the cognoscenti as "too Roman"... and that is *not* considered a compliment. The only time the Milanese really flaunt it is on December seventh, opening night at La Scala, the famous fairy-tale-like opera house constructed in the eighteenth century, then rebuilt in the late 1940s after being hard hit during the Second World War. On opening night, men in black tie and women in black evening dresses shimmering with mountains of jewels make an entrance. It seems that every woman is swathed in a sumptuous sable or mink coat (the animal-rights movement hasn't really made inroads here, yet), giving the impression that all Milanese are millionaires. And many are. This city-state accounts for nearly a third of the entire country's national income.

Generally, Milan style is discreet and elegant, as streamlined as an Alessi teapot. Women here, no matter what their economic level, dress down instead of up, in colors that harmonize with the fog that is always hovering in the air. Every once in awhile, a bright purple or persimmon jacket or coat will stand out in the crowd of grays, olives, taupes, and beiges. The person wearing it will usually be a foreigner, though. The color code is relaxed slightly during certain seasons, depending upon the palettes of the leading designers. Armani, for example, has never been a big fan of brights, although occasionally he shows color in his Emporio collection and lately he has been showing some red in his couture collection. Esthetically as well as historically, the colors that work best with the atmosphere of this city are muted and somber.

Milanese women are not renowned for their inventiveness; the men actually take greater fashion risks than the women. Rather, the women have developed an almost rarefied sense of

appropriateness that is as evident in their mix of fabrics and textures as it is in their use of colors and shapes. It is subtle and very sophisticated: a downy wool-and-cashmere jacket in a barely there plaid; a silk shirt in an almost-faded paisley pattern paired with a different but equally muted silk-and-cashmere paisley shawl. All the fabrics are in differing weights and finishes . . . while the tones echo each other faintly but never match. The total effect is extraordinarily refined. In fact, fabric is such an integral and important part of Italian chic that you'll find an entire chapter about understanding it, mixing it, and caring for it later in this book.

STYLE WITH A CAPITAL "S"

STYLE, in fact, is Milan's main business, and probably its main attraction, making it a magnet for talent from all over the world. It is not a quaint city, or a charming one, or one that is particularly inviting for long strolls, except perhaps along the mosaic-paved, shop-lined Galleria Vittorio Emanuele II leading to the magnificent spired Duomo, or along the boutique-lined streets that make up the most exclusive shopping area, the Quadrilatero d'Oro (the Golden Rectangle). Formed by the Via Montenapoleone, Via Spiga, Via Sant'Andrea, and Via Borgospesso, this part of town is for the big spenders. Here is the greatest concentration of designer shops with inventive displays and mind-boggling prices in the entire city.

Shopping aside, an important attraction of Milan is its air of success. There is an almost audible hum of things happening. The allure of this city, like its fashion style, is subtle, somewhat intellectual. For example, hidden behind many of the massive dark doors that close all of the earth-colored palazzos to the public are tiny gardens of Eden: enchanting courtyards filled with greenery and flowers, where you can sometimes hear birds chirping. In a certain sense, the Milanese reflect their city. Cool and businesslike at first meeting, they open up when you get to know them, and become warm and effusive.

Milan has been described as the most American-like—actually the most New York–like—city in all of Europe in its work ethic and work habits. Certainly the remarkable food and magnificent decor of many of the restaurants are conducive to old-world deal making. Its courtly setting—an eighteenth-century palazzo decorated classically with a touch of the rococo—its

elegant appointments—ornate gilded mirrors and soothing dusty-rose tableclothes—and its attentive but discreet service make Boeucc a favorite lunch spot for the likes of Gucci's Dawn Mello. There, a plate of melt-in-your-mouth gnocci puts you in the mood to discuss business, which, in the case of Milan, is the business of taste and style. And every day, between the hours of one and three, what they're wearing, what they're watching, what they're doing is the topic at tables all over town.

Given Milan's history—since the sixteenth century alone, having been ruled by no fewer than four foreign powers—it seems natural that it is now a stimulating mix of the old and the new, the European and the Mediterranean, in attitudes as well as architecture. The celebrated Duomo is a mix of late Gothic, Renaissance, and Neo-classic styles, while many of the churches are early Christian and Romanesque. The monumental main train station, the Stazione Centrale, is built in the imposing Fascist style. Actually, most of the city was destroyed during World War II and rebuilt shortly thereafter. The historic edifices that remain are being restored as Milan looks into its past to create its future. The building boom coincided with an industrial boom, when workers from all parts of Italy flooded into the area, attracted by the possibility of work. The farming prosperity of the rich land of the surrounding Lombardy plains provided the capital for constructing the textile factories and huge industries for which Milan has become famous in the last fifty years.

PAST REFERENCES

FROM ITS BEGINNING, Milan seemed destined to be a leader. The city was founded by the Celts in the sixth century B.C.—about the same time as the founding of Rome—as a military stronghold and a trade center for the northern routes. The site of frequent wars and changes—the Romans defeated the Celts, then were defeated by the Huns—it seems to have grown larger and stronger after recovering from each debacle.

After many more changes, Milan began a short term of democratic rule that ended in the thirteenth century when an old Milanese family named Visconti began a two-hundred-year reign. It was marked by political and cultural supremacy, bringing Milan international renown. Construction of the two most famous and astounding landmarks in the city—the Duomo and

the Castle—was begun at this time. In the fifteenth century, when the Renaissance was at its peak, power was seized by the Sforzas, who also encouraged Milan's artistic creativity. Spain seized control of the city in the sixteenth century, followed by the Hapsburgs in the late seventeenth and eighteenth centuries, the French at the end of the eighteenth century, and finally the Austro-Hungarians. In 1849 the city rebelled and became part of the kingdom of Italy. Just for the record, in 1919 the Fascist party was founded in Milan.

While this historical overview is admittedly very abbreviated, it does give you an idea of the heterogeneity of this city's past. Surprisingly enough, this rich tapestry of disparate influences is not readily apparent in Milan's fashion style, which tends to be, as you have already learned, rather classic and immutable, although reflective of fashion changes to some degree.

THE LOOK OF MILAN

AT FIVE O'CLOCK on any weekday afternoon, there is a fashion show taking place at the Cova, an overpriced tearoom on the Via Montenapoleone. There, scores of chic Milanese have an espresso at the mirrored bar, dressed in the typical "uniform"—a tailored suit worn with a shirt, a pullover, or a close-fitting cardigan sweater, topped with a huge paisley shawl from a store called Etro, or a fringed cashmere shawl. The outfit is usually accessorized with a giant brooch on the lapel of the suit, and/or a short string of pearls around the throat, outsized gold earrings, gold rings on three fingers of one hand, a shoulder bag with a chain handle, opaque pantyhose in the same tint as the suit, and flat, flat shoes.

A nontrendy elegance is the goal in Milan, and the approach to fashion is a minimalist one. A suit is usually the solution because it always looks polished and pulled-together. And the seasons do not appear to affect the formula. All that changes are the fabrics and colors; the basic styles stay the same.

If you want to recreate the look elegant Milan has so successfully exported, start with:

THE TAILORED SUIT: Wear a semifitted jacket that skims the body naturally, whether single- or double-breasted. The skirt should be slim and if short, not too short. Most Milanese abhor extremes. If the jacket is paired with pants, they might be either

pleated and straight-legged or very tapered, but usually no longer than the anklebone, depending upon your figure—and occupation. Many Milanese love pants during the day, then switch to a skirt at night—or vice versa!

Although most Milanese rarely split the suit because they find a total look chic, they increase their styling options by pairing the suit with different shirts or sweaters, shawls and scarves, and accessories.

TIP: Perfect fit is one of the basic tenets of Italian chic. It goes a long way toward making any item of clothing look expensive. Upgrade an inexpensive suit by having it custom tailored so that it fits you superbly. This might involve having a tailor nip the jacket in slightly at the waist; shorten or lengthen the sleeves; replace oversized shoulder pads with more natural ones; switch buttons; taper, shorten, or lengthen the skirt or trousers; or restitch hems that look too visible on the right side.

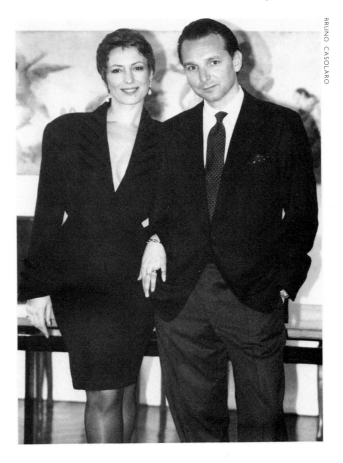

BRUNO CASOLARO

CHIC MILANESE SUIT UP FOR DRESSIER OCCASIONS AS WELL. INSTEAD OF A SHIRT, THEY MAY RELY ON A LITTLE DÉCOLLETAGE, PLUS A PAIR OF EYE-CATCHING EARRINGS. BLACK IS THE COLOR OF CHOICE, WHILE THE FABRIC CAN BE SILK, SATIN, OR WOOL CREPE.

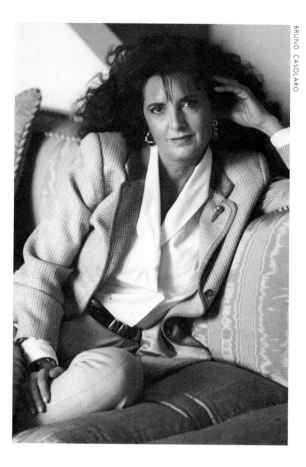

BRUNO CASOLARO

ANOTHER VARIATION OF THE
TAILORED WHITE SHIRT...THIS
ONE WITH A SHAWL COLLAR. IT
TAKES THE STARCH OUT OF A
MAN-TAILORED JACKET.

THE SHIRT: A silk shirt not only looks and feels luxurious, but layers beautifully under a jacket or cardigan-plus-jacket because it isn't bulky. Milanese women usually have several in varying shades of white, vanilla, and ecru. And in assorted styles all cut close to the body. Classics include one with a small pointed collar like a man's shirt, one that has a bigger collar that folds back, and one without any collar that buttons in the front or back.

Man-tailored cotton shirts—Italian cotton is so soft and pliable that it keeps a slim silhouette—in solid shades as well as thin stripes are also year-round favorites. They usually have small pointed collars that may be buttoned down.

A good place to find similar styles and patterns in America is in the men's or boy's department. Incidentally, Italians are wild about shirts from Brooks Brothers. Whenever they go to San Francisco, Chicago, or New York, they always visit this bastion of classic style.

THE SWEATER: The styles best suited to this look are the simple pullover with a crewneck, the polo with a small collar and three buttons, and the button-front cardigan. Italians love them in cashmere, cashmere and silk, and merino wool for winter; silk, cotton and silk, or cotton for summer. The fit is often close to the body but never tight, so that the suit jacket can be easily closed.

Colors are usually neutral—navy, beige, vanilla, gray, black tan, olive—although foggy pastels that are a bit offbeat, like a smoky aqua or pale blue, a mauvey-pink, a terra-cotta, when they harmonize with the suit, are attractive alternatives.

CARDIGAN CHOICES

Versatility makes the classic cardigan—round neck, button-front, long sleeves—an excellent wardrobe basic. There are so many ways to wear it:

- Create the sweater set plus: Match it to a pullover and a knit shawl. Coordinate all three pieces with a skirt or trousers.

- Bejewel it: Cover or change the buttons to big ornamental ones, each one different, the way Ferre does it. Pair the ornamented cardigan with a pair of silk trousers.

- Trim it with a lace collar or ruff and tuck it into a long, drifty skirt.

THE SHAWL: A giant paisley square of silk, cashmere, cashmere and silk, or wool and silk; a huge oblong of cashmere, or cashmere and wool, with fringed ends or a shallow ruffle around the edges finishes the look. It is worn draped over the shoulders with ends tossed back, or thrown over one shoulder with ends dangling.

SKIRTING THE SHAWL: One inventive way to get more fashion mileage from a shawl—expecially a fringed one—is by skirting it. Wind it around your hips so that it ends with the fringe at the left side from waist to hem. Belt the waist and top it with a blazer.

PIERRE POULARD

THE SHAWL HAS A DOUBLE LIFE
WHEN YOU WRAP IT AROUND
YOUR HIPS AND WEAR IT LIKE A
SKIRT. TOP IT WITH A BELT AND
TEAM IT WITH A CASHMERE
PULLOVER.

FASHION FORMULAS

IN MILAN, fashion is a little more suited to the business life than it is anywhere else in Italy. This makes the Milanese approach ideal for any of you who work in an office and need to look pulled together at all times. The style is professional-looking, comfortable, undeniably chic, yet feminine. While it might be considered a uniform, the myriad ways to wear and layer the suit take it out of the realm of that boring "dress for success" mode that is still, unfortunately, prevalent in corporate America.

You can easily make the same suit look as casual or corporate as the occasion demands by changing the ways you wear it. In general, however, a pantsuit is less formal than a skirt suit, and may not work in every office situation.

These variations on a simple suit—a muted checked single-button blazer with a slim skirt—were inspired by looks seen in the streets of Milan. See how the same suit can work in any office situation as well as out of it:

CORPORATE: Look efficient yet stylish. Wear the suit with a vanilla silk shirt that is open at the throat and a double strand of short pearls inside the shirt; a polka-dot silk handkerchief (in the same colors as the suit) in the jacket pocket; a thin leather belt the same color as the shoes; sheer dark pantyhose (if the suit is dark, otherwise flesh-colored hosiery); classic suede pumps on a low, thin heel; gold-and-pearl earrings; a gold watch on a leather or alligator strap.

CREATIVE: Mix patterns for drama. Team the suit with a striped or dotted shirt, turning the cuffs out and over the jacket cuffs; a paisley or patterned scarf worn around the throat and tucked in like an ascot; a thin crocodile or mock croc belt; an oversized pin on the jacket lapel; lots of bracelets on one arm; interesting earrings; dark opaque pantyhose; and dark flats.

CASUAL: Dress easy. Pair the suit with a cashmere or wool polo shirt; a man's watch; hoop earrings; an Hermès-type scarf wrapped around the waist like a belt; a fringed cashmere or wool shawl; pale, heavy ribbed pantyhose; and oxfords or loafers.

WORKING WARDROBE

SINCE 1969, one of the most famous places in Milan for finding all the elements of its style under one roof has been Pupi Solari. "Quality is elegance" is this store's trademark, and the look it sells reflects the personal taste of its owner, Pupi Solari. The clothes are styled using an Anglicized Italian approach with a touch of Japanese minimalism. The feel is designer without the label. The range of fabrics, textures, and colors (four shades of gray, six variations of green, a range of russets from pumpkin to sienna), plus the sheer delight of visiting the store and its employees make you mad to spend. Located in the same building is Pupi's children's shop with the most exquisite Lilliputian-sized fashions imaginable. She has also recently opened a men's store called Host with the same fashion formula as the women's store.

While Pupi loves beautiful clothing, she dislikes too much

of a good thing. "Spend for quality, not quantity," she advises, pointing out that versatility should be one of the key factors in determining a purchase. "A woman needs timeless styles she can count on." Her rust tweed blazer, for example, is a wardrobe staple that she wears almost every day in different combinations. She cautions you to keep your base colors neutral—beige, blue, gray, khaki, camel—then introduce color in the details.

Pupi suggests the following basics as a start for a wardrobe that works. She stresses buying only those pieces you love, because these items should provide a foundation that will last for years. Since the climate of Milan is similar to New York or Boston, this wardrobe was designed with cold temperatures in mind. Forgo the heavy coat and select lighter fabrics and colors if you live in a milder climate.

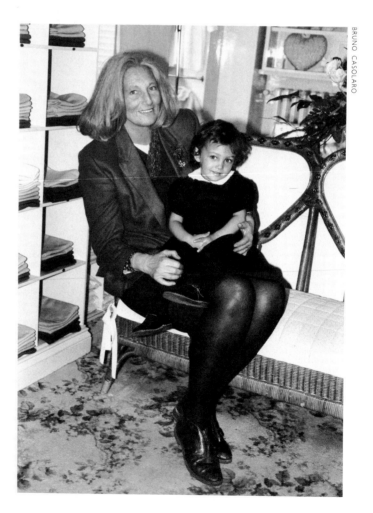

BRUNO CASOLARO

PUPI SOLARI IN HER SIGNATURE LOOK—A MARVELOUS BLAZER, SIMPLE SKIRT, FABULOUS BROOCH, DARK HOSE, AND CROCODILE SHOES—WITH GRANDDAUGHTER MARIA WEARING AN EXQUISITE DRESS FROM PUPI'S CHILDREN'S LINE.

THE ABSOLUTE MINIMUM MILANO WARDROBE

- Two skirt suits: navy and gray are good basic color choices for winter; navy and beige for summer.

- Two pairs of pants: wool gabardine is a versatile year-round fabric. Choose colors that work with the jacket of your suit.

- Six shirts: include at least one white, man-tailored style

- Two or three sweaters: include at least one pullover in a lightweight cashmere

- A raincoat: a trenchcoat is a classic in beige cotton or silk or silklike fabric

- A great sporty coat: a camel polo coat, for example, for day

- A hooded parka, either quilted or not: works for day and evening

- A lush cashmere shawl

- Flat shoes, including a pair of low boots, oxfords, or moccasins

- A pair of jeans

By now, you've already been introduced to the suit, shirt, and sweater, so let's take a closer look at the other pieces chic Milanese count on that might suit your needs, too:

THE RAINCOAT: The classic English-cut trenchcoat—with epaulets at the shoulders and belted waist—is a wear year-round style that Italians count on. While you may see it in traditional beige cotton (à la Burberry), the Italians do take fashion license with it . . . and it can be found in varying color and fabric combinations, including vinyl and a silk substitute that feels almost like suede called microfiber. Also, the trenchcoat is worn in both long and short versions.

ITALIAN CHIC

YOU CAN FIND THE TRAPEZE
SHAPE IN EVERYTHING FROM
RAINCOATS TO WOOL AND FUR
COATS. IT'S BECOMING TO ALL
AGE RANGES AND FIGURE TYPES.

PARKA POWER...THIS COVERALL
HAS TAKEN ITALY BY STORM.
SEXY AT NIGHT WITH TIGHTS
AND BALLERINA FLATS, IT ALSO
WORKS WITH SKIRTS AND JEANS.

Another popular raincoat—and overcoat—style is short and swingy. Cut like a trapeze, but not stiff, this coat drapes in soft folds and looks young and chic.

THE OVERCOAT: A slightly oversized camel polo coat (sometimes called a stadium coat) is the style that Pupi Solari was referring to—either single- or double-breasted. Milanese wear it over suits and jeans alike, topped with a fringed shawl or muffler.

Another favorite is the short shearling coat, cut rather full, with a big shawl collar or without any collar. Shearling is actually sheepskin, and looks like suede backed by fleece. Although natural shearling is tan, it can be dyed any color imaginable. Italians like it in neutral shades of black, brown, and olive. The weight or density of the shearling depends upon its country of origin: New Zealand is known for thick, heavy sheepskin, while Spain provides lightweight, fine-textured varieties.

THE PARKA: This jacket style has taken Milan by storm over the past several years. It ends midway between the knees and thighs,

features a drawstring waist and a hood that is often rimmed in fur when the parka is winterweight. Lighter-weight versions exist for warmer weather. Usually quilted, and constructed of corduroy, cotton, wool, velvet, silk, microfiber, even leather or suede, Milanese throw a parka over any outfit from jeans to a velvet evening dress.

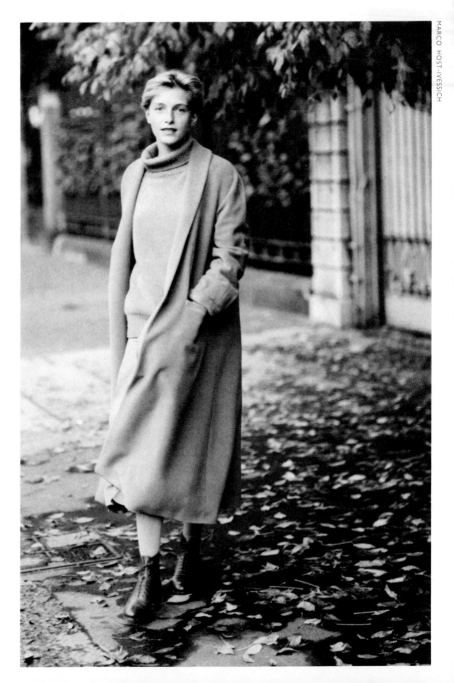

MARCO HOST-IVESSICH

THE CLASSIC CAMELHAIR POLO COAT IS A MILANESE STAPLE, WHETHER SINGLE- OR DOUBLE-BREASTED, LONG OR SHORT.

THE JEANS: The Milanese wear jeans differently from everyone else in the world, including other Italians. Jeans are treated and accessorized as meticulously as a pair of designer trousers. First of all, the jeans of choice are American—Levi 501's. Second, they are faded and somewhat worn, but always perfectly pressed. The legs are tapered and always the ideal length—to the ankle-

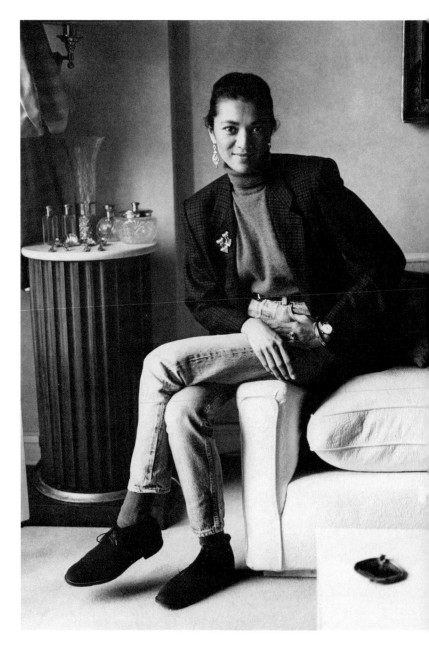

DOES ANYONE LOOK CHICER IN JEANS THAN A WELL-DRESSED MILANESE? GET THE SAME EFFECT BY WEARING YOURS WITH A CASHMERE TURTLENECK, TAILORED BLAZER, CROCODILE BELT, BEAUTIFUL JEWELRY, AND LOW SUEDE BOOTS.

bone. They are never turned up, rolled, or bunched at the bottom. They are also never tight . . . nor loose, but always skimming the body and following its curves.

They are usually saved for weekends in the city and may be paired the following ways:

- with a navy oxford man-tailored shirt; a navy wool or cashmere blazer with shirt cuffs folded back over sleeves; an Hermès scarf at the throat, folded the short way and tied once; a strand of long pearls; thin socks; and loafers.

- with a camel cashmere or cashmere blend turtleneck, a tweed blazer, a fringed cashmere shawl worn like a muffler, crocodile belt, and low boots.

- with a handkerchief linen shirt, pearls, a scarf through the belt loops, and ballet slippers (only when the weather is warm).

Portofino and Resort Points South

EVERY SUMMER WEEKEND, there's a giant exodus from the city to a posh beach resort like Portofino, once a simple fishing village, or Santa Margherita, on the Italian Riviera, a mere two hours from Milan by car. When they have more time, the Milanese voyage south to the enchanting island of Capri or to the quaint fisherman's village of Positano, situated along the scenic, wildly rugged Amalfi coastline. Capri and Positano are also the favorite haunts of Romans and Florentines, although the latter often spend their vacations at villas close to home, in the Tuscan countryside.

The dress at all of these resorts can be best described as nautical. Navy and white are important colors and most people look like they just stepped off a yacht. Italians dress ultra-casually at a seaside resort, even in the evening.

SMART SEASIDE ATTIRE

ON THE BEACH: A skimpy string bikini or a simple maillot, plus a pareo—an oversized cotton square or oblong in an eye-catching print—to wrap around the body while going or coming.

WAYS THEY WRAP THEIR WRAP

- *Hip Wrapped.* The wrap: a 54" cotton square. Fold pareo diagonally, then tie over the hip with ends dangling.

- *Fanny Wrapped.* The wrap: a 54" cotton square. Fold pareo in half and wrap it around hips and fanny. Tie ends off-center at waist, and belt.

- *Twisted and Tied.* The wrap: a giant oblong or square, anywhere from 74" to 84". If square, fold pareo in half, otherwise twist ends and wrap around the waist from back to front, as shown, twist ends around each other and tie them in back.

THIS IS HOW THE HIP-WRAP
PAREO LOOKS.

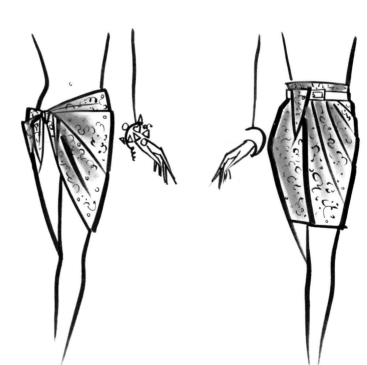

PIERRE POULARD

THE FANNY-WRAPPED PAREO
LOOKS TERRIFIC WITH A T-SHIRT
AND A BLAZER, TOO.

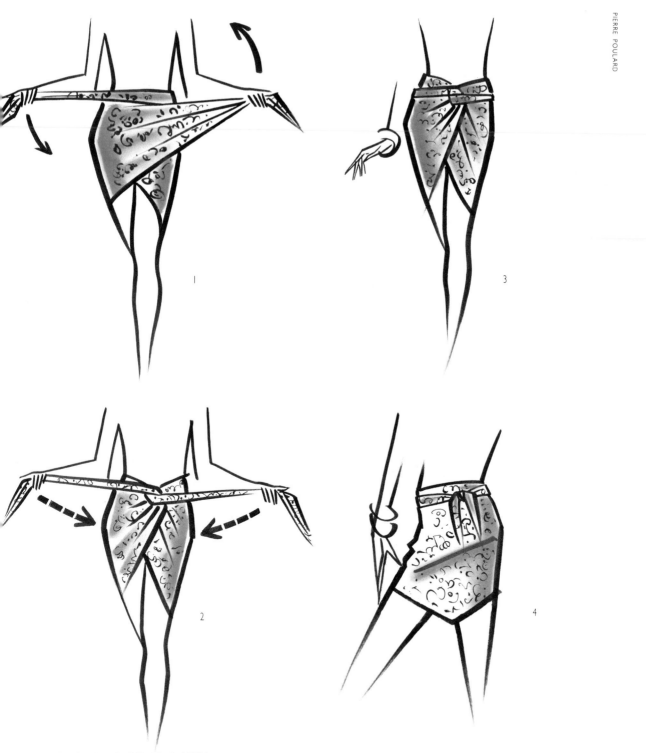

JUST FOLLOW THESE FOUR STEPS
TO WRAP AND TIE YOUR PAREO.

- *Knotted in Front.* The wrap: a 54″ square. Wrap pareo around body from back to front; tie ends over bathing suit top and knot at decolletage.

- *Halter Style:* Crossed in front over the bust and tied around the neck, halter-style. The wrap: a 54″ square. Fold it in half. Wrap around the torso, crossing the ends and tying it around your neck like a halter.

PIERRE POULARD

THERE'S NOTHING TO THIS
KNOTTED STYLE.

THE LARGER THE PAREO, THE
LONGER THE HALTER TOP STYLE.

SHOPPING: A pair of khaki bermudas; a white or navy-and-white striped man-tailored shirt or a pressed T-shirt; a crocodile belt; a pair of gold hoop earrings; a man's watch; a pair of white sneakers (like Jack Purcells) or loafers; a cotton cardigan over the shoulders (if needed); sunglasses (favorites are Raybans or Persols).

ON THE TOWN: White linen pants or white jeans, white linen or silk shirt, pearls or gold chains, an armload of gold bracelets, plus a watch, gold hoop earrings, gold leather thongs, navy blazer or a cashmere cardigan or pullover in an unusual color tied over your shoulders.

MILAN RETHINK

IN SHORT, Milan style is Italian chic at its subtlest and most sophisticated. It is an elegant business look based on an impeccably tailored suit, a marvelous shirt or sweater, a sumptuous shawl, wonderful shoes, and discreet jewelry. As such, it suits life in any of the world's busy, big industrial cities, from New York, Chicago, Detroit, and Dallas to Paris, London, and Geneva.

The Milanese look—even when it is jeans and a blazer—tends toward cosmopolitan formality. A more casual approach is taken by the Florentines, whose sporty chic style, covered in detail in the next chapter, works both in an office and out of it, and is comfortable enough for afternoons in the country.

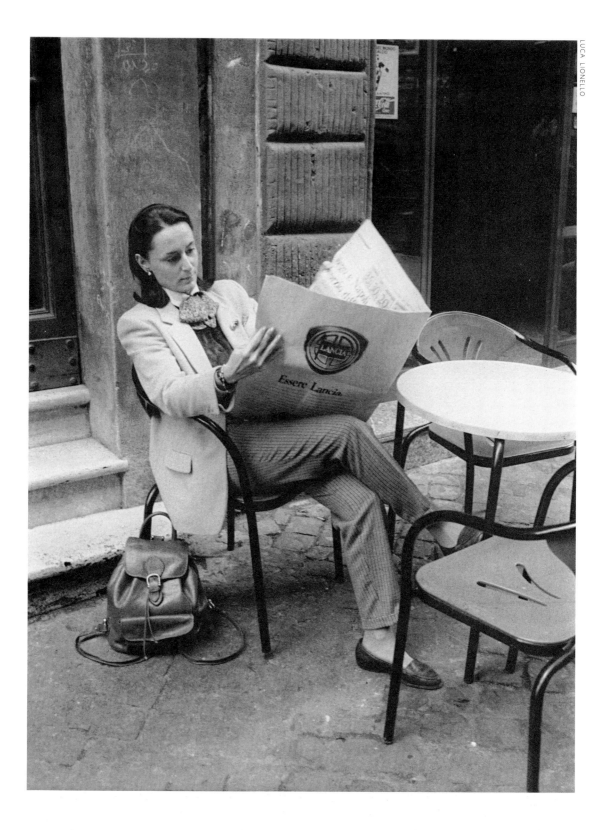

4

FLORENCE— COUNTRY CHIC

THERE IS ALMOST an overabundance of artistic, architectural, and archeological richness in this teeny jewel of a city, with its thirty museums, seventy churches, and dozens of cloisters, arcades, and *palazzi* (palaces). Perhaps this overabundance is one reason why fashion is so understated and simple in Florence. Despite the breadth and dimension of its artistic treasures, Florence is really a small town—you can walk across it in about a half hour—with a rather provincial approach to style. Interestingly, both the feel of the city and the look of its fashion are very similar to Boston's. Clothing is rather tweedy and vaguely British, but with the fantastic attention to quality and craftsmanship that is a hallmark of Italian style, in general, and Florentine style, in particular. For centuries, Florence has been celebrated for its exquisite artisanal talent, especially in fabrics, jewelry, leather, and knitwear.

Although refined and tasteful, fashion is more sporty than sophisticated here. That is probably because Florentines live a very countrified, outdoor life and need a wardrobe that works with it. Florence is the capital of the area known as Tuscany, a region of verdant countryside and rolling hills studded with vineyards, olive groves, and cypress trees, and the lines between city and country are blurred. In fact, many Florentines live outside the center and commute by motorbike. The annoying buzz of Vespas from early morning until late evening provides one of the few discordant notes in this paradise.

Most of the time Florentines look like they have just arrived back in town after hunting . . . or riding. In cooler months, a typical ensemble might consist of a tweed blazer with trousers, a cotton shirt and Shetland sweater, a lacy shawl or cashmere cape, and a backpack. The finishing touch could be a perky tweed cap or feathered hat. When temperatures rise, clothing becomes

THINK OF FLORENTINE STYLE AS RALPH LAUREN GONE ITALIAN.

59

lighter in weight. While pants may give way to bermuda shorts or a long flowered skirt, the "preppie" effect remains. Shoes are almost inevitably flat to facilitate getting around.

"It isn't considered elegant in Florence to be *too* well dressed, the way Romans and Milanese are," explains Caroline Doni, whose family owns Principe, the clothing store that practically personifies Florentine style. "Elegance here is to keep old things," she adds. Located just off the main square, the Piazza della Repubblica, Principe caters to an exclusive clientele, perhaps because the city boasts a very aristocratic population. This population, incidentally, has long had a reputation for frugality. "Florentines don't want to spend a fortune on clothes," observes Doni, adding that they try to buy as little as possible each year, updating the classics they already own by having a tailor alter them, or by adding a new scarf, jewelry, or a handbag. This philosophy is one that allows them to get lots of fashion mileage out of their lira, and one that certainly translates well to any culture.

Fashion colors are muted, neutral, and without sharp contrasts, in keeping with the maze of mustards, ecrus, pale yellows, and creams—offset by the faded terra-cotta hue of the roofs—that compose the city.

RENAISSANCE REFINEMENT

CONSIDERED A RENAISSANCE CITY, probably because it cradled the monumental artistic movement that began in the fourteenth century and exerted a tremendous and lasting influence on the development of Western civilization, Florence seems caught in a time warp. In fact, the past is so tangible that none of the modern annoyances—the traffic jams, exhaust fumes, and noise—can dispel it. It looks much the same as it probably did five hundred years ago, its narrow streets lined with medieval and Renaissance buildings. The faces of the people match those portrayed in paintings hanging in the Uffizi Gallery. Even modern fashion echoes the Renaissance. "The originality of Italian fashion is in the Renaissance," explains Paolo Petroni, former editorial director of Condé Nast in Italy. "In terms of line, structure, architecture, color, geometry, and the way clothing was shown during that time, it has inspired designers of today . . . The creative roots of this country are very deep." He points out that the look today is very reminiscent of the past. "We can

see by the art that during the fifteenth century, women were blond, wore a lot of jewelry and décolleté clothing. In short, the manner of presenting themselves was similar to today."

The word "Renaissance" is French for "rebirth" and it involved a return to the ideas and achievements of ancient Rome and Greece. Florence is the home of exceptional developments in literature, architecture, sculpture, painting, and science. Some of the great names of the time who lived and worked there include the writer Dante, the statesman Machiavelli, the art historian Vasari, and artists Giotto and Masaccio. Legendary artists Michelangelo, Leonardo da Vinci, and Raphael started in Florence but moved to other parts of Italy.

Even before the Renaissance, Florence was a fashion center. In the thirteenth century, one third of the population was involved in either the wool or silk trades, an involvement that has continued to this day. Florentines are renowned for exquisite artisanal workmanship, especially in leather and gold. The shops on the Ponte Vecchio, one of the bridges that spans the Arno River that cuts through the city, have been occupied by jewelers and goldsmiths since the sixteenth century. In 1951, the first Italian fashion shows in modern times were held in Florence.

THE LOOK OF FLORENCE

WHILE MILAN MIGHT BE the center of cosmopolitan chic, like any big city the world over, and Rome the capital of a laid-back, yet sexier style, Florence is clearly the personification of country style. The presentation is a cross between Ralph Lauren and Great Britain. While the fabrics they favor might be English, the way they are styled, worn, and accessorized is definitely Italian. Oversized gold earrings are one giveaway, as are the strand or two of short pearls every Florentine seems to wear with her cotton shirt, or cashmere or Shetland sweater.

Florence is such a tourist town that many of these looks are actually on the backs of visiting English men and women. Still, one place you can be sure of seeing the locals in their native dress is Giacosa, an exclusive bar/pastry shop on the Via Tournabuoni. Jam-packed at ten in the morning by the best-dressed employees of the luxurious and expensive boutiques that surround it, it is the perfect spot for checking out the fashion atmosphere.

These are the constants in the chic Florentine wardrobe:

A BLAZER

Tweed is everywhere, but muted checks or plaid, solid navy, gray, loden, or camel are all perennials in the winter and fall. In the spring and summer, fabrics and colors are likely to be lighter —a nubby linen or cotton, or a blend of the two, even a thin wool gabardine. Although the best-dressed blazer tends to be single-breasted and extremely classic, its fit is a matter of personal taste and figure type—it can be snug or oversized, boxy or nipped in at the waist.

The blazer is the backbone of the Florentine look and many think that it only improves with age.

FOUR WAYS FLORENTINES UPDATE A BLAZER

1. By adding suede or leather patches to worn elbows
2. By changing the buttons; choices include woven leather, gold with crests, horn, tortoiseshell
3. By belting the waist
4. By changing the collar to a velvet one

TIP: Thrift shops and flea markets are great places to find men's Harris tweed jackets at really inexpensive prices. They look very fashionable worn oversized (do shorten the sleeves, however, for a finished look) and updated in one of the before-mentioned ways.

TROUSERS: Usually pleated, trim, and tapered, these trousers are worn no longer than the ankle, and sometimes even shorter. They may be cuffed, as well. You will often see them in a subtle plaid, which looks very interesting with a tweed blazer, or the complete range of solids as well as heathers. Wool flannel in winter as well as twill and cotton corduroy, while linen, cotton, and rayon in summer are obvious choices.

A PLEATED SKIRT OR KILT: Either in plaid or solid, a skirt or a kilt is a popular alternative to trousers. Each is worn the length that best corresponds to the wearer's age and trendiness, from mid-thigh to mid-calf. They look best with opaque pantyhose and flat shoes—oxfords or loafers. When the weather gets warmer, long flowered skirts predominate. They are paired with pretty shirts and blazers in the spring, and barer tank tops in the summer.

FLORENCE—COUNTRY CHIC

A MAN-TAILORED SHIRT: Cotton is a year-round essential, styled with a button-down collar and long sleeves, in a solid fabric or one with thin stripes. Other choices include chambray, lightweight denim, and a very fine corduroy with a velvety feel. Often the shirt is slipped under a pullover, a cardigan, or a vest, with a scarf worn as an ascot and tucked into the shirt or tied and knotted in some other interesting way.

An easy little silk shirt is an alternative, especially for a dressier look. White and cream are classics, as are pale yellow and smokey pastels.

A SWEATER OR TWO: Florentines are partial to plain and cabled Shetland or cashmere pullovers and seem to have a wardrobe of them. Other collectible styles are the polo, turtleneck, V-necked, and V-necked cardigan in cashmere (a favorite), as well as lambswool and merino wool. In winter, they are often worn

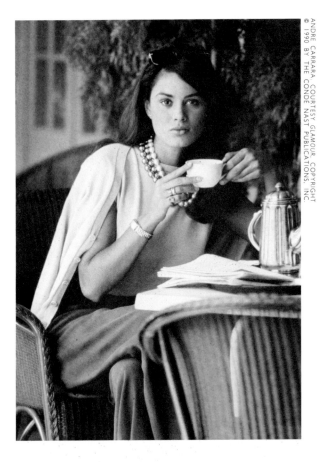

PEARLS AND A PULLOVER PLUS CARDIGAN ARE NATURAL PARTNERS. THE SIZE OF THE PEARLS CAN VARY, BUT THE STRANDS ARE USUALLY WORN RATHER SHORT.

layered as a defense against the damp chilly weather, both out-
doors and in, since homes are underheated.

The same styles are popular in cotton, linen and cotton,
silk, or linen and silk for spring and summer, in muted pastel
shades to wear with a flowered skirt or linen bermudas. One
pretty way to wear a V neck is to pull it over a cotton camisole
edged with embroidery or lace.

A SHAWL: Since shawls are so integral to the look, Florentines
tend to have several—a giant lacy triangle, an oversized cashmere
or wool oblong with fringed edges, a paisley or jacquard square
or oblong, and a giant cashmere or wool cape.

They wear the lacy knit shawl to soften the masculine edge
of the tweed blazer look. It is also often thrown over a pullover
or even a silk shirt without the blazer and looks especially pretty
in a smoky deep pastel—rose, blue, celadon.

"Shawls are so useful and becoming, especially when you
travel," adds Bona Frescabaldi, one of the great names in Flor-

PIERRE POULARD

THE DIAGONALLY BELTED,
FRINGED SHAWL.

entine society, whose giant cashmere throw has doubled as an evening coat and dressing gown in the space of a few hours.

Generally, shawls add warmth as well as chic and are extremely versatile, as you can see from the following list.

NEW PLUS TRIED-AND-TRUE WAYS TO WEAR A SHAWL

- Diagonally over one shoulder, then belted

- As a skirt, the way the Milanese do

- Over one shoulder, ends dangling

- Around both shoulders and belted or with ends dangling

- Wrapped around the shoulders, then anchored with a big brooch

THROWN OVER THE SHOULDERS, THEN BELTED.

PIERRE POULARD

WRAPPED AROUND THE SHOULDERS AND ANCHORED WITH A BROOCH.

BERMUDAS: These are a favorite warm-weather item in linen or cotton twill. They are paired with a cotton shirt and a blazer or cardigan sweater with a silk or cotton scarf around the neck to finish the look; pearls and earrings, of course; and loafers or Tod's, which look like loafers except they have pebbly rubber soles (more about them in Chapter 7), without socks.

A DUFFLE COAT: Conservative yet classy, this coat is a classic from childhood on for Florentines of all ages. Styled with a hood and toggle buttons, in loden green or navy blue, it tops trousers and skirts alike when the weather is cold. When added warmth is needed, a giant cape or shawl is draped over the shoulders.

A QUILTED HUNTING JACKET: The same style is worn by men, women, and children . . . and has been for years. Loden green and navy are most prevalent, but brown, black, and gold are also making the scene. This is a favorite style of scooter riders because it is shorter than a coat, lightweight yet quite warm, and water resistant.

PIERRE POULARD

THE QUILTED JACKET IS OFTEN TOSSED OVER A SIMPLE SHIRT AND TROUSERS.

JEANS AND A RAINCOAT: Are utter necessities. Florentines, as is to be expected, select classic styles in much the same way the Milanese do: slim, straight-legged jeans and a traditional, beige, Burberry-type trenchcoat.

OCCASION DRESSING

MATCHING THE DRESS with the occasion is an Italian preoccupation—it all stems from the concept of *la bella figura*. Florentines take this idea very seriously. They would rather be safe than sorry, so this is how they might approach the following situations.

SITUATION	APPROACH
Country wedding	*Select easy, chic but sporty pieces:* cream silk shirt, tobacco suede shirt, paisley shawl thrown over shoulders, ropes of pearls, flat shoes (avoid heels since the ceremony and/or reception is probably outdoors in the fields).
Saturday afternoon	*Opt for a country look, whether or not you're going or coming from the country:* blazer, pullover, ascot, jodphurs, riding boots, cap.
Visiting the museums	*Choose a casual, yet elegant outfit to show respect for institutions and art:* olive quilted hunting jacket, beige cashmere sweater, khaki leather or corduroy pants, a paisley silk muffler, low boots or loafers.

PIERRE POULARD

RIDING CHIC: IDEAL FOR A SATURDAY AFTERNOON IN THE CITY...OR COUNTRY.

THE LITTLE BLACK DRESS IN A
FABULOUS SETTING. DRESS UP A
SIMPLE SILHOUETTE WITH ROPES
OF PEARLS, SHEER DARK HOSIERY,
AND SEXY HIGH HEELS.

AFTER EIGHT

WHILE THERE ARE CERTAINLY movies, restaurants, and some theater, Florence is not a town with much nightlife. Consequently, people don't dress up much at night. When they entertain at home, which is a frequent occurrence, they may dress a little more formally—a black dress or evening suit, accessorized with sheer black stockings, black high heels, and gold jewelry (often family jewelry)—but the effect is low-key and understated.

FLORENCE RETHINK

A COMFORTABLE BLAZER paired with a pleated or straight skirt and a cashmere pullover or a crisp white shirt for the office, teamed with worn jeans or khaki trousers on a weekend afternoon, is the essence of Florentine chic, a chic that works particularly well in both suburban and rural areas of our country. Add a further Italian note to the mix with a beautiful scarf, shawl, or muffler; an eye-catching brooch or a series of them on the lapel or shoulder of your jacket; and a beret or baseball cap when the weather is cool.

This look is probably the easiest and most affordable to acquire since a smattering of vintage—think cheap—clothing, available in thrift shops, flea markets, even your grandmother's attic, only adds to its allure.

For those occasions when neither a smart suit nor snappy sportswear will do . . . when something sexier, perhaps, is called for, investigate the Roman way. Turn to the next chapter for suggestions about the Eternal City's more adventurous fashion approach.

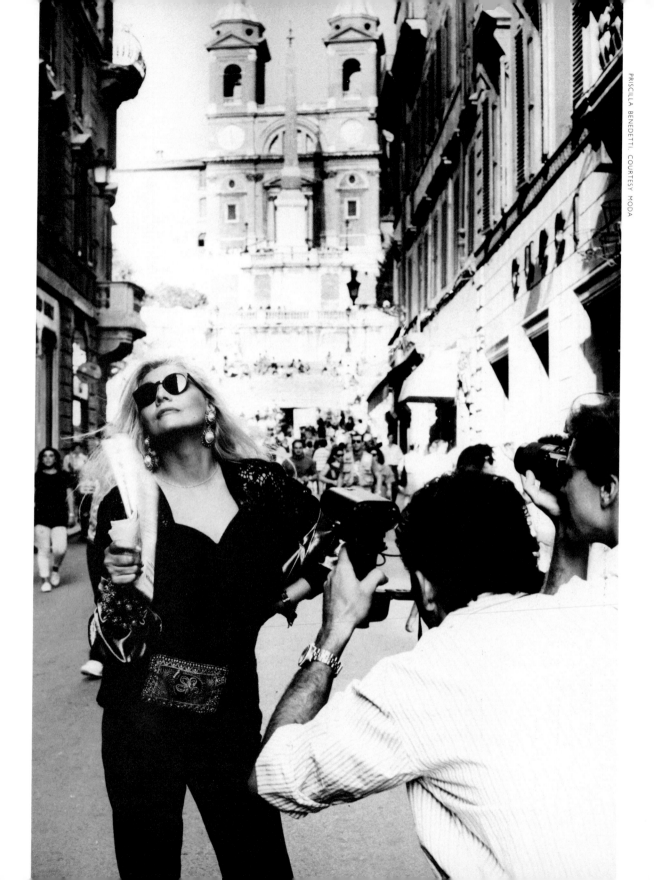

5

ROME—
HOLLYWOOD
STYLE

LIFE IN ROME IS SWEET...and seems relatively unchanged from the way it was portrayed in the 1960s' film of Fellini, *La Dolce Vita.* At that time, of course, Rome was the center of Italian cinema. The Cinecitta, a studio constructed in the Fifties, was churning films out, and the paparazzi, the name given to tabloid press photographers, and the resultant publicity created gods and goddesses out of mere mortals... some of whom couldn't even act. But they all looked good!

Rome itself resembles a giant stage set. Entering the city center (or *centro,* in Italian) from the airport, you ride past the ancient Colosseum—still surprisingly intact after all these thousands of years—where, centuries ago, the unlucky were thrown to the lions, and gladiators battled each other. Ruins and majestic monuments are scattered through the city, often alongside relatively modern hotels and office buildings. They take on even more epic proportions the few times they are illuminated at night ...which further heightens the fairy-tale feeling of this city. Rome is Hollywood, Italian style!

The fantasy element, sunny skies, palm trees, and tangerine, melon, and pink buildings really do recall southern California. And if there were a movie title that mirrored the fashion approach, it would be *Anything Goes!* Fashion is more experimental. The look could be described as entrepreneurial, rather than corporate. Clothes are tighter, brighter, more body-revealing and accessorized; hair is longer, makeup more exaggerated than in the North. Excess is in evidence, but it all seems to work and it is certainly fun to watch. Romans are less afraid of making a fashion faux pas. "We have more kitsch, more courage," explains Roman fashion photographer Christina Ghergo. An abbreviated black dress—similar to one worn in *La Dolce Vita*—accessorized any number of ways is a Roman fashion staple, as are separates

TIGHT, SEXY, AND OVERBLOWN ARE ADJECTIVES TYPICAL OF ROMAN STYLE.

worn as a suit that hugs curves, instead of skimming them (the way the Milanese suits do) and in statement colors like red, pink, orange, emerald. Legs are bronze all year long and appear bare, even when covered with sheer, tan hosiery. Shoes are ultrafeminine: ballet slippers, thin heels, graceful flats, mules, sexy thongs in summer. Pants are often leggings topped with a fitted jacket or filmy shirt, unbuttoned low and filled in with gold chains. Scarves and shawls are wardrobe staples, as they are elsewhere in Italy, but here they run the gamut from the typical—oblong and fringed—to the fanciful.

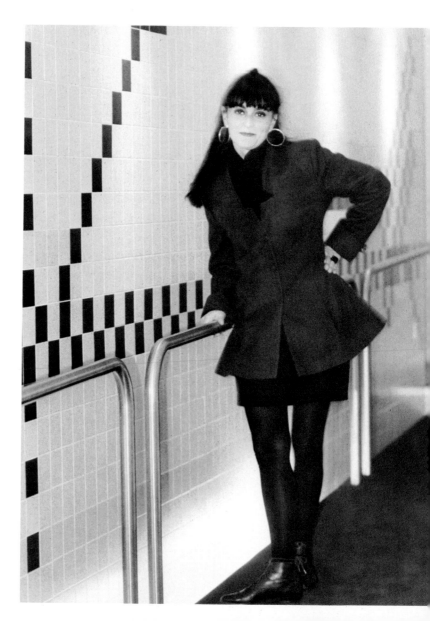

DRESSED FOR SUCCESS ROMAN STYLE MEANS A SUIT WITH SHAPE AND LOTS OF LEG.

Perhaps it is another case of life imitating art. There is a noticeable parallel between fashion and architecture in the Eternal City, where there is a predominance of the baroque. This artistic style is characterized by extravagant forms, elaborate ornamentation, and dynamic opposition. You see it daily in the buildings . . . and on the backs of the people in the way they put themselves together. And Romans themselves confirm it. "In Rome, it is important to look sexy and beautiful so that you're in harmony with the surroundings," asserts Maria Theresa Venturini, daughter of one of the Fendi sisters and designer of her own line, Fendissime, along with two of her cousins.

Actually, fantasy and myth have been important components of the culture since the city's beginning. Rome was supposedly founded by Romulus, one of the twin sons of the god Mars, who was abandoned in the area with his brother Remus when they were infants. Even during the early Christian era, gods and goddesses survived as astrological symbols and allegories. During the Baroque years (seventeenth century), they became even more popular and were celebrated in the art of the time. For instance, examples of Venus, the goddess of love—who stood for any variety of love from the pure to the profane—can be found in art at the Vatican Museums, the National Museum, and the Borghese Gallery, among other places. The manner in which these dieties were dressed and coiffed has also influenced the approach to fashion taken today.

LOVE OF LIFE

ENJOYING LIFE is the Roman credo, and the very pace of the city encourages this state of mind. It is leisurely and gentle . . . long lunches, frequent espresso breaks. Business gets done but without that sense of urgency that underscores all dealings in Milan. In the most fashionable shopping area, located at the foot of the Spanish steps, the outdoor cafes are filled to overflowing whenever the afternoons are balmy. At six o'clock, mayhem begins in the streets as people spill out of offices to meet friends, shop, or just window-shop. Boutiques stay open until at least seven in the evening, several stay open even later, so the activity doesn't wane until close to eight.

Since chic Romans like to change their look for evening, they rarely go out directly from the office. Evening attire is always sexy and it can be elaborate, too. A short bouffant red or

purple party dress is an option as is a basic black, rather décolleté evening suit or a long chiffon skirt with a tiny top. People tend to dress up more when entertaining at home, although when you go out, you are liable to see a real fashion potpourri—from someone in jeans with a lace T-shirt to someone else in a sizzling red silk sheath—at the same table in a trendy restaurant.

NEIL KIRK FOR ITALIAN VOGUE

LA NOTTE, THE NIGHT, IN ROME IS DECIDEDLY DRESSED UP AND VERY SEDUCTIVE: LOTS OF CLEAVAGE, LOTS OF LEG.

THE LOOK OF ROME

THERE IS A LOT OF fashion action in the streets of Rome, especially in the area discussed earlier: the luxury-boutique-lined Via Condotti, which begins at the foot of the Spanish steps and continues for several blocks. It is closed to traffic, so everyone walks in the cobblestoned streets. Between the hours of eleven and one in the morning and five and seven in the afternoon, you can get a fast read on the most popular looks in town.

Roman taste runs more to the rococo. While they might count on a number of the same basics that Northerners swear by —suits, silk shirts, parkas, slim pants, jeans—Romans wear them in a more carefree way.

The starter items in a Roman wardrobe suit any casual lifestyle. They can work in and out of an office, depending upon the ways they are combined and accented:

ROCOCO ACCESSORIES SEPARATE THE ROMANS FROM THE REST. THIS SPARE SUIT IS GIVEN HOLLYWOOD ALLURE WITH OVERSIZED PEARLS, LARGER-THAN-LIFE EARRINGS, AND A LUXURIOUS SCARF, SHAWL, AND CHAIN-HANDLED BAG.

THE LITTLE BLACK DRESS: Many Romans choose one with simple lines and a sporty feel to anchor their wardrobe. Then they change the look with accessories. A favorite style is cut like a long pullover or V neck with a shaped waist in a sweatery fabric—cashmere, wool knit, wool jersey, cotton knit, cotton and Lycra—or a sleeveless sheath in flannel, gabardine, linen, cotton, or silk.

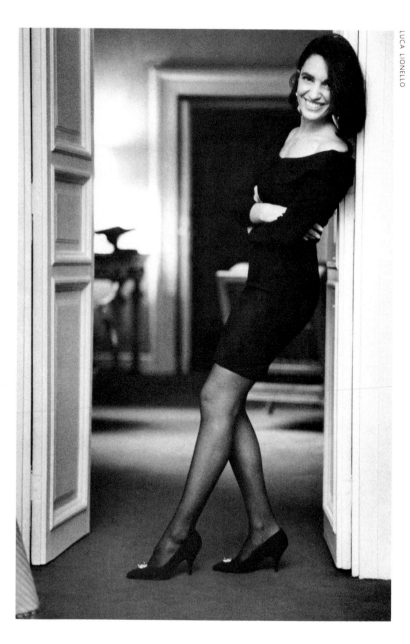

LUCA LIONELLO

THE BLACK DRESS FOR THE BEST OF BODIES: SHORT, SNUG, AND OFF THE SHOULDER. WITH IT: SHEER HOSE, HIGH HEELS, AND *BIG* EARRINGS.

While those women with the best bodies may wear dresses that seem painted on, most women select styles that are a little less form-fitting to slip under a blazer . . . or over a shirt. The options are plentiful . . . they just use their imaginations and accessorize accordingly. To expand your options, here is a week's worth of styling ideas:

Day 1: On its own under a shawl.
Day 2: Over a silk shirt with ropes of pearls and a huge pin on the shoulder.
Day 3: With a scarf worn as an ascot, belted, under a blazer.
Day 4: Over a lace or plain T-shirt and topped with a cardigan.

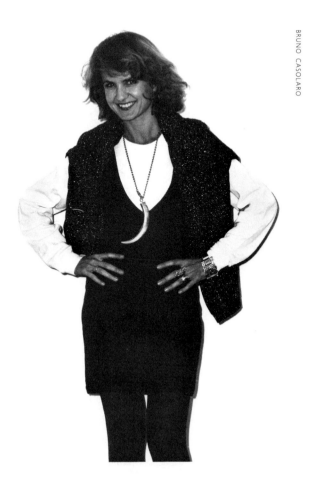

BRUNO CASOLARO

MORE OPTIONS FOR THE BLACK DRESS: DESIGNER MARINA SPADAFORA SHOWS HOW SHE CHANGES HERS: UNDERDRESSED—OVER A T-SHIRT AND UNDER A PULLOVER, WITH OVERSIZED JEWELRY.

BRUNO CASOLARO

BRUNO CASOLARO

BUSINESS MEETING—OVER A
TURTLENECK AND UNDER ONE OF
HER CROPPED KNIT SWEATERS.

DINNER MEETING—TURN THE
DRESS BACKWARDS AND TOP
WITH A LUREX KNIT.

Day 5: Worn as a tunic over leggings, belted and bloused out around the waist.

Day 6: Dressed up with a pair of shoulder-length earrings and high heels.

Day 7: Under a filmy shirt that is knotted around the waist, accessorized with two or three long medallions on silk cords.

THE FITTED JACKET: This jacket can be part of a suit, but it is usually a separate item. The silhouette is structured, nipped in at the waist, and long enough to cover the tops of the thighs. It can be either single- or double-breasted.

Since Romans like a jacketed look, they tend to own several in slightly different styles, fabrics, and colors. One is most likely in a basic, wear-with-everything color, such as black, navy blue, olive green, or camel. Another might be in a bright shade, such

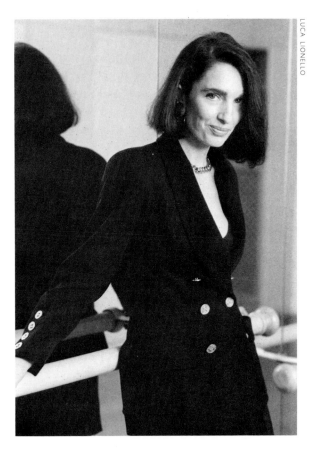

LUCA LIONELLO

THE ANYWHERE, ANYTIME JACKET IS DOUBLE-BREASTED, LONGER, AND FITTED. FOR EVENING, TRY IT OVER A CAMISOLE AND FLIPPY CHIFFON SKIRT.

as red, orange, hot pink, or yellow, to span the seasons. Warm weather choices are white (a favorite) or tan, navy, pastels, and brights.

THE LEGGINGS: They usually fit like a second skin from waist to ankle, and may be of cotton/Lycra, all cotton, or wool knit. Topped with a long jacket, they suit a day in the office . . . with a lightweight parka, an afternoon stroll . . . with filmy shirt, a night on the town. They seem to be a favorite of Romans of all ages because by pairing them differently, you can show off or hide as much of the body as you wish. Other advantages are comfort and price. Black and white are core colors year-round.

Stirrup pants are also a popular choice. They elongate the leg and fit a little looser than leggings. Usually worn with low boots, they are more a cool weather option than a warm weather one.

Trousers, too, have their place in the Roman wardrobe, especially in summer months. They are usually cut slim and tapered, ending at the ankle, or an inch or two shy of it.

THE SHORT STRAIGHT SKIRT: In Rome, it is possible to find the shortest skirts in all of Italy. They hug the thighs and are often pegged at the bottom. When paired with a long, fitted jacket, only several inches of the bottom of the skirt are visible. Generally though, the shorter and snugger the skirt, the younger and trendier the wearer.

Black, of course, is a constant, as is the range of neutrals. Except for checks and dots, patterns do not seem to be popular. Flower prints are reserved for the occasional filmy long skirt. Fabrics of choice include lightweight wools and knits for winter; linen, cotton, and cotton/Lycra blends for warmer weather.

THE BODYSUIT: An easy-to-wear foundation garment, the body-suit is available in a multitude of styles and fabrics. One with long or short sleeves, with a round or scooped neck, in stretch lace or solid cotton/Lycra, seems to be an integral part of a wardrobe. Another popular style crosses over in front and wraps permanently to the side, and is available either sleeveless or with long sleeves.

Colors run the gamut from black and white to sparkling jewel hues and softly washed pastels. Since these items are rela-

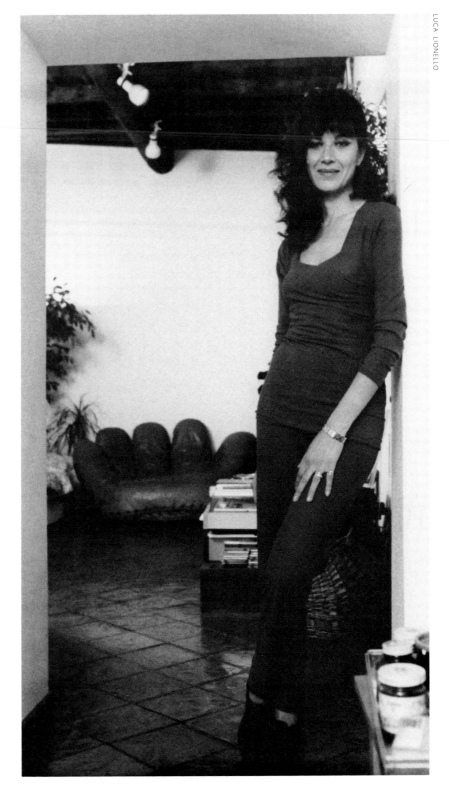

CLOSE TO THE BODY, KNIT PANTS
—SOMEWHERE BETWEEN A
LEGGING AND A TROUSER—ARE
ALSO A PREFERRED CHOICE.
ROMANS PAIR THEM WITH A
BODY-CONSCIOUS SWEATER, AND
WEAR THEM DAY AND EVENING.

THE SHIRT FOR ALL REASONS

PIERRE POULARD

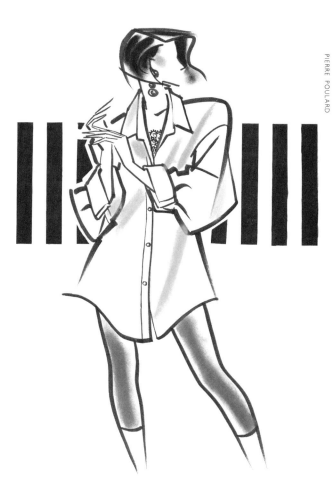

—UNBUTTONED TO THE WAIST,
 OVER A LACE BODY SUIT
 AND LEGGINGS.

—OPEN AT THE THROAT, TOPPING
 A PAIR OF NARROW TROUSERS,
 WITH SHIRTTAILS KNOTTED
 AT HIP LEVEL.

PIERRE POULARD

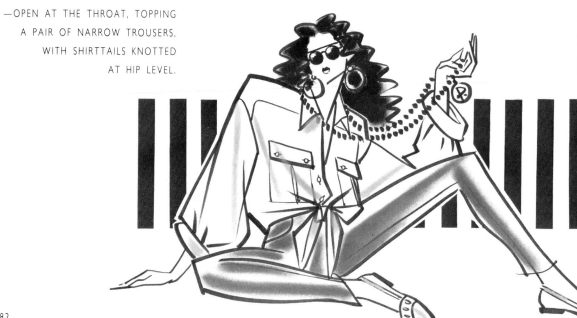

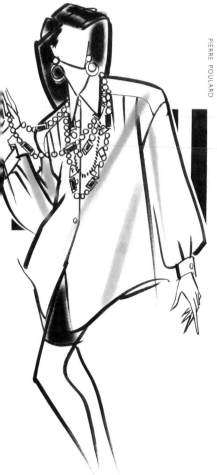

PIERRE POULARD

tively inexpensive, they are bought in multiples and worn year round.

TIP: What lingerie do you wear under lace and stretch lace to keep from revealing too much of a good thing? A white bra tends to stand out too much. A bra close to your flesh color in opaque cotton or nylon is the best choice.

THE FILMY SHIRT: Floaty, tunic length, and very slightly oversized with long sleeves, this shirt is nonetheless very feminine. Romans like it in a color, like an iridescent gold, purple, silver, or pumpkin. The choice of fabric—one that drapes and accents the body rather than standing away from it, such as chiffon, silk, or rayon—as well as the ways it is worn add to its femininity.

PIERRE POULARD

—BUTTONED UP COMPLETELY OVER A SHORT, SNUG SKIRT, FESTOONED WITH PEARLS AND CHAINS AROUND THE NECK.

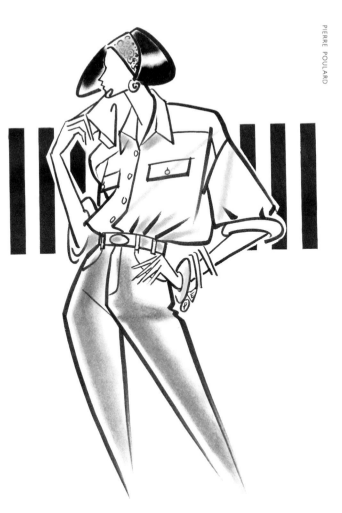

—TUCKED INTO A PAIR OF TIGHT JEANS AND BLOUSED SLIGHTLY, WITH SLEEVES ROLLED UP.

TUNIC-LENGTH PULLOVER: This is a favorite sweater style, but by no means the only option. Cut long, lean, and body-skimming, it's often worn over leggings and short straight skirts. You can find it in the ubiquitous cashmere, a blend of cashmere and silk, as well as silk, viscose, wool, and cotton knit. Color choices run the gamut, but necessities include white (especially in summer to wear with a white bottom, a long gauzy skirt, for example) and at least one bright.

A SHORT BLACK VINYL TRENCHCOAT WORKS IN AND OUT OF THE RAIN. IT ALSO MAKES AN ENTRANCE OVER BLACK TIGHTS OR LEGGINGS.

ROME—HOLLYWOOD STYLE

JEANS: A staple everywhere in Italy, jeans in Rome are usually worn snugger than in the North. You're also more apt to see a range of styles, although basic Levis are very much in evidence.

COATS: Raincoats tend not to look like they're only for inclement weather, but rather more multipurpose. Case in point: a leopard print, short swing coat, or a short black or white vinyl trenchcoat. Both double for day or evening, sun or rain. When the weather turns chilly, the favorite coverups include quilted parkas and loose dusters, although the blanket-weight shawl tossed over a blazer is also a solution.

A LOOSE DUSTER CREATES A COUNTERPOINT OVER A BODY OR CATSUIT. ROMANS LEAVE IT OPEN SO THAT THE BODY IS IN EVIDENCE.

SUMMER IN THE CITY

WHITE IS THE COLOR of choice in all of southern Italy. It suits the climate because it looks cool and comfortable, and even more important—because Italians are avid sun worshippers who love a bronze look—it complements a tan.

An all-white wardrobe simplifies planning and dressing, since everything works together. Plus, it always looks fresh and stylish . . . especially if you follow the Italian approach: try mixing shades of white, vanilla ecru, cream, pure white. The results will be surprisingly sophisticated.

The following wardrobe is minimal . . . built around just eight items:

1. a jacket (or a parka, if your lifestyle is really sporty)
2. a knit cardigan or V neck
3. a filmy shirt
4. slim, tapered pants (or leggings)
5. a short straight skirt
6. a long floaty skirt
7. bermuda shorts
8. a sheath

Then when you add a few auxiliary pieces, you can create a look for any occasion. For example:

- other shirts, one in silk, one in cotton or handkerchief linen
- a silk tank top and a lacy bodysuit
- a gauzy shawl
- a chiffon shawl
- gold jewelry
- pearls
- gold ballet slippers
- sandals in gold or tan leather
- flats and loafers in tan (never white)
- white sneakers

And don't forget your sunglasses . . . Romans wear them everywhere.

Add interest by not only mixing shades of white, but textures too. Some ideas: the jacket in linen, the trousers in washed silk or vice versa; the cardigan in a nubby knit, the dress in a flat knit or vice versa. There are a wealth of summer-weight fabrics from which to choose . . . some additional ideas include seersucker, rayon, viscose, pique, poplin, and polished cotton.

By the way, this wardrobe will work in any neutral color, like black, navy, or tobacco . . . or combinations of neutrals. It will even work in certain true colors—shades of pink or peach, for example.

THE WHITE ON WHITE WARDROBE

	PANTS/LEGGINGS	BERMUDAS
Jacket	Silk shirt (tucked in) Chain belts Sandals Lacy hanky (in jacket pocket)	T-shirt Scarf around waist Loafers
Cardigan	T-shirt Crocodile belt Espadrilles	Cotton shirt Sweater wrapped around body, with ends tied in back Sneakers
Shirt	Lacy bodysuit (shirt tucked in and opened) Handbag/belt Gold ballet slippers	Silk tank top (shirt knotted at waist) Espadrilles

	SHORT SKIRT	LONG SKIRT
Jacket	Silk tank top Lacy shawl over jacket Flats or ballet slippers	Lace bodysuit Chiffon scarf as belt Long pearls Espadrilles

Cardigan	Cotton shirt Leather belt Cardigan tied around waist Loafers	Silk tank top Lacy pantyhose Gold ballet slippers
Shirt	T-shirt Shirt belted over skirt with gold belt Sandals	T-shirt Shirt wrapped around waist Sandals Lots of short pearls around neck, inside shirt

SHEATH

Jacket	Chiffon oblong around throat Gold ballet slippers Big brooch on jacket lapel
Cardigan	Sweater thrown over shoulders Handbag/belt around waist or hips Loafers
Shirt	Lacy bodysuit Shirt worn open Lots of strands of short pearls Gold sandals

PIERRE POULARD

A SIMPLE WHITE SHEATH WORKS
ON ITS OWN, OVER A TOP, OR
UNDER A SHIRT, JACKET,
OR PARKA.

Traveling in Style

IF NOT THE MOST widely traveled Europeans, Italians are certainly the chicest en route. They appear really pulled together and comfortable, whether the occasion is dressy or sporty. Their travel wardrobe usually consists of an abbreviated version of that which is hanging in their closet. For example, they'll make do with fewer basics, but more shawls and accessories. They also feel that natural fibers and fabrics take to the road better: most wrinkle minimally or not at all, and retain their shape even through prolonged plane or train trips.

"Italian women are very aware of their appearance when they travel," confirms Daniela Grosso, a former Alitalia flight attendant who currently oversees the company's selection and training of flight personnel. Beauty and fashion are integral parts of the training program given at Fiumicino, Rome's enormous international airport, and are areas in which Daniela is expert. "Comfort is very important, especially during a long flight, but this never means sloppiness," she observes.

Since the tissues retain water during a long flight, the body and feet swell. She advises the following: If you'll be in the air for several hours or more, wear clothing that doesn't bind, in natural fibers that allow the skin to "breathe," and flat, comfortable shoes. If you're not already wearing one, bring a sweater along, since the air can get very cold, especially during overnight flights.

According to Daniela, Italians traveling in tourist class tend to dress a little sportier than those in business or first class. A typical "tourist" travel outfit can be: a pair of well-cut jeans, a silk or cotton shirt, a cardigan or pullover tied around the shoulders, a pair of ballet slippers. A "business" outfit can consist of a beautifully tailored pant or skirt suit with a shirt, and flat shoes.

Traveling stylishly means feeling comfortable as well as looking it. Here are a few of Daniela's tips:

- Because there is such low humidity in the air in a plane, skin can dehydrate quickly. Moisturize skin before flight, paying extra attention to mouth, neck, undereyes, and hands. Wear very little makeup.

- Drink one glass of water per hour of the flight and avoid alcohol.

- Exercise hands and feet during a long flight by flexing, then circling them at intervals. If you have the room, prop feet up on a piece of luggage.

PACKING IDEAS

ITALIANS ARE ALWAYS TRAVELING, which is why they've perfected their packing techniques to an enviable degree. So whether their trip is for a week or just a weekend, they arrive wrinkle-free and well-equipped . . . You can too, by following their lead.

- Edit what you're bringing to just a few basics—and lots of accessories—that you can combine differently.

- Stick to relatively wrinkle-resistant fabrics, like knits and jerseys, Lycra mixes, and washed silks.

- Always choose the smallest possible suitcase into which you can squeeze everything. This way, clothes won't shift and wrinkle.

- Roll socks and hosiery and place them in shoes. Then pack shoes into breathable cloth bags. Place heavy items at the bottom or near hinges of suitcase.

- Put unfolded clothes in overlapping layers across open suitcase, allowing sleeves and extra cloth to hang out at both sides. Then gently fold in alternating layers, making a sandwich of pants, jacket skirt, etc., and using the next layer as the natural lines of the garments. You can also roll everything except jackets.

- Fill in unused spaces with accessories, tissue paper, or crumpled plastic dry-cleaning bags.

- Purchase toiletries and cosmetics in plastic containers (or transfer them to plastic), and carry them on board with you if there is any chance they might leak.

■ When you're unpacking, if you notice that some garments are wrinkled, hang them in the bathroom while you take a hot bath or shower. The steam relaxes most wrinkles.

ROME RETHINK

A MORE BAROQUE and trendy approach to fashion than in the North of Italy, Roman style is a wonderful warm-weather choice for anyone who lives in southern America . . . or anywhere else for that matter. (While Italians culturally lock themselves into one particular fashion style based on their location, we Americans tend to be more eclectic.)

Milanese style might be your look of choice for a power business meeting, for example, while a Florentine country look could be the ideal one for a lazy Sunday. However, when the occasion is a dinner à deux, it probably deserves nothing less than an abbreviated little Roman-style black dress and shoulder-length earrings.

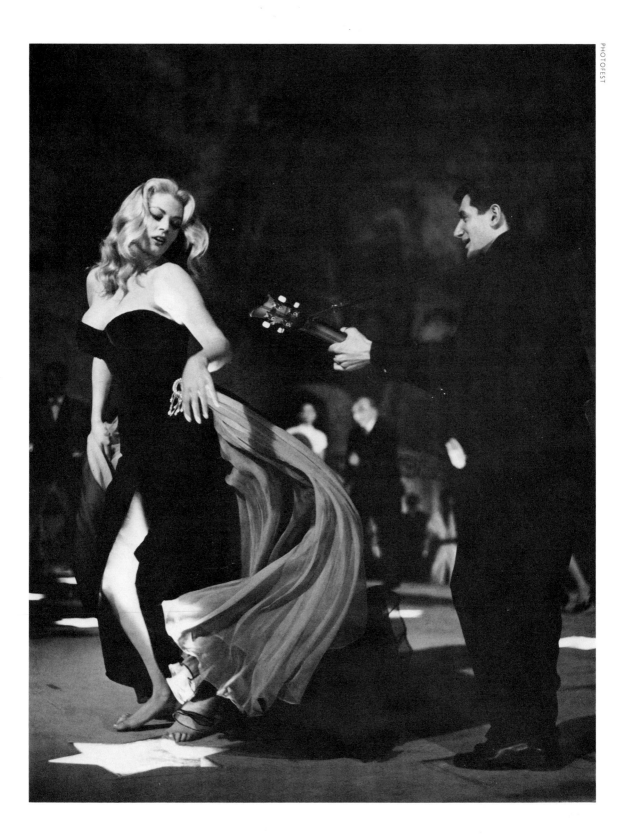

6

ON AND OFF THE SILVER SCREEN

POUTY LIPS, outlined eyes, tight sweaters, and skinny low-cut sheaths showing *molto* décolletage . . . this was the Italian cinema look of the Fifties and Sixties, when starlets set the fashion trends. Style then was frankly feminine and flirtatious . . . even women in the street wanted to create cinematic effects. That attitude is certainly light years away from today's: now fashion designers are the stars and dictate the looks.

Thirty to forty years ago, the Cinecitta, Rome's best known movie studio, was at its zenith, churning out a multitude of films featuring actresses with what was then considered the ideal female form—the hourglass. The big five at the time were Sophia Loren, Gina Lollabrigida, Monica Vitti, Claudia Cardinale, and Anna Magnani, although Magnani fought the glamour girl image that the others cultivated. Interestingly enough, it was she who became the inspiration and "ideal" woman for the hot designing duo of the Nineties, Dolce & Gabbana.

THE GREAT FILM GODDESSES

ALTHOUGH SHE WASN'T ITALIAN, ANITA EKBERG EPITOMIZED STARLET CHIC IN THE FILM *LA DOLCE VITA*, WEARING PERHAPS THE BEST BLACK SHEATH EVER FILMED.

THINK ITALIAN FILM GODDESS, and picture big black eyes, big hair, a sulky mouth, and breakneck curves. The screen featured her, the paparazzi followed her, and her every move was carefully chronicled in the daily newspapers. Her life, her loves were envied, her looks were copied. Here are the big five of the time, plus information about their current goings-on:

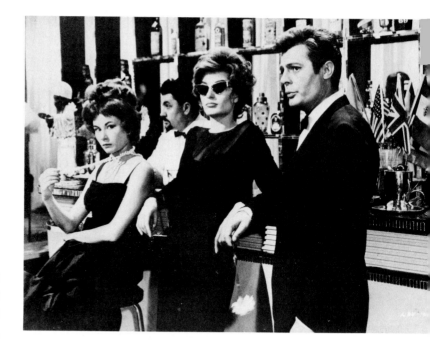

MORE FASHION FROM *LA DOLCE VITA* THAT SET ITALIAN DRESS STANDARDS IN THE EARLY SIXTIES.

SOPHIA LOREN

From her humble beginnings as an illegitimate child in Naples, Sophia Loren has risen to international stardom. Known for her extravagant cleavage as much as for her acting, her best-remembered films remain *Two Women,* for which she won an Oscar in 1961, *Yesterday, Today, and Tomorrow,* and *Marriage Italian Style.* Although she hasn't made a memorable film since the Sixties, she's considered a living legend. Currently in her late fifties and married to producer Carlo Ponti, who helped her get her start in films, she's the mother of two sons. Still astonishingly glamorous, she constantly receives an inordinate amount of press.

GINA LOLLABRIGIDA

Practically a household name around the world in the Sixties, "La Lollabrigida" starred in more than sixty films, playing roles ranging from sultry Italian peasant girls to modern-day temptresses. Her first film was in 1947, when she was twenty years old, and she worked steadily into the Eighties, when she appeared on the American television show *Falcon Crest.* In recent years, however, she's been concentrating on a career behind the camera instead of in front of it. Her photographs, documentaries, and videos have been widely acclaimed.

IN THE BEGINNING OF HER
CAREER, ALL EYES WERE ON
SOPHIA'S CONSIDERABLE ASSETS,
RATHER THAN ON HER CLOTHES.

PHOTOFEST

A TYPICAL FIFTIES GLAMOUR GIRL
DRESS ON GINA LOLLABRIGIDA.
NOTE THE PLUNGING
SWEETHEART NECKLINE.

PHOTOFEST

LONG HAIR, BRIEF DRESS, AND
LOTS OF DÉCOLLETAGE—THAT
WAS CLAUDIA CARDINALE'S LOOK
AS WELL AS THAT OF
A MULTITUDE OF CARDINALE
LOOK-ALIKES.

PHOTOFEST

CLAUDIA CARDINALE

Cardinale's entrance into film resulted from her winning a beauty pageant in which first prize included a trip to the 1957 Venice Film Festival plus a movie contract. Her archetypical Mediterranean beauty—she was young, voluptuous, dark-haired, and dark-eyed—certainly helped her on-screen presence. Although she was in a number of well-known Italian movies, including the 1960 Italian classic *Rocco and His Brothers* and Visconti's *The Leopard* in 1963, much of her career in the Sixties and Seventies was in spaghetti Westerns.

MONICA VITTI

Star of Antonioni's internationally renowned classic of 1960, *L'Avventura,* followed by three more Antonioni films, Monica Vitti actually began her career on stage as a comedienne. She gradually returned to more light-hearted film roles in the late Sixties. In recent years, she's been seen on stage and screen but has never received anywhere near the popularity or critical acclaim of her early years.

ANNA MAGNANI

Passionate, earthy, and sensual, Anna Magnani, one of the most famous Italian actresses of them all, could hardly be considered a fashion plate. Yet more than a decade after her death at age sixty-

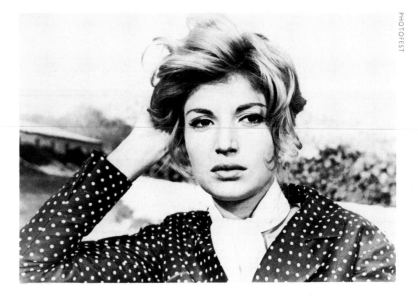

PHOTOFEST

SNUG SHEATHS AND FITTED
SUNDRESSES WITH SCARVES TIED
ASCOT STYLE WERE POPULAR
LOOKS THAT MONICA VITTI WORE
IN *L'AVVENTURA*.

four, she became the inspiration for the collection of one of Milan's hottest design teams, so the legend lives on. Magnani, who became a star in Rossellini's 1945 film, *Open City,* won an Oscar for *The Rose Tattoo* in 1955, which she filmed in Hollywood. And although she protested that she would not be made over by that city's famous glamour factory, she did however look more sophisticated as a result of her stay.

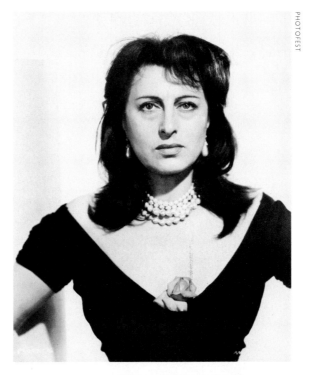

PHOTOFEST

IN HER NATIVE ITALY, MAGNANI
LOOKED EARTHIER, LESS ELEGANT.
HERE'S HER MORE HOLLYWOOD
FACE AND FASHION OUTLOOK AS
PHOTOGRAPHED IN 1955 FOR *THE
ROSE TATTOO.*

PERSONAL STYLE: REAL-LIFE FASHION CHOICES

THESE DAYS, Italian films appear to follow fashion rather than set it, with the strongest influences being both designers and tradition. Italian women seem to develop their personal style early on and remain true to it. "It's most important that a woman be recognized for the same style at every age," observes designer Romeo Gigli. "While she can play with different details throughout her life, or maybe even change her fashion silhouette, she should remain true to a point of view."

Here's how six women of different ages, with different needs and outlooks, from different parts of the country, make their fashion choices:

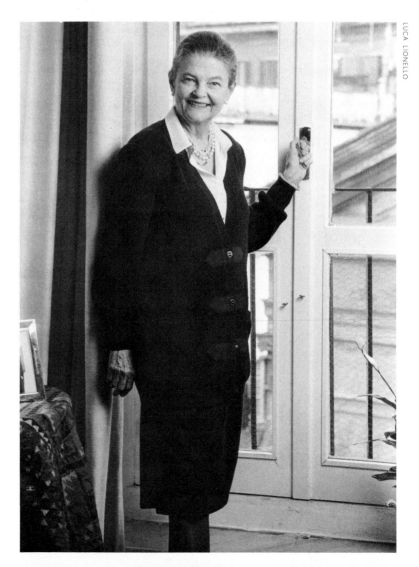

LUCA LIONELLO

JO BETTOYA IN THE SIMPLE CLASSICS AND UBIQUITOUS PEARLS THAT SHE FAVORS.

AGELESS ELEGANCE: JO BETTOYA

She speaks Italian as if she were a native. It's only her soft drawl when speaking English that gives her away as an American. Georgia-born Jo Bettoya has spent the last forty years or so in Rome —except the first year or two of her marriage, when she lived in Paris—and her approach to both food and fashion reflects an Italian sensibility. As wife of hotelier Angelo Bettoya, scion of the largest family-owned group of hotels in Italy (among them Rome's Mediterraneo), it was only natural that she get involved as well. Under her husband's tutelage, she began selecting the menus and initiating new dishes for the hotel restaurants. The culmination of this "apprenticeship" was a cooking school called Lo Scalda-vivande that she opened in 1976 with a friend. Originally conceived as a place where modern Italians could learn traditional Italian cooking, it eventually accepted groups of American students four times a year. The experience resulted in a book, *Italian Cooking in the Grand Tradition,* which is available in both Italian and English. Her latest book is *Southern Italian Cooking.*

At present, she no longer maintains the school and prefers needlepoint to cooking, a hobby she's turned into a family affair. Extraordinary examples of intricate designs executed by herself as well as her husband and one of her sons are framed, upholstered as pillows and chairs, or otherwise treated as the fine art they resemble.

A devotee of classic and tailored elegance, she outlines her fashion philosophy—a fusion of two cultures:

"I think that I dress more like an Italian than an American. Italians have a certain way of dressing for morning, then another for afternoon to evening. Americans tend to be a lot more casual, then get all dressed up for a specific occasion. Plus, Italians keep up with fashion . . . they really understand it. When you go into a shop, the salesgirl knows exactly what you mean. Italians also have a sense of proportion and they know what's good for their bodies.

"I'd describe my style as classic. One of the reasons is because I'm frugal. I buy good clothes and keep them. It was the way I was brought up in Georgia. And now, as I get older, I find myself wearing clothes that are older, that I've had for a long time. Good clothes hold up.

"I used to have clothing made by a dressmaker. In fact, I had the same dressmaker for thirty years and she made everything for me. Then she opened a shop and stopped accepting private clients . . . That nearly killed me. So I discovered ready-made clothes . . . Ferragamo, Krizia, and Biagiotti are my favorites. And I wear skirts, not trousers, because I find them uncomfortable. However, while comfort is important to me, I'll put good looks ahead of it.

"I've always worn pearls, but I usually don't wear the same jewelry every day. Italians are involved in the total look and change their jewelry to go with what they're wearing, and I tend to do the same."

BOARDROOM STYLE: MARIA ROSARIA MONTIROLI

As vice president and deputy general manager of Revlon, Italy, Rome-based "Cicci" Montiroli is more often than not working —whether it's checking on a boutique in the area, traveling throughout the country, entertaining various accounts, or the myriad other responsibilities that her position with a very upscale beauty company involves. It leaves her precious little time to spend at home with her husband in the marvelous house that they renovated near the Appian Way.

The image she likes to project is formal and businesslike, yet very feminine, too. And looking chic on the road is one of her priorities. Petite and slim, she favors suits with short skirts, and curvy jackets without a hard edge. She avoids pants in the office and wears jeans only on the rare weekends she can relax in the garden.

Although she may wear a suit she's had for several years, she'll more than likely pair it with new shoes—her weakness— in a shade that coordinates with her outfit. These shoes will inevitably be pumps on a sexy, skinny, mid-high heel. Interesting pieces of antique jewelry that she wears in unexpected ways also personalize her look: a heavy watch chain as a necklace, a pair of earrings as lapel clips.

Her style has basically remained constant through the years . . . and that's the way she likes it:

"I never want to appear overdone . . . and I don't like to be a victim of my clothing. Comfort is an important consideration

LUCA LIONELLO

A SOFT SHIRT, A SMALL
STRUCTURED JACKET, AND
INTERESTING ANTIQUE JEWELRY—
THE "PINS" ARE REALLY EARRINGS
—ARE THE PIECES CICCI
MONTIROLI LIVES IN.

for me. The style that works best for my life is a little formal, yet
it's varied. For example, I wear Chiara Boni's designs because
they're feminine, Mugler because they're sexy yet elegant, and
Armani because there's that slight masculinity.

"However, I generally like everything to have a feminine
touch. It's a personal preference, but one that suits my body type
and my work. When I wake up, I look at the weather, then look
in my closet and decide how I'm going to dress that day.

"I keep clothes for a long time, but immediately give
away anything that doesn't work. My biggest indulgence, how-
ever, is shoes. Comfort is less important to me than the look. I
find that shoes are never right for a long time, so I change them
continuously.

"Jewelry is another weakness. I don't like costume jewelry, but love antiques, although I have a few modern pieces. I also never wear big earrings because they're not becoming on me.

"If my husband doesn't like the same thing that I do, I won't wear it. Luckily, he usually likes what I like."

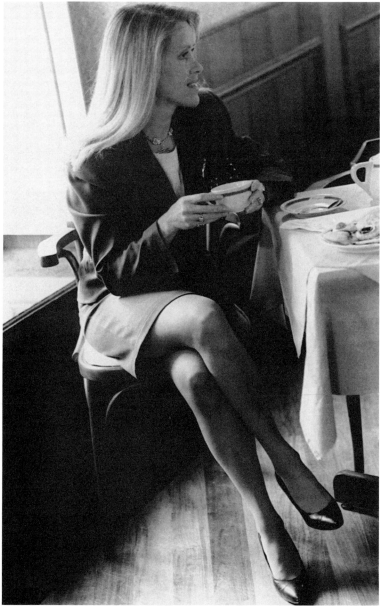

LUCA LIONELLO

WHILE THE SUIT CHANGES, THE STYLE STAYS THE SAME. CICCI FEELS BEST IN SHORT SKIRTS AND HIGH HEELS.

FAITHFUL TO FERRE: NALLY BELLATI

Two of her most recent books, *New Italian Style* and the Italian section of *Tiffany Food,* show the eclectic side of photojournalist Nally Bellati. In fashion, however, she's loyal to one look—Ferre. She has a collection of his best pieces from the past thirteen years, and she mixes periods with abandon. The result is a tailored and extraordinarily elegant style that totally suits her particular beauty. It's a style that not only all of Milan has noticed, but the world too, it seems, as she was voted a member of the 1990–1991 International Best Dressed List. Her favorite outfit for day is a beautiful blazer with tailored pants and a white cotton T-shirt; for evening, a romantic white organza shirt with skinny dark silk pants.

Her unorthodox fashion approach may result from years spent in London and Paris before settling in Milan. Daughter of an English father and Italian mother, she was born in Italy, was raised and educated in England, and worked in France. Since 1968, she's been living in Milan with her husband, photographer Count Manfredi Bellati, and their teenage son, as well as two Jack Russell terriers that are treated like members of the family. Since the dogs accompany her almost everywhere she goes during the day, they're as much part of Nally's look as her Ferres.

Like many Italian women, she won't go out of the house in the morning (even if it's just to walk the dogs) without "looking right." This means being immaculately groomed and dressed. Since her beauty ritual involves letting her long hair dry naturally after shampooing it—which she does several times a week—she often makes only afternoon appointments.

Nally has very high standards and precise ideas about her look, which she explains this way:

"I used to dress according to the occasion. But through the years I became more secure about fashion, and now I just dress in my own style. I'm a real city person.

"I'm also one of the few people who wear Ferre in Milan. I've been wearing his designs almost exclusively for a long time, although I also have a little bit of Armani and some baggy sweaters from Gigli.

BRUNO CASOLARO

NALLY BELLATI AND "FAMILY."
NALLY WEARS HER FAVORITE
EVENING LOOK—BLACK TROUSERS
AND A WHITE SHIRT, BOTH FERRE.

"I have a great respect for clothes, but I hate to shop. So twice a year, I go to the Ferre boutique and select what I like. I buy about five pieces each time, which I mix with things I already own. With Ferre pants, I might wear a quilted nylon hunting jacket, which I've had for years, then an Hermès scarf around my head, or a fur hat.

"Since black doesn't suit me, I build my wardrobe around navy, white, and gray. I then add touches of color . . . bright gloves, for example.

"I won't wear anything that doesn't look good on me. I used to wear skirts but don't anymore and tend to feel best in

pants, usually wide ones. I never wear high heels, only comfortable shoes, which are usually Chanel flats, either the classic style or the ballerinas. I like men's sweaters, which I buy extra large. Because they're classic and I keep them forever, I always choose cashmere.

"My jewelry is either antique that I inherited, like my pearls, or designs by Robert Lee Morris. Every time I go to New York, I buy one new piece.

"I'd say, however, that my one most indispensible article of clothing is a simple white T-shirt. If I were stranded on a desert island, all I'd need would be a tee and a pair of Levi 501's."

BRUNO CASOLARO

FERRE FROM ALL SEASONS— BELLATI MIXES THE OLD AND THE NEW TO ARRIVE AT A LOOK FOR WHICH SHE'S FAMOUS. BOTH THE JACKET AND SHORT COAT ARE DIFFERENT BUT HARMONIOUS SHADES OF PURPLE, WHILE THE TROUSERS ARE GRAY FLANNEL. SHE ACCESSORIZES WITH OVERSIZED PEARLS, WHITE SOCKS, BLACK CHANEL SHOES, BLACK GLOVES, A BLACK HERMÈS KELLY BAG, AND A DARK FUR HAT.

NO SHOW . . . THE UNDERSTATED APPROACH: SILVIA RUSCA TOFANELLI

Although she has all the beauty, breeding, and good taste for which the most fashionable Milanese women are famous, Silvia Tofanelli shies away from designer labels or any show of wealth in her dress. She prefers quieter fashions and loves to pair a bargain find with a much more expensive piece to create an original look.

Understatement is key—this is an approach that revolves around a blazer, pants or a skirt, and T-shirt, a strand of pearls, a watch, and lovely shoes. Like many well-dressed Italian women, she has a penchant for footwear, which she views as the most important accessory.

She also loves jackets and coats—things to wear over other things—which she layers on in cold weather. While her typical day outfits are casual, she prefers a more glamorous look for evening. She'll often wear high heels instead of flats even with pants, and will almost always wear something velvet during the winter or silk during the summer.

Her purchases are more random than planned, and she rarely buys much at one time. While she always takes the price into account, Tofanelli readily admits choosing beauty over practicality:

"I love clothes that are beautiful objects . . . simple things in colors that I can combine. I shop wherever I happen to be, but I try to avoid the labels that let people know exactly what one has on.

I avoid fashion that looks too expensive. I don't wear fur, for instance. But I do wear thin cashmere pullovers. They're understated and that's what I like. I often mix rich and poor—a cheap jacket with an expensive shirt and real pearls.

Although I love antique jewelry, I wear very little of it. I wear earrings and pearls around my neck, and I always wear a watch. I usually change watches according to the occasion. I don't wear rings or bracelets, though.

"I don't plan my purchases. I just buy what I like when I see it. But I like to keep what I own for a very long time. Typical of my approach would be to wear a very old suit with a new fantastic pair of shoes. Shoes are my very favorite accessories.

MARCO HOST-IVESSICH

WITH THE KIND OF EASY, SILK
T-SHIRT SHE ADORES, SILVIA
RUSCA TOFANELLI WEARS
SIGNATURE GOLD AND STONE
EARRINGS WITH A NECKLACE.
THE TOTAL EFFECT IS
CASUALLY ELEGANT.

"In winter, I usually wear pants because they're comfortable
. . . and I'm cold all the time. If I have to go somewhere during
the day, I'd wear a suit [skirt] with a viscose T-shirt . . . I like
silky T-shirts under jackets and have many of them. For evening,
I'd wear the suit with a silk shirt and add high heels. If I'm
entertaining at home, I wear evening pants with a velvet top.

"In summer, I wear a lot of silk and lightweight fabrics, and
tend to wear skirts more than pants. Year-round, I go to the
country on the weekends, where the dress is very casual—a
blazer, sweater, and pants during the day. Evenings, though, I
like to get a little dressed up. There my husband and I play golf.
I also play tennis, and ski in the winter. But to tell the truth, I'm
not very good at sports."

ANTIFASHION: BARBARA FRUA

Formerly one of Milan's best-known fashion editors/stylists and wife of a well-known photographer, Barbara Frua has currently turned her talents toward interior decorating. While her work, especially her home—an airy apartment she shares with her young daughter—features a range of interesting colors, her clothing color palette is strictly limited to neutrals and red. Rather than black, which she dismisses as "too fashion," she prefers navy blue.

She describes her personal style as simple and easy, founded on a base of vintage clothing she's collected through the years. In fact, flea markets still top the list of her favorite places to shop. The others are two Milan shops that she always frequents. She likes menswear touches, especially big sweaters and jackets, and veers toward shapes that are slightly oversized.

Her mood dictates her look, and she decides what to wear when she wakes up in the morning. Her governing rule is that she has to feel good in whatever it is she puts on.

A woman with a highly developed visual sense, Frua is also very specific about her personal choices:

"Although I like to decorate with colors, I don't like to wear them. I also find black makes a little too much of a statement, so I wear navy blue instead.

"I don't buy clothes anymore because I have so many. And I think you can keep classics forever. Of course, if I happen to see something I absolutely love, I might get it. Price is very important to me. I don't like to pay a lot for fashion, and just because something is high-priced doesn't necessarily mean it's nice. If I see something I like and it's too expensive, I don't buy it. Except for shoes, that is. They're my weakness. For me, they're the most important accessory. I also love boots.

"I'd describe my style as very simple and practical. I feel good in pants or bermudas—the latter I wear year-round—and a man's sweater, for example . . . or a velvet blazer. I like man-tailored clothing and men's clothing that I wear a little oversized. In the evening, I like to be very Forties-looking. I have lots of evening dresses that belonged to my mother that appear timeless. They're all rather long—over the knees—just the way I like them.

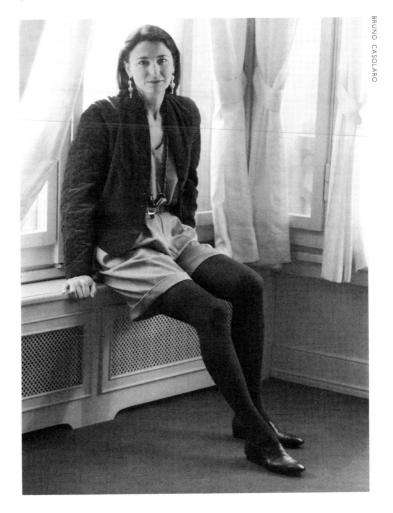

BRUNO CASOLARO

BECAUSE SHE LOVES THE LOOK OF BERMUDAS, BARBARA FRUA WEARS THEM YEAR-ROUND. A COLD-WEATHER SOLUTION IS TO TEAM THEM WITH OPAQUE TIGHTS.

"I enjoy playing with clothes. For example, two of my favorite looks are an old St. Laurent velvet jacket that I wear during the day with a long skirt or pants, and a vintage Loden wool cape that I might put over trousers with riding boots.

"Moschino is my favorite designer. I have a pair of his suede harem pants from years ago that I like to wear with a sweater tucked in and a short jacket, or an old silk shirt with a jabot front, and English riding shoes.

"I only like old jewelry—I have a collection of my mother's, including bracelets from the Thirties—and ethnic jewelry, especially American Indian. I also have beautiful pearls, but I never wear them because they make me feel old."

PUCCI NINETIES STYLE: LAUDOMIA PUCCI

Currently very involved in father Emilio's business, Laudomia Pucci seems to have inherited his eye for color . . . and his ability to break established fashion rules with fantastic results. Her unorthodox approach—a futuristic twist on classic Pucci—reflects more of a French approach than a Florentine one. Not surprising, considering she was educated in Paris and travels there constantly.

Responsible for the Pucci accessory line, she also collaborates with her father on the fashion collections. Her brother Alessandro is involved with the financial side of the business.

She feels that her generation, Italian twentysomething, is less Italian and more assimilated within either the European community or the American one. She does point out that although Italian women in particular have changed in the last ten years, they've still been brought up to appeal to men.

Young, spirited, slim, her look is decidedly "Pucci classic." She's usually dressed or accessorized in at least one Pucci item, which she mixes with either a basic or avant-garde piece (like thigh-high boots). Here's her reasoning:

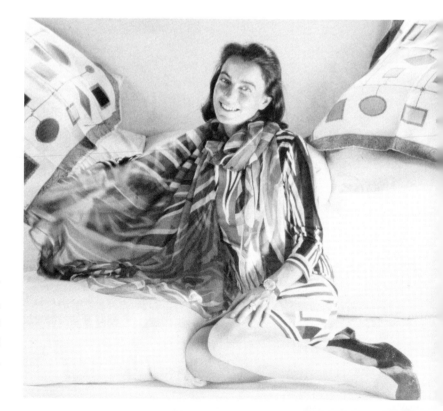

LAUDOMIA PUCCI PROVES THAT MORE IS MORE: SHE TOPS A CLASSIC PUCCI SILK PRINT DRESS WITH A DIAPHANOUS CHIFFON SCARF IN A SIMILAR PUCCI PRINT.

"I'm basically very classic, but very Pucci, too. However, I try to wear Pucci in a different way to create a look of my own. I like to use just touches of it, mixed with other things, like a pair of the print leggings with a simple blazer.

"My fashion recipe is one classic piece with one crazy one, because contrasts are fun. For example, I might wear a plastic miniskirt with a traditional silk jersey top. I usually buy French clothes because of the fit. I'm small and they look best on my body.

"I'm always traveling, but hate taking a lot of baggage. Luckily the fabrics we use travel fantastically—they take up practically no space, and they don't wrinkle. Anyhow, I've pared my wardrobe down to just five or six pieces that take me every-where: a jacket, a silk jersey or cashmere dress, an evening piece (either a dress or suit), a pair of pants, leggings, a T-shirt, and a shirt.

"What's often missing from Italian fashion is a sense of humor and youth. I think this is what my father's designs offer. The silhouettes are rather traditional, but the colors and the fabrications are fresh and young, while sophisticated and time-less."

STYLE CHOICES

IT'S CERTAINLY APPARENT from the preceding interviews that personal choice adds the fillip and liveliness to Italian chic. While the basics may remain similar, the accents change: Italian women express their individuality through their accessories, as you'll see in the next chapter.

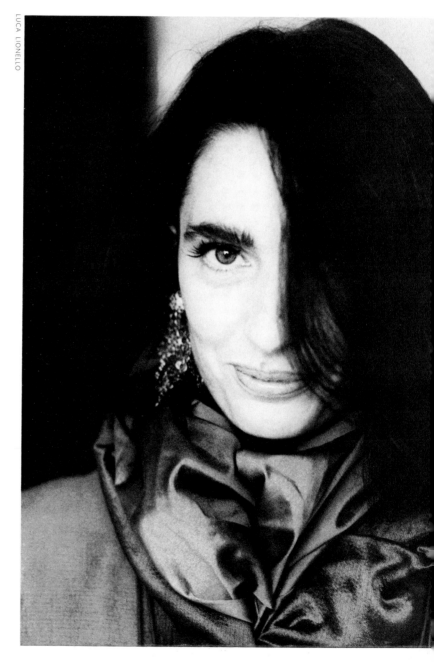

LONG DANGLING EARRINGS—
OFTEN THE LONGER THE
BETTER—ARE FAVORITE
EVENING ACCESSORIES.

7

ITALIAN ACCENTS

ASK ANY ITALIAN WOMAN to name her one fashion indulgence and she'll unhesitatingly answer —shoes! She confesses that she'd rather scrimp on almost any other article of clothing to be able to splurge on shoes. Why? "Shoes are more sculpture than object," maintains shoe designer Armando Pollini. And it's true that their art is a major attraction. "Italian's love of shoes goes back generations . . . and comes from the craft," observes Andrea Pfister, an award-winning footwear designer known for some of the most seductive and imaginative shoes in the world. Marchesa Fiamma Ferragamo di San Giuliano, who runs Ferragamo's shoe business, adds, "A beautiful, quality shoe that works with the dress defines a person of a certain level and taste. It means many things."

Italians put their money in leather—shoes first, then bags and belts—and gold: earrings, necklaces, watches. Cashmere and silk, in the form of shawls and scarves, are other popular accents, although the Italian approach to accessories is similar to their approach to fashion. It involves few but high quality items that make an outfit look timeless and far richer than its actual price.

Generally, Italians eschew fad accessories, with the exception of Swatch watches (which have become classics), big brooches from the Fifties, and certain other pieces of costume jewelry, which are discussed later in this chapter.

SHOES

"ITALIAN WOMEN pay attention to what's on their feet," explains designer/manufacturer Diego della Valle. "They express their personality through shoes." And most Italian women confess that they not only buy shoes to match their mood . . . but whenever they're *in* the mood. Most Italians own far more pairs than they need. As with clothing, Italian shoes are an

artful blend of fine materials and beautiful workmanship, even though mass-produced. The level of the technology and the attention paid to each step of the process ensures a quality product. And although comfort counts, the look of the shoe counts more.

In addition to topping the accessories list, footwear is Italy's second largest export to the United States. Not surprising, since this small country has been renowned for fine footwear since the Middle Ages. However, the Etruscans, Greeks, and Romans also had remarkable skill and creativity in shoemaking, which especially since Roman times balanced both the decorative and practical sides of the craft. Venice in the fifteenth century was the center of the shoemaking trade, where a lengthy apprenticeship before being "licensed" insured the elevation of the craft into an art.

A STEP FROM THE PAST

In the sixteenth century, the ultimate platform shoe—with carved soles from two to twelve inches—became the fashion rage. Although they originated in the East, they achieved cult status in Venice, where they allowed their privileged and aristocratic wearers to maneuver muddy streets. Colin McDowell makes the point in his book *Shoes: Fashion & Fantasy* that styles at this time and even in ancient times were often initiated to gratify a royal need for exclusivity, even though they were then copied by the middle classes. A historical footnote: the pointed toe predated the platform shoe; the heel came after it.

Italy lost its footwear lead in the eighteenth century, only to regain it at the end of the next century, when the technology

THIS VINTAGE FERRAGAMO PLATFORM SANDAL, DESIGNED IN 1935, SHOWS THE MASTER'S INVENTIVENESS WITH VARIED MATERIALS AND FINISHES. IT'S COMPOSED OF RED SUEDE STRIPS OVER A CARVED WOOD PLATFORM AND WEDGE SOLE THAT ARE PAINTED WITH A YELLOW, BLUE, AND RED GEOMETRICAL PATTERN.

of the Industrial Revolution added a new dimension to the traditional Italian workmanship. The result was a mass-produced, beautifully designed and crafted product. Today, Italy is still renowned for a quality product that's perhaps even more stylish than ever before because of a wealth of design talent.

FOOTWEAR GREATS

The volume of modern Italian design talent in the shoe industry is staggering, but only a few "names" are known in America, such as Ferragamo, Gucci, and Mario Valentino. There is, however, a multitude of designers who are less ensconced in our economy but are certainly creating reputations on this side of the Atlantic, such as Diego della Valle, Andrea Pfister, Armando Pollini, Fratelli Rossetti, Bruno Magli, Prada, and Pancaldi, each of whom produces different products at different price structures. Then there are the additional eight thousand footwear manufacturers in Italy, almost all of whom produce a quality product, who, for one reason or another, aren't even known in their native land. Some produce very small quantities, others manufacture under private labels. In fact, the majority of the famous American "designer" footwear is styled and manufactured in Italy, often by smaller, lesser-known manufacturers.

SALVATORE FERRAGAMO: Possibly the greatest Italian shoe designer of this century, Ferragamo was renowned for his imaginative shapes and innovative use of materials. He invented the stiletto heel and the cork wedge, and created shoes for famous Hollywood feet in the Twenties. While his name is now associated with a multimillion-dollar, worldwide empire that includes men's and women's footwear and accessories and women's ready-to-wear, his story is a true rags-to-riches one, which began in the slums of Naples. When he died in 1960, his wife and six children continued the legend. The company's base of operations is in Florence because "my father thought that this was the closest town to his way of thinking: it's chic and elegant," explains daughter Marchesa Fiamma Ferragamo di San Giuliano. "Our philosophy is to continue what my father has done," she continues. "Our shoes are first quality and the technical part is very important. Our feeling is that *we* don't wear shoes, they wear us, because they bring us along. They take the weight of the body so they have to be comfortable." Ferragamo produces two principal shoe collections a year, in addition to the ready-to-

SALVATORE FERRAGAMO FITTING
ANNA MAGNANI WITH A PAIR OF
SEXY, STRAPPY HEELS.

wear collections, which are developed by sister Giovanna Ferra-
gamo Gentile. While shoes still count for a large part of the
business—about fifty percent of sales—the other divisions are
growing and the company is opening additional directly owned
boutiques in different parts of the world.

MARIO VALENTINO: Son of a Neapolitan shoe designer,
Mario Valentino, who died in 1991, became a prominent name
in luxury leather goods. From the start, his footwear creations

were imaginative, inventive, and brightly colored, like the flat sandal adorned by a flower holding two skinny straps that *Vogue France* featured in the Fifties. In the Sixties, he began working with I. Miller in the United States and his career began to soar. When he returned to Italy in the late Sixties, he added handbags to his shoe line, then luxurious suede and leather fashions. He, along with the Ferragamos, was the first to open a store in Manhattan in the early Seventies, where his stylish shoes for men and women are still sold, along with women's apparel, handbags and leather accessories, luggage, and fragrance. The business is currently run by his three children, with daughter Fortuna in charge of footwear and ready-to-wear. Retailed in Mario Valentino namesake boutiques throughout the world, the collection is also wholesaled to a multitude of luxury stores.

GUCCI: The Gucci loafer, perhaps the most famous Italian shoe of all time, is currently looking more fashionable than ever due to a very subtle update. In fact the entire company has been given one in recent years, since Maurizio Gucci, a grandson of founder Guccio Gucci and the only family member still involved in the business, took control of it. Heading the team of professionals that he assembled in 1990 is Dawn Mello, the former president of Bergdorf Goodman, who currently is in charge of development and image and plans to bring the firm back to its former glory. "Gucci's heritage is quality and leather goods. We're creating an international style that has its roots in the

THE CLASSIC GUCCI LOAFER, WHICH HAS BEEN UPDATED AND STREAMLINED IN RECENT YEARS, IS POSSIBLY THE BEST-KNOWN ITALIAN SHOE STYLE OF THE CENTURY. IT'S SHOWN WITH A NEW GUCCI CLASSIC, THE BAMBOO-HANDLED LEATHER BAG.

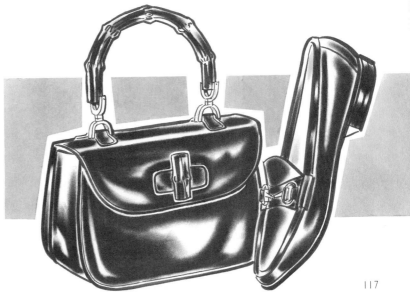

PIERRE POUIARD

Gucci heritage," explains Mello about the current philosophy. "Gucci used to appeal to a youthful customer and we want to do this again," she continues. One of the ways she's going about it is by combing the extensive company archives for ideas. "They're as appropriate today as they were in the Fifties, Sixties, and Seventies," she maintains, pointing out that everything created by Gucci first has to do with leather and the "hand" or touch. "It's where the Italians differ from the French," she says. "Everything we do has to feel good."

FOOTWEAR CLASSICS

"Style is the goal, not fashion of the minute; rather something that stays fashionable and new for a long time," insists Armando Pollini, echoing the sentiment of many of the leaders in the field. Shoes in Italy generally tend to be classic as much as stylish. And Italian women usually wear neutral colors, except in summer. Then, especially for resort wear, they sport gold flats and sandals, as well as brightly hued ballerinas and canvas espadrilles.

Favorite Italian looks that work well on this side of the Atlantic include:

TUXEDO FLAT: A flat pump with a grosgrain bow at the toe, this style works well for almost all occasions—with anything from business suits to evening pants. Ferragamo is most famous for this look, which was developed in 1978 and continues to be the company's best-seller in both Italy and America (here, it's considered the ultimate "yuppie" shoe). Black, beige, and navy are always constants in the Italian wardrobe.

DRIVING SHOE: A sport shoe in either leather or suede, it has a sole made up of small rubber pebbles. While the category may be generic, and although copies abound, in Italy the ultimate driving shoe is JP Tod's by Diego della Valle. "Tod's," as they're popularly called, are considered a status shoe, perhaps because early devotees were famous names like Gianni Agnelli and Princess Caroline, among others. Two favorite warmer-weather styles are the moccasin and the loafer; colors include the range of neutrals. Italians wear them with very casual gear—leggings, bermudas, slim pants, and without socks—in much the same way we wear sneakers here. Other styles include lace-front low boots with heavy rubber soles, which are worn with jeans during the colder months.

PIERRE POULARD

THE WORLD-FAMOUS FERRAGAMO TUXEDO FLAT.

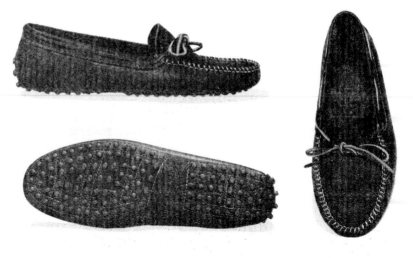

DIEGO DELLA VALLE'S TOD'S—THE
FAVORITES OF INDUSTRIALIST
GIANNI AGNELLI—WITH THEIR
INSTANTLY RECOGNIZABLE RUBBER
PEBBLE SOLE.

MAN-TAILORED OXFORDS: Whether lace-front or side-buck-led, these are distinctly masculine and somewhat heavy. Best colors are black, brown, or luggage, either leather or suede. They're worn with heavier ribbed pantyhose or socks during the winter months.

LOAFERS: They're usually tailored with flat heels and tend to be more feminine and less clunky than either classic American loaf-ers or Italian oxfords. The Gucci loafer, characterized by a gold bit across the vamp, fits in this category. Copies abound so it's possible to buy the look without spending a fortune for it. De-pending upon the hosiery worn with loafers in general, they're paired with both tailored suits and more casual outfits.

CLASSIC PUMPS AND FLATS: They're designed in a range of heel heights, colors, and materials. Several Prada styles that have become classics, including a flat with a high vamp and low, lace-front boots, are made of satin although meant to be worn during the day. In addition to leather and suede, fake and true alligator, lizard and crocodile are year-round favorites. Styles with con-trasting toes—a luggage flat with a black toe, black leather with a black patent toe, and so on—similar to those designed by Chanel are basics.

BALLERINA FLATS: These are perhaps the most popular warm-weather shoes to wear with just about anything except a suit . . . and especially simple sheaths, leggings, long skirts, and casual beach looks. They are very feminine, especially in gold—a favorite—as well as brights and pastels.

ESPADRILLES: Made of canvas with a rope sole, these are popular from the beaches of Portofino south, in colors as well as black and white. Espadrilles suit beachwear and very casual gear.

SANDALS: Simple thongs as well as more complicated, strappy, and decorated models are additional resort alternatives. They're also worn in cities like Rome and points south. Gold sandals are a good go-with-almost-everything choice for day and evening, as are black, tan, and brights.

BOOTS: The to-the-ankle boot, with a lace-up front, is a constant in suede and leather, although both satin and velvet are popular . . . as is linen for warmer weather. In winter, they're worn with ribbed or opaque pantyhose or socks. Other classic styles include a structured boot, like a high leather riding boot, or softer, crushier boots in both suede or leather.

ALBERT WATSON FOR PRADA

THESE LOW, LACE-FRONT BOOTS
BY PRADA COME IN A RANGE OF
UNEXPECTED FABRICATIONS,
INCLUDING LINEN AND SATIN.

HANDBAGS

ITALIANS TEND TO JUDGE each other by their handbags as well as their shoes. Bags, too, are finely crafted, usually in neutral shades, although they don't have to match footwear. Perhaps the favorite Italian signature bag comes from Prada, a company with retail outlets all over the world. A quilted nylon tote with a chain handle and immediately apparent Prada logo is a wardrobe staple. The well-appointed original boutique in Milan's Galleria (there's a second, newer one on the Via della Spiga) is a leather lover's dream. The entire handbag collection, plus shoes and a small collection of apparel, is elegantly showcased.

Italians are as concerned about what is contained in their handbag as the bag itself. All accessories are beautiful objects, almost like tiny jewels—the wallet, cardcase, pen, pad, calling cards, makeup case. In fact, often the wallet itself is worth more than the amount of money contained in it.

THE QUILTED LEATHER BAG: Whether a real or fake Chanel (this style has been so authentically copied by Italian craftsmen

ALBERT WATSON FOR PRADA

THE TRIANGULAR PRADA LOGO REALLY COUNTS IN ITALY...IT REPRESENTS NOT ONLY QUALITY AND CRAFTSMANSHIP, BUT STATUS, TOO.

that it's often difficult to tell the true one), this bag is made of quilted leather or suede, with a distinctive chain handle.

THE NYLON BAG: It could have a chain or leather handle, be roomy or tiny, but it usually bears the distinctive Prada logo. The most popular look is a top-zippered tote that comes in sparkling colors, as well as the ubiquitous black and brown.

Actually the use of industrial-weight nylon—even satin, a newer Prada material fast gaining in popularity—treated in the same manner as the finest leathers and skins was the brainchild of Miuccia Prada, who is continuing the tradition of quality, luxury, and exclusivity of the company since its founding in 1913 by her grandfather Mario Prada. She's infused a new spirit and has followed a more modern course since taking charge of Prada in 1978. "I like to link the past with the future," she explains, pointing to the mix of the industrial and the artisanal that marked her first major success. Leather goods, a staple upon which the

ALBERT WATSON FOR PRADA

A BEAUTIFULLY CRAFTED PRADA TOTE BAG IN SHINY NYLON WITH LEATHER STRAPS.

company built its reputation, are still very important—with handbags the most popular category—but in recent years shoes and then ready-to-wear have become part of the collection. In both categories, Miuccia's forward and original thinking is apparent. "I never wanted to create things that were typically Italian," she explains, adding that her education was international and the collection reflects it. She favors simple shapes that exhibit a touch of eccentricity and likes to mix masculine and feminine lines and touches: a spare shirt might have a collar edged in tiny seashells, an A-shaped dress might be draped with a metallic shawl. It's the same as her approach to her own wardrobe—she favors touches that are both personal and a little cultured. The most important item in her closet changes every five years, she explains. Right now she favors narrow trousers. And antique jewelry. She wants to expand her neutral color palette, but finds it difficult to wear color in a modern way. For her, a workable wardrobe includes:

- narrow trousers in different fabrics for day and evening

- one or two short skirts, depending upon your age

- a suit

- a jacket

- a trenchcoat

- a cape, for day or evening. Capes are easy to wear and feminine.

- a sweater that's a tunic or long cardigan. She likes matching trousers with a cape or tunic.

THE STRUCTURED BAG: These leather bags are firm and structured, in a variety of shapes from a variety of manufacturers. They usually have a small handle, plus optional shoulder strap, and look very ladylike. Two of the most sought after are the bamboo-handle and closing bag by Gucci and the Hermès Kelly bag that's been copied in every conceivable material, color, and size.

PIERRE POULARD

THE DRAWSTRING OR HOBO BAG: This style is soft and unstructured on a shoulder strap. Although the looks within the category differ slightly—the hobo bag usually closes with a zipper—they have the same basic feel and are good choices for everyday wear.

THE BACKPACK: While this is also a choice of the young, fashionable women about town are often seen with a polished leather backpack—or even a Chanel backpack—thrown casually over one shoulder.

BAG-ON-A-BELT: This style is gaining in popularity and available in many styles and finishes, including alligator, lizard, leather, and nylon. The wearer usually slings a tote over her shoulder as well to carry all the belongings that won't fit into the Lilliputian bag at her waist.

A QUILTED LEATHER POUCH ON A DOUBLE-CHAIN BELT—VERY CHANEL-LIKE—IS A STYLE THAT SEEMS TO BE POPULAR WITH ALL AGE GROUPS.

LUCA LIONELLO

THE BACKPACK IS PRACTICAL WHEN ZIPPING AROUND TOWN ON A MOTOR SCOOTER.

BELTS

A QUALITY BELT in brown and in black is basic to the Italian wardrobe. It could be made of alligator, crocodile, lizard, or leather with a simple gold-tone buckle. A 1″-to-1½″ width is most frequently worn with tailored suit, a simple skirt, jeans or trousers, or a shirt.

MARCO HOST-IVESSICH

THE BASIC ALLIGATOR BELT IS SIMPLE, ELEGANT, AND EXPENSIVE, BUT IT LASTS A LIFETIME.

HOSIERY

ITALIAN WOMEN usually wear opaque or sheer hosiery in the same hue as their ensemble, which serves to unify their look as well as visually lengthen their legs. Colors are neutral, usually black, brown, gray, navy, olive, or beige. In winter, they switch to a heavier gauge opaque or ribbed pantyhose when wearing skirts. With trousers, they might wear a smooth or ribbed sock, often in a solid color, but also argyle, heather, or tweed in colder weather.

SCARVES/ SHAWLS

ITALIAN WOMEN count on scarves, shawls, and other neckwear items to finish their outfits. Giant shawls in fringed oblong or square sizes are mainstays, as well as all manner of silk and lightweight silk and cashmere scarves to tie on a handbag or around the throat or waist.

The Etro paisley shawl, already referred to in this book, is one of the most coveted styles. Etro is a fabric house as well as a retailer with over thirty-five boutiques, a producer of accessories and fragrances, and most recently, a ready-to-wear label with a small collection of very select, high-priced, and classic clothes for both men and women.

The Hermès scarf, a French favorite, is also an Italian status symbol. As you may know, Hermès is a very elegant and expensive store in Paris, renowned for equestrian as well as fine leather

LUCA LIONELLO

ITALIANS OFTEN DRESS UP A DAY SUIT FOR EVENING BY TOSSING AN OVERSIZED SILK SHAWL OVER THEIR SHOULDER.

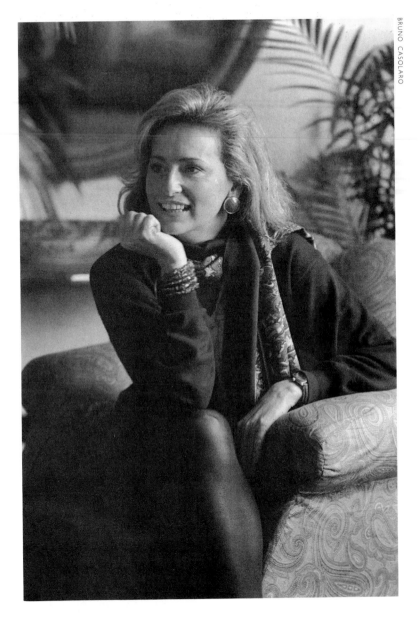

BRUNO CASOLARO

AN EASY WAY TO WEAR THE
UBIQUITOUS HERMÈS SCARF: TIE
AN OBLONG AROUND THE
THROAT WITH THE ENDS TOSSED
OVER THE SHOULDER.

gear. Their scarves have become the ultimate collectibles, even though they retail in the vicinity of $200 each (and going up every year). The most popular shape is the 36″ square, which is available in almost a thousand styles. Italians tend to wear it in classic ways, unlike their French neighbors, who really go to great lengths to be creative with a scarf. Here are several typical Italian approaches to tying one on:

- folded diagonally and tossed over the shoulders with the ends knotted

- folded diagonally and wrapped around the neck with the ends loosely tied

- folded several times on the diagonal, then tied snugly around the throat with ends tucked inside a shirt or sweater, ascot-style

- folded several times on the square, then bow-tied around the throat

Cashmere or wool mufflers are also important accents to a look. They're worn thrown around the neckline of a blazer with ends trailing or singly or doubly wrapped around the throat.

Beautiful lengths of brocade or tulle, or a boa of marabou or feathers are occasionally wrapped around the shoulders or throat by the more adventurous to add interest to a simple suit or blazer and pants.

Pocket handkerchiefs, also called pochettes, usually ornament a classic blazer or business suit. Some have a real menswear feel, while others are frothy bits of lace or tulle.

LUCA LIONELLO

A POLKA-DOT POCHETTE SPILLS OUT OF A JACKET POCKET.

A SILK SCARF AND HARMONIZING HANDKERCHIEF ADD INTEREST TO THIS CLASSIC ENSEMBLE.

LUCA LIONELLO

A CHIFFON SCARF TAKES THE
EDGE OFF A LEATHER JACKET.

EYEWEAR

SUNGLASSES ARE IMPORTANT components of the Italian look. To be expected, the most classic styles are the most coveted. Favorite frames are either black or tortoiseshell. Shapes are simple and timeless, sized small to average, rather than oversized. One perennially sought-after style is the Wayfarer by Ray Ban, which has been an Italian choice for years. Incidentally, sunglasses are not usually worn indoors, even by the most fashion-forward.

HATS AND GLOVES

HATS ARE RARELY part of the Italian look, with the exception of jaunty caps or berets in Florence. Italian women leave their heads uncovered, even when the weather is frigid . . . although they may put up the hood of their parka on rare occasions.

Gloves, however, are a fashion item, especially in supple leather or suede, materials that Italians have historically made into works of art. The finest gloves are hand-stitched; they're expensive, and they look it. Simple, tailored gloves are most popular to wear with everything. They offer chic protection when the temperature dips.

JEWELRY

FROM THE LOOK OF IT, Italians have gold fever. They love the rich color of eighteen-karat gold and wear an abundance of it—usually all at the same time. But somehow, they get away with overkill. Perhaps it's because each gold item is so finely wrought. Italians fashion gold as exactingly as they do fabric, and the results are exquisite. Interestingly enough, twenty-five percent of the gold jewelry sold in America is imported from Italy.

You could say that beautiful gold jewelry is in the Italians' genes, since Italy has such a long tradition of goldsmiths. In fact, the gold jewelry manufacturing capital of the world is in the city of Vicenza.

While gold is the only precious metal that combines rarity and virtual indestructibility—it doesn't rust, tarnish, or corrode—its softness makes it extremely workable and malleable: one ounce can be hammered into a sheet so thin it covers one hundred square feet. In its purest state, twenty-four-karat, gold is generally considered too soft to be used for jewelry. Its hardness can be increased and its color modified by alloying it with other metals. The term "karat" is used to designate the proportion of gold in an alloy. So the eighteen-karat gold that is an Italian mainstay and legally the lowest permissible standard is actually eighteen parts gold and six parts other metals. In this country, ten-karat is the legal minimum accepted standard, with fourteen-karat the most popular gold.

While there are countless artisans creating wonderful pieces, two of the most readily recognized names in Italian jewelry making are probably Bulgari and Buccellati.

BUCCELLATI: Instantly recognizable by the wealth of extraordinary engraving and embossing that set them apart, Buccellati designs are entirely handmade in almost the same manner they were when Mario Buccellati began in 1919. The jewelry, in gold as well as a mix of precious metals often ornamented with stones, has a very elegant, timeless, and traditional feel. The rings, for which the company is famous, are a favorite choice of Italian women, followed by earrings, necklaces or pins, then finally bracelets, points out Claudia Buccellati, marketing manager and wife of Mario's son Lorenzo, who currently runs the firm.

The bracelets are especially inventive, many featuring a system of joints that render them as fluid as fabric. Equally amazing are the silver designs—vases, goblets, plates, and ornaments in the shape of shells, fruits, leaves, and animals—which Buccellati has replicated so faithfully and artistically that they are true collector's items. Explains Claudia, "Buccellati represents history, culture, something beautiful and sure, a tradition you can use."

BULGARI: One could describe the Bulgari style as a mix of elements from classical Greek aesthetics and typical Italian taste. An ancient archaeological coin on a modern heavy gold chain, cabochon stones fashioned into rings, bracelets, and earrings, gold or steel bracelets or rings bent and wound like a spring to hug the wrist or finger are but a few "typical" Bulgari designs. The unexpected and innovative color and texture combinations of both stones and materials are striking, as is the modern feel of the pieces despite their ancient inspirations. "Our jewelry is designed to be palatable around the clock . . . not only for formal occasions," explains Nicola Bulgari. "We aim to create something pleasurable and enjoyable, not obvious and embarrassing." Grandson of founder Sotirio Bulgari, a silversmith who moved from Greece to Rome in 1879 and opened a shop five years later, Nicola and his brother Paolo presently head the company. There are currently more than a dozen Bulgari shops in fashionable cities throughout the world, including New York.

Bulgari watches are as important status symbols as the jewelry. A particular favorite is one in gold, engraved with the word "Bulgari," on a leather or spiral gold band.

THE WAY THEY WEAR GOLD

Sometimes it seems like the Italian is a gold horse . . . in actuality, she might own only a few key gold items, which she then wears every day, and all at the same time. Her jewelry wardrobe may of course vary according to her personality and pocketbook, but in general, it probably includes the following:

- Hoop earrings: In Milan, the hoops tend to be smaller and finer; however, the further south you travel, the larger and heavier they become. Hoop earrings are worn year-round, for day and evening.

- One short-link necklace: The chain is usually rather thick and substantial and nestles in the hollow of the throat. A variation of the chain look is a cluster of longer, finer chains, all worn together.

- One or more link bracelets: The number worn together depends on the thickness of each bracelet. Generally, like necklaces, finer link bracelets are clustered together, while one that is substantial is worn alone, usually paired with a watch. Elite Italians may wear a Cartier love bracelet, which is a narrow bangle that is permanently screwed around the wrist.

- Rings on more than one finger: Italian women often wear a multitude of rings, usually on the fourth and fifth finger, sometimes on every finger except the thumb.

- Gold and semiprecious stones: Italians have a way of working stones with gold that's pure artistry. Often a chain necklace or bracelet will be studded with either cabochard or faceted semiprecious stones in eye-catching colors.

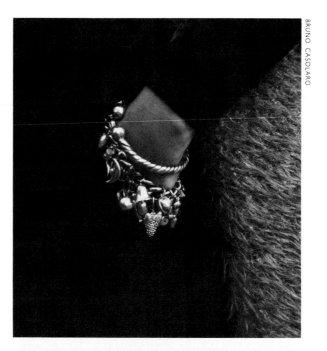

BRUNO CASOLARO

CHARM BRACELETS ARE GAINING IN POPULARITY, ESPECIALLY WHEN THEY'RE COMPOSED OF VINTAGE PIECES.

TIP: One way to get mileage out of a single real gold item is to pair it with a few gold look-alikes. Invest in small gold hoop earrings perhaps, then wear them with costume jewelry chains. These days, it's getting more and more difficult to recognize a fake.

PEARLS

A single or double strand of short pearls is another Italian signature, especially when worn in an offhand and casual way. You often see them inside the neckline of a simple white shirt, with jeans and a cardigan, for example. Because it's so difficult to tell real pearls from fakes, almost any pearls will do. If you're thinking of adding them to your accessory list, buy an inexpensive medium-sized strand or two, about 14″ in length, or a longer strand that you can double or triple.

You can also wear these strands as bracelets . . . just wind them around your wrist as many times as they'll go.

COSTUME JEWELRY

Although gold is a staple, costume jewelry is gaining a foothold, especially if it's a signed vintage piece, or anything Chanel. Giant pearls and pearl and gold earrings, and American brooches and earrings from the Forties and Fifties, which sometimes cost as much as gold, are favorite items.

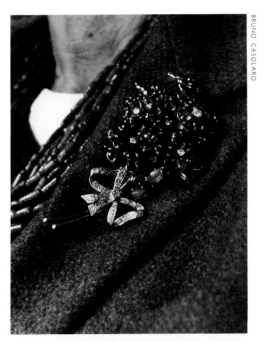

BRUNO CASOLARO

IT COULD BE COSTUME...BUT THEN AGAIN, IT COULD BE "REAL." NO MATTER, THE OVERSIZED BROOCH PINNED TO A LAPEL IS A FASHIONABLE STATEMENT.

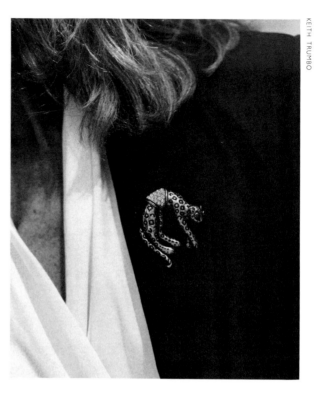

KEITH TRUMBO

ANOTHER STYLE OF VINTAGE
ORNAMENTAL BROOCH THAT'S
VERY COLLECTIBLE.

TIP: Here's where combing a thrift shop or flea market can really pay off. Keep your eyes open for an oversized brooch—in the shape of a flower or an animal—to pin on your lapel. These pins can sometimes be found for pennies.

AN EXPERT APPROACH TO COSTUME JEWELRY

"Earrings sell the best, then necklaces," explains designer Donatella Pellini, who has two stores in Milan that sell her own eye-catching creations, which are also exported to the United States, Japan, and England. "Costume jewelry has gained in popularity now because more designers are doing it and more magazines are featuring it," she points out, adding that Romans wear more fakes than other Italians.

Pellini is her own best advertisement, with a fashion style that can best be described as highly eclectic and original. "It's my character to invent and improvise," she says. "I like to take things and mix them." Her jewelry rule: When clothes are simple, wear lots of accessories; when clothes are more ornate, stick to only one fabulous piece.

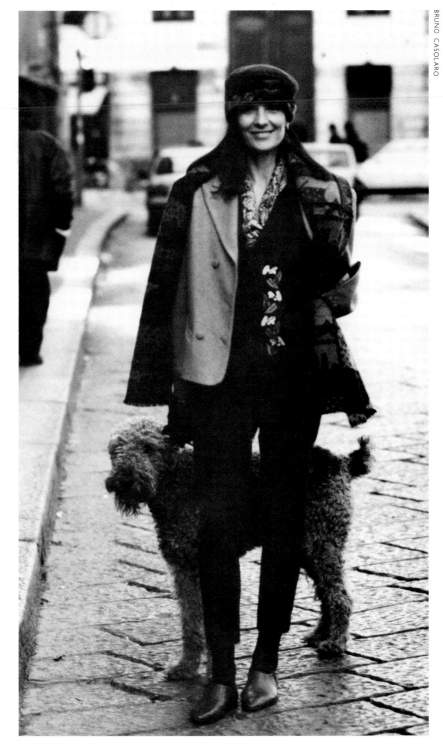

BRUNO CASOLARO

JEWELRY DESIGNER DONATELLA
PELLINI, CONSIDERED ONE OF THE
CHICEST WOMEN IN MILAN,
APPROACHES FASHION AS A
GAME. SHE'S CERTAINLY HER OWN
BEST ADVERTISEMENT.

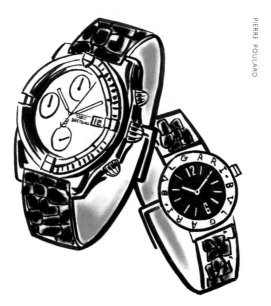

PIERRE POULARD

TWO "HOT" WATCHES: THE
BREITLING CHRONO, WHICH IS
REALLY A DRIVING WATCH, AND
THE BULGARI CLASSIC IN GOLD
ON AN ALLIGATOR BAND.

WATCHES

ITALIANS ARE CONSTANTLY on the watch for
watches. Current favorites include rare Swatches—in fact the
Italians drove up the auction prices of Swatches and they're
known to buy them by the armful when they're in America—
along with Rolexes, Breitlings, Bulgaris, and an array of antique
models, especially those from the Thirties, worn on fine leather,
crocodile, or alligator bands.

For a while, trendy young Italians, especially the men, were
wearing their watches over their shirtsleeves, like Italian mega-
industrialist Gianni Agnelli, but that trend seems to be lessening.
Most watches, whatever their breed, are worn in combination
with a gold bracelet or two . . . by men as well as women!

ELEGANT
ACCESSORIZING

THE SECRET TO ACCESSORIZING the Italian way
could just be to choose those accents that look like they *belong*
with the clothing . . . it's almost as if one can't imagine the outfit
accessorized any other way. Whatever you choose should look
high quality (even if you bought it for a quarter at a flea market).
And while all accessories should suit your style and personality

type, do as the truly chic and adventurous do—include one unexpected piece that stretches your fashion limit. For example: a giant, ornate brooch with a tailored suit, rather than a small, safe pin; gold-tipped Chanel-type flats with a sweater and well-cut classic trousers, rather than black loafers; ropes and ropes of short pearls with a sweater set, rather than one short strand of them.

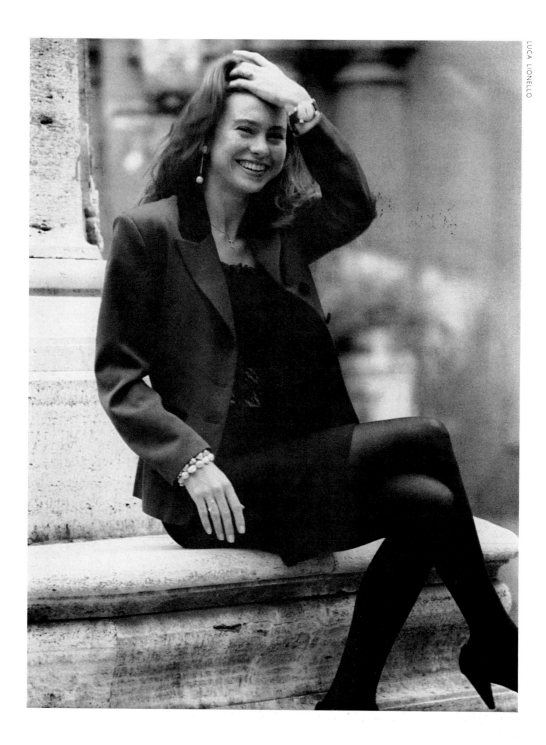

8

FIBERS, FABRICS, AND FINISHES

WHILE SUPERIOR DESIGN and quality are integral to the Italian fashion sensibility, feel-good fabrics and a subtle interplay of textures are fundamental to it. "The Italian woman shops with her hands," observes designer Saverio Palatella. "When she finds a garment she likes, she'll touch it first, then she'll turn it inside out to see how it's finished. If she's satisfied with the feel and the workmanship, only then will she try it on." Palatella, who specializes in creating knitwear—cashmere in particular—for a company called Gentry Portofino, explains that natural fibers are a national priority. "Italians view fabrics in the same way they do food," he maintains. "They're not used to things that aren't fresh or pure."

This taste for touchable textiles with luxurious finishes comes from an age-old tradition of elegance and originality. Italy has long produced some of the most beautiful fabrics in the world. Ancient revered examples are on view in churches and museums. Closer to home, heirloom pieces are handed down from generation to generation. Since the Renaissance especially, the manufacture of sumptuous brocades, silks, and velvets has been an important aspect of Italian artistry. In the past, Venice, Genoa, and Florence provided exquisite cloth to all the courts of Europe. During the seventeenth century, Italian weavers immigrated to France and Flanders and established what eventually became the great silk weaving centers of Paris, Rouen, and Lyons. Today, Prato in Tuscany is the small city where most of Italy's modern textile production takes place, while Como, outside of Milan, is the center of Italy's silk industry, and Biella in the Piedmont area is known for the manufacture of wool and cashmere, as well as for new innovations in other fields of textile technology.

THE ITALIAN FASHION MESSAGE IS IN THE FABRIC MIX: YOUNG ITALIAN ACTRESS YVONNE SCHIO WEARS A VELVET-COLLARED FLANNEL JACKET WITH A LACE CAMISOLE AND WOOL GABARDINE SKIRT.

THE QUEST FOR THE BEST

THIS EMPHASIS ON FINE and natural fibers, fabrics, and finishes is a basic tenet of Italian chic. Italians expect the best, and the country's leading yarn and fabric companies are constantly experimenting with new processes and techniques to further refine the already elevated quality of their products.

"Italy is a country where the consumer has been educated by both manufacturers and retailers," says Pierre Guerchi, who runs Loro Piano's American business. This yarn/textile company is renowned for its superb cashmeres and the development of a unique lightweight wool suiting fabric known as Tasmanian. According to Guerchi, "Fabric represents eight-five percent of the reason why a consumer buys a garment, but only fifteen percent of the cost."

"Sometimes in history, there's an equilibrium between fabric and form. Today, however, fabrics count most. They inspire the form for many designers," observes Vittorio Solbiati, a leading name in linen manufacturing, whose family has been in the business for more than 120 years. His company, Michele Solbiati Sasil Spa., is a recognized pioneer in the creation of new finishes and treatments. The results—novel and original genres of linen— have influenced the world's top designers, from Giorgio Armani in Milan to Ralph Lauren in New York. Different effects, which are achieved with elements as unexpected as sand, for example, prompt Solbiati to point out the rapport between the surface of a painting and that of fabric.

And certainly the collage effect that Italians strive for, which is recognizable in the way they mix textures—a shiny satin shirt paired with a crinkle silk skirt and a jacket of heavier nubby linen—could be described as fashion art, Italian style.

THE REAL THING

THE FABULOUS ITALIAN FABRIC and texture combinations are a result of being well informed about the ingredients that go into their fashion recipes, and well aware of differences in yarns and weaves. The education usually starts at home, where Italian mothers and grandmothers pass down centuries-old knowledge about textiles. It then continues at the dressmak-

er's or in favorite boutiques where the innovative and beautiful results of Italian fabric making at its most advanced are on view. Innovative technological developments have produced new fabric weights, blends, and finishes that add greatly to the versatility and popularity of all of the major fibers, both natural and man-made. Different types of fibers are blended in certain ratios to achieve the quality and form needed to best suit a particular garment.

Italian taste runs to the real thing: pure and natural fibers in silk, cotton, linen, and wool, including cashmere, mohair, and alpaca. Generally, synthetics are avoided, with the exceptions of viscose, which has a plant base, and microfiber, a newly developed fine-gauge polyester that feels like sueded silk.

The following fabric classifications can guide you toward current favorite fibers and fabrications, including their wear and care:

WOOL

ITALIAN MILLS manufacture truly exceptional wools of all possible descriptions, and Italian women excel at mixing different fabrics of varied weights, textures, and harmonies of this natural fiber to achieve original results.

Created from the fleece of living sheep, wool is believed to have been first worn in Babylonia (which literally means the land of wool) and Mesopotamia about 4000 B.C. While the structure of the fiber is basically the same despite the breed, about two hundred different strains of sheep from all over the world produce the many varied grades of wool.

Interestingly enough, although sheared wool is no longer alive and growing, it does retain the moisture-balancing characteristics of its living cells, which is why it's said to breathe. It also has enormous elasticity and resiliency. Because its fibers grow permanently crimped like springs, each has the ability to return instantly to its natural position after stretching.

Italian mills offer endless varieties and combinations of both pure wool and blended yarns, which are made into knit and woven fabrics. The Milanese, especially, often wear lightweight wools year-round. A typical summer outfit might be a sheer wool gabardine jacket, a handkerchief linen shirt, and silk pants, for example. They save their heaviest wools for the coldest months.

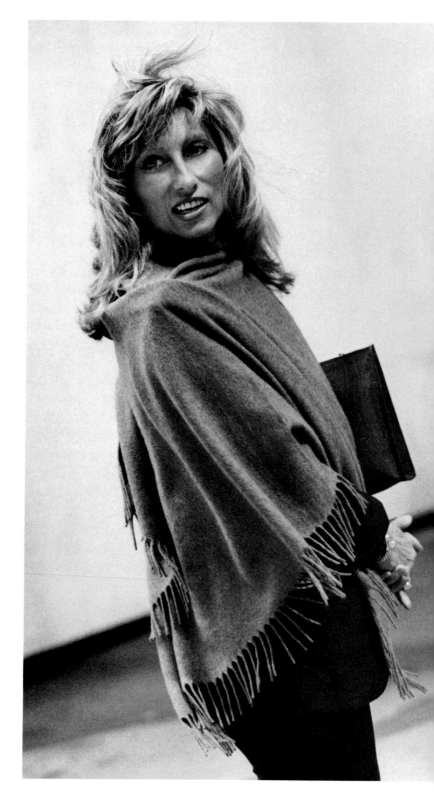

LUXURIOUS, FRINGED, AND FLUNG
OVER ALL—THE PURE CASHMERE
SHAWL IS A FASHION STAPLE.

**FAVORITE
WOOL
FABRICS**

- *Blanket cloth*—has a softly brushed finish, similar to a blanket.

- *Bouclé*—knitted or woven with bouclé yarns, which produce a looped or knotted appearance on the surface and add great textural variety. (Also exists in cotton.)

- *Broadcloth*—compactly woven, elegant cloth with a smooth finish, velvet feel, and high luster. Available in medium and chiffon weights. (Also exists in cotton and in silk.)

- *Cavalry Twill*—strong, rugged cloth made with a pronounced raised cord on a diagonal twill weave. (Also exists in cotton.)

- *Challis*—fine, lightweight, very soft fabric that is often printed.

- *Chenille*—has a pile finish that protrudes at right angles. (Also exists in cotton.)

- *Covert*—closely woven lightweight twill fabric characterized by a speckled effect.

- *Crepe*—has a crinkled or pebbly surface; woven in various weights. (Also exists in silk.)

- *Double-faced*—reversible fabric often used for unlined garments.

- *Double-knit*—firm, stable fabric similar on both sides.

- *Flannel*—finely woven fabric with a soft, brushed surface.

- *Gabardine*—strong twill weave that comes in various weights. (Also exists in cotton.)

- *Gauze*—lightweight, open-texture fabric produced in plain weave or simple line weaves. (Also exists in cotton and in silk.)

- *Jersey*—single-knit fabrics that are fluid and lightweight, without any distinct ribbing.

- *Lambswool*—very soft, luxurious wool used for sweaters, from the first shearing of a lamb up to seven months old.

- *Loden*—thick, full fabric woven of coarser wool grades with a natural water repellency.

- *Melton*—heavy fabric made from woolen yarns in which the fibers are tightly matted together.

- *Merino*—very fine, soft wool of superior quality from the Merino breed of sheep.

- *Ottomon*—heavy fabric with distinct rounded crosswise ribs in various widths. (Also exists in cotton and in silk.)

- *Poplin*—resembles broadcloth but has a heavier rib. (Also exists in cotton and in silk.)

- *Sharkskin*—hard-finished twill or basket-weave fabric with a semicrisp texture. (Also exists in silk.)

- *Shetland*—fluffy wool shorn from sheep raised on the Shetland Islands near Scotland. Used to make coarse warm fabrics and sweaters.

- *Tropical wool* (or cool wool)—lightweight woven fabric that feels smooth next to the skin and is comfortable in warm climates.

- *Tweed*—strong, pliant woolen fabric woven with flecks of color and a dimensional texture. Donegal and Harris are two tweed types.

- *Twill*—diagonal rib weave. Cavalry twill has pronounced rounded ribs. Whipcord has compact rounded ribs.

- *Velour*—has a soft feel and velvet appearance. (Also exists in cotton.)

SWEATER CARE

Italian sweaters wear for years because they receive proper care so they don't show their age. Here's how you can care for yours:

- Fold knits flat so their shape won't be distorted.

- Store wool with cedar flakes or mothballs.

- Rinse any stain immediately in cold water. Hot water sets stains.

- Dry-clean any sweater that is a complicated or loose weave, ornamented, or is not colorfast.

- Handwash any other sweater, including cashmere. Soak it for several minutes in a mix of mild detergent and tepid water. Swish gently and rinse clean using several changes of clear water. Do not wring or twist. Eliminate excess water by rolling in a terry towel and gently wringing the towel. Remove the sweater and dry flat on a sweater dryer or a clean, dry towel.

TREATING STAINS

Large stains are best dealt with by dry cleaners, but small spots can often be effectively treated at home. Try to attend to them as soon as they occur to prevent them from setting. The following treatments are recommended for pure wool wovens or knits, not blends. For all colored garments, you might want to first test for color fastness before attempting to remove the spot: apply the stain-removal agent to an inconspicuous part of the garment; place the treated area between two pieces of white cloth and press with a warm iron. If no color has been transferred to the cloth, you can proceed. Otherwise have the garment dry-cleaned.

In general, soaking in a mix of diluted detergent or dissolved soap for no more than two hours is a last resort effort for dealing with protein-content type stains—tea, coffee, milk, gravy, blood.

Solvents, like perchloroethylene, turpentine, and isopropyl alcohol—available at a hardware store—are effective for treating grease or oil-based stains. Be sure to rinse the garment thoroughly after treating.

Butter: Treat with a solvent, then rinse and wash in the normal way.

Chocolate: Sponge with mild soapy water.

Coffee and tea: Sponge with glycerine. If not available, use warm water.

Egg: Scrape off excess, then sponge with soapy water.

Grass: Saturate stain with isopropyl alcohol. Rinse and wash normally.

Grease: Sponge with a solvent, such as perchloroethylene.

Ink: Dab with isopropyl alcohol. Air or rinse thoroughly, then wash.

Iron rust: Sponge with a weak solution of oxalic acid until stain disappears. Then sponge carefully with household ammonia and rinse with water.

Lipstick: May often be erased by rubbing white bread over area with a firm, gentle motion.

Mud: Once dry, brush and sponge from back with soapy water.

Tar: Soften with margarine or butter, then wipe. Remove residue with solvent.

Wine, red: Cover with salt to absorb the wine, then rinse with cold water.

CASHMERE

IT COMES FROM the soft belly hair of a goat found in China, and it's one of the lushest, silkiest wool fibers imaginable. "Cashmere is addictive. Once you wear it, you don't want to wear anything else," says knitwear designer Laurie Westberg. And millions of Italians would agree with her. Cashmere is definitely the fiber of choice. Italians love cashmere sweaters, as well as sweaters of cashmere blended with silk. They also appreciate blazers and coats made of pure cashmere or cashmere and wool blends.

While cashmere should really be classified in the wool family, its preciousness and popularity set it apart. So does its exorbitant price tag. One reason for its expensiveness is its scarcity. Not only are the number of goats producing it limited, but it takes the hair from three of them to make just one sweater.

Since they are extremely lightweight despite their warmth,

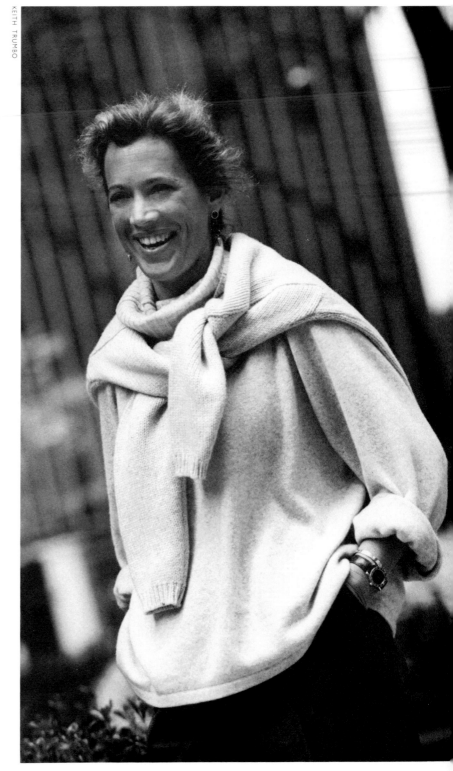

KEITH TRUMBO

A TYPICAL MILANESE LOOK,
MODELED BY KNITWEAR DESIGNER
LAURIE WESTBERG: A PLUSH AND
SLIGHTLY OVERSIZED CASHMERE
TURTLENECK WITH A CARDIGAN
CASUALLY TIED OVER HER
SHOULDERS. OTHER TYPICALLY
MILANESE TOUCHES: GOLD AND
SEMIPRECIOUS STONE EARRINGS, A
BULGARI WATCH AND GOLD
CARTIER "LOVE" BRACELET,
AND EASY, PLEATED
FLANNEL TROUSERS.

cashmere sweaters are year-round favorites. In winter, Italians might wear a double- or triple-ply (two or three yarns knitted together resulting in a heavier weight); in summer, they choose a single-ply sweater or a mix of cashmere and silk to throw over their shoulders in the evening.

Cashmere is best cared for in the same manner as fine woolens.

COTTON

A SOFT BLUE CHAMBRAY SHIRT paired with pressed chinos and a denim blazer is one of the casual looks Italians favor . . . and an attractive mix of different weights and textures of another popular fiber—cotton. The earliest origins of this versatile fiber have been fixed at about 3000 B.C. by archeological discoveries in India, although some researchers say it was much earlier in Egypt. At the same time, however, the ancient Inca culture of Peru in the undiscovered Americas was producing some of the richest colored cotton fabrics the world has ever seen.

Produced by the cotton plant, cotton fibers are first spun into yarn through a complicated process, then manufactured into various fabrics, which are either woven or knit.

Cotton fabric can be finished in more ways than any other. Some finishes change the look and feel of the cloth, while others add special characteristics like durable press, water-repellency, flame resistance, and shrinkage control, among others.

FAVORITE FASHION FABRICS

- *Broadcloth:* See wool broadcloth. Cotton broadcloth is used for shirts and blouses.

- *Chambray:* A plain-weave fabric made of one color vertical yarn and a white horizontal yarn

- *Chino:* Classic all-cotton twill fabric

- *Chintz:* A plain woven fabric with a glazed finish; often printed

- *Corduroy:* A ribbed-pile fabric, available in various weights and weaves

- *Denim:* A rugged, durable twill fabric

- *Double-knit:* See wool

- *Jersey:* See wool

- *Oxford:* A plain- or basket-woven fabric used primarily for shirting

- *Poplin:* Has a fine rib effect on the surface

- *Sateen:* Has a smooth lustrous surface

- *Seersucker:* A lightweight fabric with a woven crinkle

- *Twill:* See wool

- *Velour:* See wool

- *Velvet:* Short pile surface that looks rich and feels soft

- *Velveteen:* Similar to corduroy, with a short, full-cut pile finish

CARING FOR COTTON

Follow the manufacturer's care directions. Most pure cottons are machine washable. Cotton knits should usually be washed by hand to prevent excess shrinking or stretching. Wash them in the same way you would a cashmere sweater, but with hot water. Use the towel method to blot, then dry them flat.

SILK

ITALIANS LOVE the quiet luxury of silk, its characteristic pearly sheen and sensuous feel. A white or ivory silk shirt is basic and a black silk evening dress or suit is a must. "Silk is a feminine, sexy fabric," says Elizabeth Trettor, former vice president/CEO of Ratti USA, the American arm of the largest

silk producer and merchandiser in the Como area. "Italians are the masters of utilizing beauty, sensuality, and creativity; they're the world's best packagers," she continues. For although Italy ranks third in the world's silk production, its silk is considered first in quality.

Silk probably originated in China more than 4000 years ago. It was brought to Italy in the tenth century by the Byzantines. While the technology utilized in silk weaving has changed tremendously, the way the fiber is formed has remained the same since ancient times. It's a continuous protein filament spun by the silkworm (which incidentally is not a worm, despite its name, but a caterpillar) to form its cocoon.

Most cultivated silk, even that from Italy, originates in China, which produces more than half the world's cocoons. In fact, in the early days, the Chinese so treasured the fiber that it became a measure of currency and a reward, and they guarded the secret of its production for hundreds of years.

In the Middle Ages, Venetians traded heavily in silk, but also imported growers and weavers to help pioneer their own silk industry. By the thirteenth century, Italy had become the silk center of the West. Interestingly enough, the industry helped finance the Italian Renaissance. By the fourteenth century, Italian silks were made in other northern cities, and the craft was encouraged by noble families who themselves wore splendid silks.

Today, Como is the silk center of Italy, where the manufacture of this lustrous substance is elevated to an art.

FAVORITE SILK FABRICS

- *Broadcloth:* See wool

- *Brocade:* A heavier textured fabric, with a raised pattern design on its surface, usually composed of a combination of natural and manmade fibers

- *Chiffon:* A floaty, sheer, often transparent fabric

- *Damask:* Available in a variety of weights with slightly raised patterned areas on its surface

- *Faille:* Has a raised crosswise rib and is usually composed of a mix of natural and manmade fibers

- *Georgette:* Similar to chiffon

- *Gauze:* See wool

- *Organza:* Sheer lightweight fabric with a crisp feel

- *Ottoman:* See wool

- *Peau de soie:* Medium-heavy with a satiny smooth surface

- *Shantung:* Has a textured surface of irregularly twisted yarns

- *Sharkskin:* See wool

CARING FOR SILK

Italians follow the manufacturer's care labels and usually dry-clean silks, except their white shirts, which they hand wash in this manner: they soak the shirt for several minutes in a solution of mild soap and tepid water, then swish it gently through the soapy water. They rinse the shirt thoroughly using several changes of clear cool water, then blot out excess water by rolling it in a clean terry towel, which they press gently. They roll it in a second dry towel, store the towel-wrapped shirt in the refrigerator for an hour or more, then iron it with a warm iron.

LINEN

IT'S THE PREFERRED summer-weight fabric of discerning Italians, who love the texture of linen that has been softened by frequent washings. It's also reputedly the oldest textile in the world. The first evidence of its existence dates back to Neolithic lake dwellers who lived in Switzerland in the Later Stone Age, about 10,000 years ago. Through the ages, linen has been the historic fiber of purity and cleanliness. In ancient Egypt, priests wore only linen, and pharaohs and princesses were mummified in strips of it.

The Phoenicians introduced Egyptian linen along their trade routes to Greece and later Rome. As Rome became an empire, refined patricians wore white or scarlet linen tunics, while

women wore linen tunics of such a fine and transparent weave as to be scandalous. Linen then went into a decline after the fall of the empire, until the rule of Charlemagne, who developed the linen industry, realizing it would help restore the economy.

During medieval time, the Catholic Church chose linen as a cloth for liturgical use, and it also grew in favor and popularity with the aristocracy. It was used to create the wrap blouses of the Renaissance and neck pieces that became fashionable in the seventeenth century, as well as the lace, trims, and embroidery that adorned the gowns and were woven into the horsehair crinolines of the eighteenth century.

Made from flax, the fiber is contained in the stem of the plant. Through a complex process, it's transformed into yarn, which is then woven or knitted, on its own or mixed with other fibers, in a range of weights, textures, and finishes.

FAVORITE LINEN FABRICS AND BLENDS

- *Lacquered and coated linens*

- *Laminated linens* to create a sheer chiffon effect

- *Rubberized linens*

- *Linen denims* with a stone-washed look

- *Sheers,* especially in shirtings

- *Stretch linen mixed with Lycra*

- *Delicate linen knits*

- *Double-cloth linen*—actually two fabrics woven together

CARING FOR LINEN

Italians love the rumpled, lived-in look that linen takes on as it's worn. They often wash sheerer-weight shirts and tops in tepid water with mild soap, and then proceed in the same way as they do silk, ironing linen while damp with a hot iron.

Heavier, more structured garments are dry-cleaned.

TREATING STAINS ON LINEN AND COTTON

To prevent a stain from lasting, treat it immediately, following the chart below. Linen and cotton respond to the same solutions; if white, both can be bleached with chlorine bleach.

Ballpoint pen: Hold spot against a towel and spray closely from behind with aerosol hairspray; ink should transfer to towel.

Blood: Rinse with cool water.

Candle wax: Chill wax with ice and scrape off as much as possible. Iron out remainder between sheets of absorbent paper.

Coffee, tea: Rub glycerine into spot. Stretch fabric over a bowl and carefully pour boiling water through stained area.

Cosmetics: Rub a little cold cream or salad oil to dissolve stain; follow with a commercial prewash product.

Egg: Rinse with cool water.

Fruit juice: Rinse with cool water.

Grease spots: Rub in talcum powder to absorb the grease.

Milk: Rinse with cool water.

Red wine: Cover with salt to absorb the wine. If wine has dried, use club soda.

Tomato: Rinse with cool water.

Vinegar: Rinse with cool water.

White wine: Dab with club soda.

VISCOSE

GIORGIO ARMANI loves it, as do the Byblos boys and a wealth of other well-known designers who have brought this fabric back from obscurity. A version of it—rayon—was popular in the Fifties. While it shares many of the same properties as rayon, viscose is by definition a solution from which rayon is made. Because it comes from trees—wood pulp is treated with chemicals to extract cellulose, which is spun into thread—it is considered by some to be a "natural synthetic" fiber. Drapable and fluid, viscose bears a resemblance to silk, with an absorbancy similar to cotton. While it offers comfort, style, and year-round

wearability, it does have a major disadvantage, which at this date hasn't been corrected. It wrinkles almost on contact and stays wrinkled until ironed. Because it lacks what experts call "memory," it doesn't return to its original shape, so creases don't hang out the way they do with most of the natural fibers. Viscose can also spot, discolor, or shrink when exposed to water. Manufacturers recommend dry-cleaning instead of washing.

The first fabric produced synthetically, rayon dates back to the late 1800s. Today's more technologically advanced version is found in its pure state, or blended with other fibers, like linen and cotton. But while it's often used to fabricate inexpensive clothes, it's no longer a cheap fabric. Italian rayon is especially expensive because of high import duties.

If it's colorfast, pure viscose knit can be hand-washed. Test a bottom corner to make sure. You can wash it the same way you would silk, but using only cold water. Dry by shaping the garment flat on a towel. Press slightly with a tepid iron, if necessary.

MICROFIBER

ALTHOUGH IT'S SYNTHETIC, it has the look and feel of natural silk with a suede finish. Microfiber is the latest development—and one of the most sophisticated—in the evolution of manmade fibers, and it can be found in many Italian designer collections, often as outerwear and sometimes combined or blended with other fibers.

Microfiber is actually the generic name for a soft, silky, ultrathin version of polyester, a chemical base synthetic. It's manufactured by different companies in both Italy and America, under different names, with a range of surface finishes. DuPont's Micromattique, for example, is half the thickness of silk, three times finer than cotton and more than twice as fine as traditional polyester. Its appeal is not only in its luxuriousness, but also in its practicality. It resists wrinkling, keeps its shape, and can be machine-washed and -dried.

INTERESTING TEXTURAL MIXES

A COMBINATION OF FABRIC FINISHES, often in varying intensities of tones of the same color, is a characteristic of Italian style. And you can achieve similar tasteful results by experimenting with different weights and surfaces. The best mixes involve two or three finishes that don't resemble each other—a nubby surface combined with a sheer, then a shiny one, for example.

To help you get started, try the following mixes, gearing weights for the season:

- organza/gabardine/velvet

- tweed/flannel/silk chiffon

- linen/cashmere

- jersey/corduroy/lambswool

- leather/satin/velveteen

- ottoman/peau de soie

- denim/tissue linen/cotton knit

DECODING INTERNATIONAL CARE SYMBOLS

BECAUSE QUALITY can often be quite costly, Italians may sacrifice quantity when shopping. They then stretch the life of the few fabulous pieces they do buy by caring for them properly, such as washing silk blouses and cashmere sweaters in the manner described previously, the way their grandmothers probably did. When they don't know exactly how to clean a garment, however, they're usually guided by a tiny symbol or set of symbols on or near the label that indicates the best method, sometimes accompanied by written directions as well.

These international care symbols are especially helpful for anyone who doesn't speak the language in which the directions are written. The following chart should take the guesswork out of caring for your garments and make you as knowledgeable as an Italian. Since water temperatures in these symbols are given in European centigrade, it also provides the Fahrenheit equivalents.

WASHING

 Do not wash.

 Hand wash gently in lukewarm water.

 Machine wash in lukewarm water (up to 40°C, 100°F) at a gentle setting (reduced agitation).

 Machine wash in warm water at a gentle setting (reduced agitation).

 Machine wash in warm water (up to 50°C, 120°F) at a normal setting.

Machine wash in hot water (not exceeding 70°C, 160°F) at a normal setting.

MACHINE	HAND WASH
Very hot (85°C) to boil, maximum wash	Hand hot (48°C) or boil

Spin or wring

White cotton and linen articles without special finishes.
(85°C = 185°F) (48°C = 119°F)

MACHINE	HAND WASH
Warm (40°C) medium wash	Warm (40°C)

Spin or wring

Cotton, linen, and rayon articles where colors are fast to 40°C (104°F) but not at 60°C (140°F).

MACHINE	HAND WASH
Hot (60°C) maximum wash	Hand hot (48°C)

Spin or wring

Cotton, linen, and rayon articles without special finishes where colors are fast to 60°C.
(60°C = 140°F) (48°C = 119°F)

MACHINE	HAND WASH
Warm (40°C) minimum wash	Warm (40°C)

Cold rinse, short spin. Do not wring.

Acrylics; acetate, and triacetate including mixtures with wool; polyester/wool blends. (40°C = 104°F)

MACHINE	HAND WASH
Hot (60°C) medium wash	Hand hot (48°C)

Cold rinse, short spin or drip dry.

White nylon; white polyester/cotton mixtures.
(60°C = 140°F) (48°C = 119°F)

MACHINE	HAND WASH
Warm (40°C) minimum wash	Warm (40°C)

Spin. Do not wring.

Wool, including blankets and wool mixtures with cotton or rayon; silk. (40°C = 104°F)

MACHINE	HAND WASH
Hand hot (48°C) medium wash	Hand hot (48°C)

Cold rinse, short spin or drip dry.

Colored nylon; polyester; cotton and rayon articles with special finishes; acrylic/cotton mixtures; colored polyester/cotton mixtures.
(48°C = 119°F)

 HAND WASH ONLY
Warm (40°C)
Warm rinse. Hand hot final rinse. Drip dry.

Washable pleated garments containing acrylics, nylon, polyester, or triacetate; glass fiber fabrics (40°C = 104°F).

DRYING

 Dry on flat surface after extracting excess water.

 "Drip" dry—hang soaking wet.

 Hang to dry after removing excess water.

 Tumble dry at low temperature and remove article from machine as soon as it is dry. Avoid overdrying.

 Tumble dry at medium to high temperature and remove article from machine as soon as it is dry. Avoid overdrying.

BLEACHING

 Do not use chlorine bleach.

 Use chlorine bleach with care. Follow package directions.

IRONING

 Do not iron or press.

 Iron at a low temperature (up to 110°C, 230°F). For example, this is recommended for acrylic.

 Iron at a medium temperature (up to 150°C, 300°F). For example, this is recommended for nylon and polyester.

 Iron at a high temperature (up to 200°C, 390°F). For example, this is recommended for cotton and linen.

 Cool. 120°C, 248°F

 Warm. 160°C, 320°F

 Hot. 210°C, 410°F

DRY-CLEANING

 Do not dry-clean.

 Dry-clean.

 Dry-clean with any solvent.

Use any solvent except trichloroethylene.

Underline indicates "sensitive." Reduce cycle and/or heat.

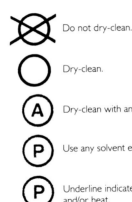

 Dry-clean, tumble at a low safe temperature.

 Use petroleum or fluorocarbon only.

 Underline indicates "sensitive." Reduce cycle and/or heat.

GIOVANNI COZZI

9

BEAUTY AND HEALTH

I TALIAN WOMEN are famous for a healthy beauty —glowing skin that's faintly bronzed year-round, yards of tangled, shiny hair, shapely bodies, an overall, almost animal sensuousness. To them, skin care is always more important than makeup, a naturally balanced eating plan takes precedence over dieting, and water is one of their most essential beauty staples.

Italians rely on this vital source of well-being, actually the body's most essential—but often overlooked—nutrient to keep them looking and feeling fit and fabulous. They usually drink at least a liter (approximately a quart) of mineral water throughout the day: a bottle of water is a fixture on every European desk in the office and dinner table at home. They also "take the waters" whenever they feel their systems need a recharge . . . usually every year.

WATER CURES

DOTTED THROUGHOUT the Italian countryside are hundreds of hot springs from which mineral-rich water bubbles up from volcanic craters deep within the earth. They've been an important part of the Italian beauty/health regimen for at least the last three thousand years. Celebrated for the rejuvenating and healing powers of their waters by first the ancient Etruscans, then the Romans (who, as you might remember from early history classes, were inordinately fond of baths), these thermal springs, or *termes* in Italian, are as popular now as they were in the past.

Many of them have been developed into internationally known, medically supervised beauty resorts—we'd call them spas in America—with stays covered by health insurance. Guests

go to relax, be indulged, and take the resident water cure, which can differ from spa to spa.

Two of the best-known watering holes—Terme di Montecatini and Terme di Saturnia—are located in Tuscany, a lush, verdant region in northern Italy with Florence at its heart. They're of particular interest not only because of the excellence of their treatments and the beauty of their settings, but also because their products—thus spa benefits—are available in America. In fact, all Saturnia formulations are created, packaged, and imported from Italy. They're sold in leading department and specialty stores as well as in a sister spa, the Doral Saturnia International Spa Resort, located in Miami, Florida.

SPA-GOING, ITALIAN STYLE

THE ITALIAN APPROACH to spa-going is based on pleasure rather than pain, indulgence rather than deprivation. A spa is a place where the food is excellent, the treatments top-notch, the attitude celebratory. Most of the program is built around the curative effects of the resident thermal waters. And taking the cure involves a program of thermal mud baths, mud or algae facials, calming soaks, invigorating whirlpools, saunas, underwater massage, Swiss showers, steam, and inhalations.

Although treatments may vary in the different spas, fangotherapy is one offered at both Saturnia and Montecatini. Fango is volcanic mud that's soaked in mineral-laden waters. It is used for revitalizing the skin, not only over the face but the body, too, where it's believed to have a therapeutic effect on the system.

Although you can certainly give yourself this mud bath, it's a blissful experience when performed by an expert. You lay naked on a sheet-covered table in a small private room. A therapist slathers handfuls of warmed mud over various parts of your body, depending upon where you hold stress or have a physical ailment. She then wraps you in warm towels to keep in the heat, but you scarcely notice the time passing because you're usually asleep after the first three minutes. Thirty minutes later, you're first immersed into a tub of warm mineral water to ease off the partially dried mud, then sponged off. After, it's into a Swiss shower, where pressurized jets of hot mineral water remove the last traces of mud. You're again wrapped in clean terry towels, then cocooned in sheets to rest for several minutes.

Inhalation therapy is another specialty at these two spas.

Thermal waters in steam form are inhaled to cleanse nasal passages and restore and rev up respiratory functions.

Generally, the beauty spa program isn't rigid, because you yourself can set the pace. It all depends at what time you've scheduled your appointments.

But while fitness is not a priority in the Italian spa, food is. Italians might take an occasional long stroll around the grounds, swim a lap or two as they soak in the thermal pool, or even follow a low-key exercise class, but it's done in a desultory manner. Nonstop aerobics classes and nutrition lectures coupled with tiny amounts of low-calorie foods are definitely not the Italian way. While they might pay attention to diet—or better, have it watched for them by the experts—Italians wouldn't dream of forgoing wine at dinner or pasta at lunch. The goal is to revitalize the system and refresh the senses. And the way to

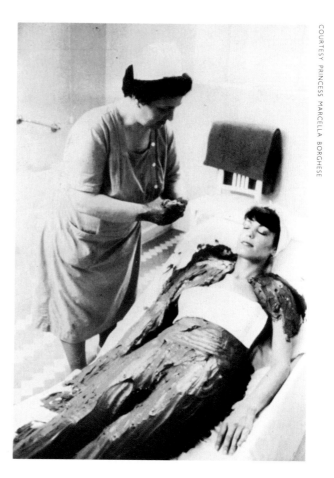

COURTESY PRINCESS MARCELLA BORGHESE

MUD RESTING COULD BE THE NAME OF THE GAME IN MONTECATINI, WHERE YOU RELAX IN A BATH OF HOT "FANGO."

do this, Italian-style, is to eat well, enjoy a few mud baths and massages, and have a generally good time. Moderation and self-indulgence are key. The benefits are more emotional than physical, but one very positive outcome is a renewed feeling of self-worth. Italians tend to like their bodies just the way they are . . . perfection might be a size six, but it's also a size fourteen. The goal is to feel good about yourself at every size . . . and every age.

Spa-going in Italy is both social and fashionable. Although dress is often casual during the day, it does depend on where you go. For example, at the height of the season Montecatini can get quite dressy, because there are clubs, theaters, and race tracks, while Saturnia, because it's a self-contained resort, tends to stay low-key.

TERME DI MONTECATINI

TWENTY-EIGHT MILES from Florence, nestled in the heart of Tuscany's most treasured historical places like Lucca, Pisa, and Siena, is Montecatini, a small but surprisingly cosmopolitan spa town. Its celebrated waters have supposedly worked their magic since 400 B.C.

Some of the most famous Roman names in the pre-Christian era undoubtedly indulged in the cure, but the names we might be more familiar with who have benefited from these waters include the Duke and Duchess of Windsor, Prince Rainier and the late Princess Grace, Clark Gable, Katharine Hepburn, Audrey Hepburn, Somerset Maugham, Picasso, Puccini, and Toscanini.

The town contains hotels at all price levels to house spa-goers, from the ultraluxurious Hotel e la Pace to a simple *pensione*. It has swank restaurants and simple pizzerias, cinemas, both indoor and outdoor theaters, nightclubs, and pink-walled buildings with elegant shops up and down the tree-lined streets.

THE MONTECATINI CURE

The Montecatini water cure involves drinking one or more of five types of mineral water. All have the same saline-sulphate-alkaline base but different chemical makeups, to relieve the most common of digestive disorders. This program usually lasts about two weeks, and may be repeated at intervals throughout the year.

Upon arrival, each guest meets with a member of the spa's medical staff for an evaluation. Along with drinking the waters, the treatments prescribed usually include fangotherapy; hydro-

therapy, or soaks in warm thermal baths and whirlpools; physio-kinesitherapy, or physical therapy in a giant thermal pool; talc massages; inhalation therapy; facials; and supervised exercise classes, for those who are so inclined.

The "spa" itself actually consists of nine separate pavilions that differ in function as well as in grandeur and elegance. Five are dedicated to the drinking-water cures, although one of them provides the full gamut of treatments. The remaining three administer only the various external treatments. Five facilities are open seasonally, and of the four open year-round, two are reserved for physician referrals through Italy's national health care program. A new facility to be contained in one of the existing establishments is being planned, to house a luxurious beauty-treatment spa.

The most majestic pavilion is called Tettuccio, a colonnaded travertine structure with an arcaded courtyard built in the style of ancient imperial Rome. Early in the morning—because all but one of the waters have to be taken on an empty stomach—people filter in to place their cups under gilded faucets along marble counters, where they find a selection of waters: Tettuccio water, for example, exerts a stimulating effect on the system, especially the liver; Regina water regulates the intestines; Tamerici and Torretta waters calm the intestines; and Rinfresco water, the only water taken in the afternoon, acts on the kidneys. They then relax for half an hour, then have coffee in the courtyard. Late in the morning, a small group plays chamber music, then later in the day dancing music is played for the entertainment of spa-goers.

Fango and thermal bath treatments utilizing local mud and waters are given at the Leopoldina spa, with its eighteenth-century façade still resplendent. Here, too, you can have a unique deep-tissue massage. The masseur or masseuse first rubs your body with talc so that his/her grip doesn't slip, then concentrates on manipulating the tissues and muscles along the length of your body, with special attention paid to problem areas.

ABOUT THE WATERS

Montecatini waters come from stratum about sixty to eighty meters below the earth's surface. At this level, water gradually picks up minerals and biological elements that have been in the earth's crust for millions of years. It also picks up traces of limestone, diaspore, sandstone, and clay as it climbs through

these deposits, but is naturally purified and filtered as it moves. Each spring gushes forth at a constant temperature, which is usually around body temperature. While the waters in these numerous springs share the same saline-sulphate-alkaline base, they act in different ways because of their different chemical makeups. Therefore, they are medically prescribed in specific combinations to address various ailments.

MONTECATINI IN AMERICA

As the watering hole of the wealthy, the titled, and the celebrated, as well as lesser mortals, it's no wonder that Montecatini was the inspiration for Princess Marcella Borghese's body and treatment line, launched in 1983 as a division of Revlon. "Montecatini was part of the cures and rituals of my family. My grandfather used to take the medicinal waters every September. He'd rest, take the cure, and return in wonderful shape," she explains.

The entire collection was based upon the healing and rejuvenating properties of Montecatini's natural therapies. It is available not only at the Borghese boutique in the Tettuccio Spa, as well as other locations in Italy, but throughout America as well. One of the most sought-after products for home use is fango, which is the ultimate mud bath.

The princess, whose royal lineage dates back to the thirteenth century, always adored cosmetics—creams, makeups, perfumes—and began experimenting with them at an early age. "Upper-class families had secret creams and potions made up especially for them. Both my mother and grandmother had beautiful skin, and they made me start young to care for mine. Our philosophy was that creams should be simple and pure," she emphasizes. She began her career in Italy in 1956 with a line of coordinated lip and nail colors to complement Emilio Pucci fashions. Two years later, cosmetics tycoon Charles Revson backed her, distributing the Princess Marcella Borghese collection all over America.

TERME DI SATURNIA

AMID BREATHTAKING VIEWS of jagged hills and rolling green countryside, in a spectacularly beautiful, almost rural, and isolated part of Tuscany midway between Rome and Florence, is the Terme di Saturnia. A luxurious resort with a four-star hotel and complete spa facilities was rebuilt here in

1980 around a thermal spring, which has been bubbling at a rate of one cubic meter per second for over three thousand years. The water emerges at body temperature and flows directly into a vast outdoor pool as well as outlying cascades.

Since it was the center of the ancient Etruscan civilization, the region around the spa, known as the Maremma, is particularly rich in cultural lore and archeological sights. But many guests view their stay at Saturnia as a complete retreat and simply relax in and around the pool when they are not enjoying a meal or being otherwise pampered.

THE SATURNIA STAY

The Saturnia water cures are strictly external, although inhalation therapy is offered. Renowned for their rejuvenating properties, Saturnia's waters are rich in biogenic and vitamin nutrients in the form of plankton, a natural substance with therapeutic properties. Plankton is believed to nourish and balance the skin. It's the key ingredient, in fact, in all of the Terme di Saturnia products, which were developed at the spa's Institute of Aesthetic Medicine and are sold in both Italy and America. The institute, recognized by the Italian medical community, is dedicated to the holistic study and treatment of human appearance. It continually monitors the study of thermal energy and researches the control and retardation of skin aging and cell infirmities in the belief that beauty is an expression of health. A team of doctors and physiotherapy experts collaborate to help each guest determine the best program for him or her.

The average spa stay is a week and guests can choose among a variety of health and beauty programs—Health Balance and Psycho-Physical Efficiency, Anti-stress, Body Firmness, Anti-cellulite, Diet, Aesthetic Treatments—based on the cures developed by the institute. Upon arrival, you meet with members of the medical team at the institute to prepare an individualized program, after you have been thoroughly medically examined and diagnosed. You can also receive a variety of skin tests to plan individual skin care programs through the institute, if you desire.

A favorite Saturnia treatment is the body gommage with thermal plankton, which is a body polisher that is often paired with a facial and is rather unique. So is the preparation: you lie naked in an apparatus called Hydrostar that resembles either a time capsule or a streamlined iron lung—depending upon how you look at it—with your head exposed. Jets of hot thermal

water alternated with cold bounce off the front of your body for ten minutes. You then turn over and the same procedure is repeated on the back of your body to hydrate and soften the skin. After drying off, you are ready for a complete body peel (gommage). You lie on a sheet-covered table, where an algae mask, called plankton, is spread over your entire body. You're then wrapped up in a sheet and blanket, and while you relax, you receive a facial, which also includes a plankton mask. After an hour, both masks are sponged off, leaving skin softer, moister, clearer, and brighter.

For those who want to reap the benefits of the Saturnia therapies without traveling, the product line includes a Thermal-Plankton Rejuvenation Mask and Purifying Thermal Facial Mud and is available at department stores around the country.

WATER FOR BEAUTY

WHILE TAKING THE WATERS can do wonders for the skin and overall well-being, the Italian custom of drinking quantities of bottled water provides ongoing beauty/health benefits. Although Italians believe that water keeps the system running smoothly, they drink it more out of habit than as a conscious choice. But, according to health experts all over the world, drinking six to eight glasses of water a day is a wonderful habit to cultivate.

Water is an essential nutrient and a primary property of our system. Every chemical reaction within the body occurs in water. Each human cell is bathed in water. Water helps remove waste from the body. It's essential for digestion and absorption of nutrients. It keeps joints and internal organs lubricated and prevents skin from drying out. We can live longer without food (up to five weeks) than we can without water (less than five days).

In its everyday functioning, the body constantly loses water: through perspiration, waste elimination, even breathing. When you breath out, you lose water through the lungs in the form of water vapor. In fact, the average adult loses two and a half to three quarts a day. This amount increases in hot weather and/or with intense physical activity.

The body consistently demands water to function properly, both physiologically and psychologically. "There's a health rationale for drinking water. But also, dehydration can impair think-

ing," explains Dr. James Rippe, a cardiologist and director of the exercise physiology and nutrition laboratory at the University of Massachusetts Medical Center who is director of research for the Evian Hydration Center. "There's an artificial distinction between fitness and beauty. Attractiveness is complex and made up of lots of components, including energy and vitality, but also self-perception," he maintains, pointing out that fitness issues are very important for healthy skin. Well-hydrated skin looks better, in addition to functioning better. "Most cosmetics are viewed as coverups," he maintains. "Think of water as a natural beauty aid."

Since their tap water doesn't taste very good—it tends to be hard and calcareous—Italians rely on bottled mineral water to sip throughout the day and with meals, even if wine is served. Their afternoon espresso or cappuccino is usually ordered with a side of bottled water as well. By way of explanation, mineral water is the name for natural spring water in Europe. This water comes from a free-flowing source—rather than being pumped or forced from the ground—and is bottled directly at the source. Naturally effervescent water emerges from the ground with enough carbon dioxide to make it bubbly. Italians label their water "gassata," with bubbles, or flat, "non gassata" or "senza gas." Effervescent mineral water usually accompanies meals, while "non gassata" is the water of choice for sipping throughout the day.

In addition to drinking water, there are many foods with a high water content, like fruits, vegetables, and cheese . . . all staples of the Italian diet. If you want to up your fluid intake, start thinking and eating Italian!

FIVE WAYS TO GLOWING SKIN

As a beauty tool, water is almost unparalleled. A well-hydrated internal system results in a smoother, moister complexion: skin is plumped up from the subcutaneous tissues out to the surface so it looks brighter, firmer, healthier. Of course, an adequately hydrated system runs more efficiently overall, so that you look and feel fitter. By facilitating proper circulation, water provides skin cells with those nutrients necessary for health.

Although thirst indicates the body's need for fluids, its signal is often inadequate or ignored. The secret is to make drinking adequate quantities of water a habit—like the Italians —and these five ways are a positive start:

1. Keep a liter bottle of water on your desk and sip it throughout the day.
2. Before exercising, drink at least one glass of water . . . after exercising, drink at least one more glass.
3. Drink a glass of water every time you drink a cup of coffee or tea or a glass of wine.
4. Keep a carafe of water near your bed. Drink a glass the moment you wake up in the morning and the moment before you go to bed.
5. Drink a glass of water before each meal.

A BEAUTY OVERVIEW

APPEARANCE IS A TOTAL PACKAGE to the Italian woman. Her grooming receives as much attention as her dress. And as they do with fashion, Italian designers influence beauty at all levels. The Italian woman often identifies with a certain designer's style . . . she dresses according to it, and does her hair and makeup that way, too. Or rather, she has herself coiffed that way. Italian women tend to let experts take care of their beauty needs at all levels:

HAIR: Her hairdresser is practically part of the family and she sees him (or her) sometimes more than she sees her mother-in-law . . . usually twice a week for a shampoo and blow-dry. Every two to three weeks, she has a treatment, and every month, a shaping and, if she needs it, color. Hairstyles are very regional in Italy: in the North, hair is shorter, more fashion-forward, and coiffed. As you move farther south, hair gets longer, wilder, and more extravagant. The color of choice is consistently sun-streaked blond.

MAKEUP: The goal is a natural, healthy, barely bronzed look, especially in the North. Both Milanese and Florentines are generally under-made-up, certainly during the day. At night, they emphasize their eyes much more. Romans tend to be more made-up and colorful at all times.

SKIN CARE: Healthy, smooth skin is very important to the Italian woman. In fact, the first cosmetic purchase of Italian teenagers is usually a skin care formulation like a cleanser or moisturizer. Contrast that with the American teenager, whose

first product is a color cosmetic, often a lipstick. The Italian regime consists of a professional facial every few weeks, often with natural herbal products. Care at home is simple and straight-forward: cleansing, toning, and moisturizing, morning and evening.

STARTING AT THE TOP

"ITALIAN WOMEN want hair that looks spontaneous, not styled, no matter how much thought or work goes into it," observes top stylist Sergio Valente. His salon inside the Bulgari building on Rome's most fashionable street, the Via Condotti, has been the beauty haven of those in the know since he opened it in 1971. A vast space divided into several salonlike rooms, it's as welcoming as an Italian home. Valente, when he's not cutting and styling hair, acts as a genial and interested host, chatting to one client about her daughter, to another about her garden, urging the third to have a cappuccino. And indeed, the cappuccinos are among the best in Rome. Frothed up in a tiny kitchen near the shampoo room, they're offered along with an assortment of brioches, sandwiches, and salads, further reinforcing the feeling of being in someone's palazzo.

GIOVANNI COZZI

ITALIAN WOMEN CHOOSE THEIR BEAUTY STYLE IN MUCH THE SAME WAY THEY DO FASHION. AND EVEN IF THEY OPT FOR THE MOST NATURAL LOOK, THEY USUALLY PLAY UP THEIR EYES.

Valente, whose creations are often featured in Italian fashion magazines, also designs the hairstyles for a number of fashion collections, including Fendi, Valentino, and Biagiotti. So the styles he proposes to his salon clients always reflect the fashions of the times. However, they're never too avant-garde. Looking beautiful is the goal. "Even to the young Roman, it's not so important to be *very* fashionable. She just wants a lot of hair and she wants it to be healthy and fantastic," he points out, adding that this outlook differs from Milan's. "In Milan, the young are very avant-garde and the rest are conservative." Florence, however, he describes as a conservative town—thus conservative hairstyles that are quite natural.

Stefano Gatti, a superstar on the team of renowned Milanese stylist Aldo Coppola, agrees with Valente's assessment. He creates the coiffures for Ferre, Moschino, Versace, and Armani. "Italian women want to look young, so hair is very important," he states. "Traditionally, they've liked blond-streaked hair, worn rather long. Men here like that, too." For the Milanese woman especially, elegance and good taste are the most important concepts. She likes to always be in step with fashion, but doesn't want to go too far.

THE ITALIAN WAY TO WONDERFUL HAIR

- Always begin with a professional haircut.

- Talk to your stylist about your needs and lifestyle, the looks you love, and the amount of time and effort you're willing to take to maintain your hair. Unless you have the time and money to have your hair professionally shampooed and styled once or twice a week, you'll need a look you can manage yourself.

- Select those products formulated for your hair type.

- Condition your hair intensively at least once a month, at the change of seasons, and after exposure to sun, salt water, chlorine. If hair is badly damaged due to chemical processing, deep-condition more often.

- For the most professional-looking coloring results, consult an expert. Streaked hair is difficult to do yourself at home.

- Shampoo your hair only as often as needed. If you like to wash it daily, select a very mild shampoo or dilute your regular brand, and lather only once, rinsing thoroughly. Follow with a conditioner. Overcleansing your hair can dry it out.

- Play with hair accessories. Hair bands are an Italian favorite. Sergio Valente has an entire collection of hair bands made of hair: braids, knots, twists. They look best matched to your own hair color. Other ideas: a ponytail at the nape adorned with a Chanel bow, or scarf-tied with ends trailing; hair held back at one or both sides with combs or barrettes.

COURTESY SERGIO VALENTE

A SERGIO VALENTE SPECIALTY
AND A FAVORITE ROMAN
ACCESSORY—THE
"HAIR" HEADBAND.

A TOUCH OF MAKEUP

THINK SOPHIA LOREN. When the Italian woman wears makeup, it's always to emphasize her eyes, while the mouth is underplayed. "Italians think a mouth that's too pronounced is vulgar," observed Stefano Gatti, who developed the following makeup plan adapting Italian style for American life.

In general, whether they're Northern or Southern, Italians tend to be more dramatic at night. But whatever the hour, they love to look tan—whether real or fake—so they begin with a bronzed base.

DAY:

BASE: Spread a lightly bronzed liquid foundation over the face and throat.

BLUSH: Brush or smooth on very little in a shade slightly rosier or peachier than skin tone.

EYE PENCIL: Rim upper and lower lashlines in black pencil.

EYESHADOW*: Stroke a light layer of gray, brown, or taupe on the eyelid only.

MASCARA: Apply black to upper lashes only.

LIPSTICK*: Select a shade slightly deeper than skin tone in the beige or rose family; may be lightly glossed but never shiny.

EVENING: The effect—all eyes. The basic makeup stays about the same; the mouth might be slightly intensified and the eyes are dramatized with more and darker shadow, black pencil around the entire eye, blended out from the lash line, and a more generous application of mascara.

FAKING A TAN

IN SUMMER, they let the sun bronze them naturally. They slather themselves with tanning cream and head for the sea, where they sunbathe at chic resort spots like Portofino, Capri, and Positano. They then intensify the appearance of their tan by wearing pale lipstick and bronzing powder over their cheeks.

At all other times of the year, Italian women prepare their skin in the following way to create the illusion of a tan:

* Not indispensable

- After cleansing and toning skin, they smooth on a light film of moisturizer, followed by a sheer coating of bronzing gel over the face and beneath the chin.

- Edges are blended carefully so that there are no lines of demarcation, especially around the jawline.

- Nose, chin, and forehead are blotted lightly with tan powder to minimize shine.

- Bronzing powder/blush is brushed lightly over the cheekbones and temples and anywhere else the sun would naturally hit the face.

BEAUTY IN BRIEF

THE BASIS OF the Italian beauty approach is cared-for skin, which involves a woman's total being: eating fresh, relatively low-fat foods, drinking more than adequate amounts of water, following a skin care regimen that involves at-home cleansing and moisturizing as well as professional facials and masks, visiting a spa for total revitalization. You can probably incorporate some of these steps into your daily routine. Also follow the Italian lead with hair and makeup. Put the former in the hands of a good professional for your cut and color . . . and for the latter, keep it to a healthy minimum, emphasizing your best feature only.

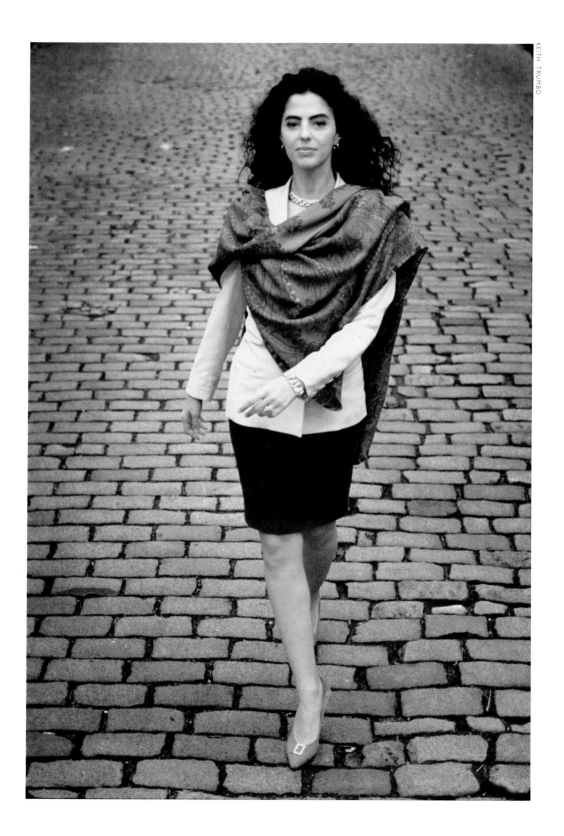

10

TRANSLATING ITALIAN CHIC INTO AFFORDABLE AMERICAN STYLE

IF OWNING a tailored Armani suit, a cashmere and silk shawl, a cashmere pullover, Ferragamo shoes, a Prada handbag, and Bulgari jewelry appeals to your senses but annihilates your lifetime fashion budget, don't despair. There is a way to be best-dressed Italian-style without spending a fortune. You could adopt the prevailing fashion philosophy in Italy and buy only one fantastic outfit but wear it almost every day. However, that may not be an option if you work in an office.

Or you could use American savvy and translate the basics in the Italian approach into affordable style. It may take as much thought and planning as it does serendipity and spontaneity, but you'll find that "the end justifies the means," as that famous Italian Machievelli said several centuries ago. To do so involves seeking out quality and fine workmanship, sometimes in places you might not have before considered, like your grandmother's attic, a thrift shop, even the boy's department of a specialty store. Be open and experimental, ready to try the unexpected—like wearing a shawl as if you were born in one, then making it a signature.

Moreover, it involves education. Since many of us don't have the cultural background and historical perspective of native Italians, visiting museums and glancing through art books can teach us many things. In a fashion sense, such observation acquaints your eye with the classic and classiest color harmonies, proportions, even fashions throughout history, to help you look your chicest right now.

THE KEY PIECES TRANSLATE WELL IN ANY LANGUAGE...AND DON'T HAVE TO COST A FORTUNE.

TWENTY-ONE WAYS TO GET THE LOOK FOR LESS

1. SHOP THE DESIGNER'S SECONDARY AND LESS EXPENSIVE LINES

Buying Italian designer fashions is the fastest way to achieve the look, but it can be the most expensive. Today, there is a way to save if you select from a designer's secondary or "diffusion" collections. While Krizia Poi, for example, might be less elaborate and luxurious than Krizia, the clothes clearly reflect the style for which the designer is famous. The same is true of Emporio Armani and his even less expensive line, A/X, ditto for Moschino's Cheap & Chic, and the list goes on. In addition to offering the designer's attitude, you also buy fairly high quality and workmanship.

2. MIX RICH AND POOR

The well-dressed do it, Italian fashion publications, even the designers themselves, advocate it—mixing the costly with the cheap to achieve real style: a fabulous jacket with jeans; silk pants with a men's shirt; a cashmere shawl with a flea-market find. The pieces depend upon your personal style and attitude. The feeling, too, is that one expensive, high-quality item, especially if it's among the first things that one sees, like a jacket, shawl, or shirt, raises the worth of the entire ensemble.

Incidentally, no one says that this "expensive" piece has to cost the price, either. Try buying it on sale or borrowing it from your grandmother. The important thing is that it look and feel elegant and extravagant, not where you got it.

3. SEEK OUT SALES; SHOP FACTORY OUTLETS

With stores having seemingly perpetual sales, paying full price for any garment seems unnecessary. The secret is knowing how to shop sales wisely. "Don't buy it if you don't need it, no matter how much the markdown," should be the first rule. "Ask yourself whether you would buy it if it were full price," says Elysa Lazar, president of Lazar Media Group, who advises establishing a yearly clothing budget, then shopping in both a practical and pragmatic

way. "You should look at labels to see what the garment is made of," she advises, expressing the Italian attitude that it's more important to shop for value than bargains.

Sometimes what seems like a sale really isn't, cautions Lazar. "Some retailers mark up their prices so that they can mark them down," she says, explaining that a one-day, 20-percent-off sale indicates to her that the retailer never intended to sell the merchandise at full price. "A valid sale is anything that's thirty percent or more off the original price," she observes.

Lazar feels that shopping manufacturer's showrooms and factory outlets provides much more value and savings. Her company produces a number of publications to point you in the right direction. The *S&B Report* is a monthly guide to New York designer showroom sales; *Shop by Mail,* a guide to mail-order companies that gives information about wholesale or discounted services, is published twice a year; *Outlet Report,* published once a year, is a directory of major outlet centers throughout the country. You can call (212) 679-5400 for more information.

One advantage to shopping in factory outlet stores is that there's probably one or more near you. Another is that the savings are truly substantial. "On the average, they're about thirty-three percent," says Randy Marks, president of Outlet Marketing Group, whose outlet hotline—(800) 33-OUTLET— informs any caller where the nearest factory store is located. This resource is particularly valuable since many of the over 6,500 outlets on his list aren't under the name found on the label. Most of the major American designers have outlet stores, including Calvin Klein, whose designs in recent years uncannily resemble Armani's; Donna Karan; Ralph Lauren; and right on down the list. At some outlets, you can find Italian merchandise as well. But while stores differ, Marks advises that generally at least 75 percent of the merchandise is current season, first quality. "However, last year's merchandise is often this year's best buy," he points out.

4.
SCOUR THRIFT AND
RESALE SHOPS

Thrift and resale shops are the best-kept secret of stylish women all over America. Depending upon the neighborhood in which the shop is located, as well as the charity with which it's affiliated, it can be a veritable treasure trove of otherwise pricey items. The trick is to visit these shops on a continuing basis, since the merchandise is often renewed weekly.

Someone else's cast-off—a once-worn evening sheath, two-year-old Armani pants suit, or beaded cashmere evening sweater from the Forties—could become a cornerstone in your wardrobe or at least an accent to take your look out of the ordinary. Some items to be on the lookout for include leather handbags and very expensive gloves; sweaters in cashmere, lambswool, merino knit; silk blouses and beautiful lingerie; a wealth of costume jewelry.

5. FORAGE THROUGH FLEA MARKETS

Flea markets are an Italian, as well as an American, bargain sales outlet. Every Saturday, there's a giant one in the old section of Milan, where you can find both new and antique items and fantastic values. In Florence, too, there's the blocks-long leather market. However, wherever in the world the market happens to be, the manner of negotiating price seems to be the same. Often the price isn't marked, but even when it is, there seems to always be maneuverability. After you learn what it is, you may want to ask, "Is this your best price?" There'll usually be a reduction. If, however, you still think it's too costly, it sometimes works to state what you'd like to pay and offer cash.

Flea markets are good places to find vintage cashmere or tweed overcoats or jackets, shawls, scarves and pocket squares, collars and cuffs, and all manner of jewelry, ribbons, belts (often alligator or lizard), alligator pumps, and beautiful day and evening bags.

6. INVESTIGATE THE BOYS' DEPARTMENT

If you're slim and don't like to wear your sweaters and shirts oversized, you can find terrific bargains in the boys' area—sometimes the men's area, too—of a top department store. Classic cotton dress shirts and T-shirts, luscious Shetland and lambswool sweaters (and occasionally cashmere), and ties to wear around the neck or waist are probably the most-wanted items. These are usually much less expensive than similarly styled women's garments, and if they're on sale, cheaper still.

7. LEARN TO SEW

It takes years to learn to be a top-notch tailor. Chances are you don't have the time or inclination, but performing simple alterations—hemming, replacing a button—isn't too difficult. And you can save substantially by doing it yourself. For the more nimble-fingered, stitching up a straight skirt is also rather easy and inexpensive. And one yard of fantastic Italian fabric will probably cost less than even the cheapest ready-made skirt.

If sewing—no matter how uncomplicated—is not your forte, try knitting. A beautiful hand-knit sweater—an item that can instantly upgrade a look—can cost hundreds of dollars to buy, but not very much to make yourself.

**8.
ORDER
FROM CATALOGS**

Catalog shopping is sweeping this nation . . . and for good reason. It's convenient and the costs can be significantly lower than retail, particularly when the catalog house has its own label, like J. Crew and Tweeds. Several companies are adept at copying Italian designer clothes, especially jackets and narrow trousers in washed silk, cashmere and wool, linen, and cotton. Shoes, too, like ballet flats and suede boots, are well priced. Basics are also best bets—pantyhose, T-shirts, sweaters, slim pants, Lycra and cotton separates, and oversized shawls.

**9.
PRACTICE
WEARING A SHAWL**

It can instantly change whatever you have on and expand your styling options without breaking the bank. The shawl is an extraordinarily versatile accessory that Italians deem a necessity. "Being able to carry a shawl is an acquired skill that comes about by wearing one every day," observes Peter Dubow, formerly a consultant to Etro, the fabric company whose shawls are Milanese staples. "There's a naturalness about the way the Italian woman wears one . . . it's never studied."

While *she* might have been wearing one since birth, *you* might need a little practice. But making a shawl a habit can save you money with style. Drape one around your neck to change the neckline of a little black dress or classic sweater; drape one over your shoulders and it can completely change the look of the jacket under it. Since a shawl is certainly less expensive than a jacket or coat, you'll be able to buy a few different ones to add variety to your wardrobe. There are many low-cost options, including lambswool in a rainbow of colors, mohair, and cotton. Check Chapters 3 and 4 about fashion in Milan and Florence for lots more styling ideas.

**10.
INVEST
IN SHOES**

Italians aren't the only nationality to judge people by their shoes, though they might be the only ones who admit it. Beautifully crafted footwear is a very prestige item this side of the Atlantic as well. And the wonderful thing about fine leather is that it improves with wear.

However, suede can look just as rich and is often less

expensive, making it a very accessible alternative. You may want to pay the price for a wonderful pair of wear-for-years leather loafers or boots, then fill in with lower-priced versions in suede or even fabric, which also provide the look affordably.

11.
AVERAGE OUT YOUR PURCHASES

There is both economic and emotional justification in investing in a few expensive things that you love. First of all, you'll feel fabulous in them . . . rich, adventurous, indulged, depending upon the item. And all of us need to occasionally be transported out of the ordinary. In a purely practical sense, however, you'll save money in the long run because you'll get years and years of wear from the item, like a luscious peach cabled cashmere turtleneck for $250. Divide the price by twenty (the number of years of wear it will provide), and the number makes sense. Do the same with the few costly items that will make a difference in your look and it becomes apparent that you can actually *save* money by spending more.

12.
GET IN SHAPE

Krizia's Mariuccia Mandelli maintains that the most fashionable item we own is our body. When it's fit and toned, you can wear almost anything—the simplest unstructured shapes and most minimalist accessories—with ease and style. Being in shape also gives confidence. This assurance then becomes apparent in your bearing and the way you wear your clothes.

13.
ADOPT A MINIMALIST STYLE

Become starkly minimalist. Pare your look down to the barest essentials and cut out the extraneous. In this way, you'll buy much, much less, so you can afford to spend more for each item. Some ideas: wear one signature piece of jewelry that never changes; build your wardrobe around only one color, or two complementary colors (like black and white), that you wear year-round; let your hair and makeup be your fashion accessories—be outrageous and change them often for variety.

14.
CULTIVATE A SUBTLE COLOR SCHEME

"Harmony is very important . . . there has to be a balance of tones," says designer Romeo Gigli. "You can put three greens together, but they have to be the right greens. You can put red with blue, but it has to be the perfect red. There aren't any formulas." However, wearing a palette of understated colors in the same tones can definitely give you more for your money. Each piece can be less expensive because the sum of the parts is

so rich, especially if you vary textures. Take gray, for example. Begin with a simple gray flannel skirt. Add a sweatshirt-gray T-shirt, then a soft gray pullover and gray ribbed pantyhose. Accompany with pearls or silver jewelry. Finish with black suede or leather shoes. For a dressier look, wear the sweater with the skirt and sheerer, paler hosiery, and accent with rhinestone or marcasite jewelry. For a casually chic gray look, combine gray sweatpants with a gray cashmere sweater, loafers (or Tod's), and pearls, of course.

Any of these looks will work in every neutral color scheme, like black, navy, beige, white, olive, and brown. Newer neutrals include pink, peach, and celadon, as well as a creamy yellow often called maize that is a few shades richer than ivory.

You will find, too, that you will not tire of neutrals the way you might brights. In fact, the newest way to wear them is to pair them—black with navy is an Italian favorite, as is black with brown. Other thoughts: navy and olive, pink and apricot, olive and maize, gray and brown. Neutrals also provide the ideal backdrop to color when you want to wear it. Brilliant red or purple shoes with a black outfit can create a smashing effect, as can a chartreuse shirt with navy, brown, black, or gray. Remember, too, that you can make any neutral shade work for your complexion by combining it with any color that flatters your skin, and wearing the latter close to your face.

15. BUY ONLY YEAR-ROUND FABRICS

Keeping the same wardrobe round-the-calendar can also ease the strain on your wallet. Cotton, viscose, silk, and lightweight wool and wool blends are all perfect choices, except perhaps in arctic climates. Supplement with a few sweaters, shawls, and, of course, a coat or two, if needed. You can then layer your clothes on or off depending upon the temperature.

16. COLLECT KEY PIECES

As you have already read, enduring Italian style is essentially classic. Italians build their look with a few traditional, tried-and-true pieces that they purchase over the years—a cashmere blazer, a giant cashmere-and-silk shawl, a marvelous shearling jacket, a fine leather or skin handbag. These are items that last through a lifetime . . . and actually improve with wear, according to the European way of thinking. European, too, is the notion that less is more, and a core of carefully edited—and often costly —items is the foundation. You can build variety and versatility

into your look by adding a few of each season's "hot" pieces, whatever they might be.

17.
SAVE ON DRY CLEANING

Italians tend to hand wash with wonderful results many of the items Americans routinely send to the cleaner. It is a way of life for them—they love the feel and scent of freshly laundered fabrics—in addition to loving the savings, as dry cleaning is extraordinarily expensive in Europe. Sweaters; silk, cotton, and linen shirts; unlined cotton and silk trousers; cashmere gloves, and scarves are all cared for at home. Many things that you own can be carefully hand washed, then ironed, following the suggestions in Chapter 8. As for your more constructed garments, especially when they are made of wool, most should not be cleaned after each wearing because the solvents used can ultimately wear down the fibers. They should be brushed, then aired in an open space overnight—the bathroom is a good choice—before they are put in the closet.

18.
LEARN WHEN TO GET AWAY WITH DIRT-CHEAP PIECES

It is as important to Italians to know where they don't have to put their money, as where they do. Denim—in the form of jeans and jeans jackets and shirts—is a case in point. Once you wear any denim items, wash them frequently for that worn and faded appeal, then iron them so they look neat and crisp. Then wear them as if they are expensive, combining each with a luxurious piece: a denim shirt with an Hermès scarf, a jeans jacket with beautifully tailored flannel trousers, jeans with a cashmere sweater or silk shirt.

Save your money for those special pieces and avoid spending much for the following: pearls, gold chains, and earrings (except for the one real piece you already own); cotton shirts; pantyhose and socks; T-shirts; pocket squares; simple wool gloves; a dark straight skirt; a plaid pleated skirt; ballet flats; long chiffon skirts (buy them in an Indian import store); and bodysuits.

19.
TRAIN YOUR EYE

While their mothers and grandmothers provided their first taste of chic, Italian women often look outside the family to sharpen their style acumen. Magazines are one place Italians shop for image, because the photographs show them what the designers are creating and inspire them to put together similar looks.

Two of their most influential publications are *Vogue (Italia)*

and *Moda,* both based in Milan. *Vogue* upholds the rather elitist, expensive fashion tradition of its sister publications throughout the world, although it is generally acknowledged to have the most inventive photography of them all; *Moda* is a whimsical fashion-forward monthly with sometimes outrageous photography and a very personal style. Here is what they believe style is all about:

"Children have toys, women have fashion items. The attitude I'm trying to convey is not to be scared about fashion, which is why we play with the mood of different models. Of course, the attitude is also to be elegant, but elegance doesn't mean status symbols. Elegance is in the mix. We offer the mix . . . a woman could learn it by looking at our pages."
—FRANCA SOZZANI, editor in chief, *Vogue* (Italia)

"We present fashion as well as newsworthy themes, contemporary social issues with the rhythm of a television show to appeal to stylish, image-conscious, more youthful readers. Showing our audience how to dress, how to use fashion to express their femininity and personality to enrich their lives, these are some of our themes."
—MARINA FAUSTI, fashion director, *Moda*

You can easily follow the Italian lead with either European or American publications, many of which are available in your local library. Italians also train their eye by simply being aware: watching what others wear; observing shop windows, architecture; visiting museums and galleries; becoming acquainted with each designer's style, then experimenting to see what suits them best.

20. BORROW

This is such an obvious route to style that it is often overlooked. Yet it is certainly viable, especially when the item is something you rarely wear yet costs more than the basics, like eveningwear. Most of us have a formal occasion only a few times a year, if that often. Yet formal-occasion clothing is usually high priced. This is when you should call on a friend to borrow that brocade evening dress, or ask your grandmother to loan you her beaded sweater-jacket that you can wear over your basic simple black sheath.

MODA'S FASHION DIRECTOR
MARINA FAUSTI AND HER
PERSONAL APPROACH TO STYLE.

Renting is another alternative. In New York, for one, there are boutiques that rent women's eveningwear (the way men's tuxedos are rented) at a very nominal price. Look into it in your city. The obvious place to start is the Yellow Pages of your telephone book.

21. CARE FOR YOUR CLOTHES

Clothes last many lifetimes in Italy because they are treated like heirlooms. You can extend the wearability of yours by doing the same. Outside of the obvious—hanging or folding garments after you wear them, cleaning them in the correct manner (see Chapter 8) when necessary—here are several other ideas:

- Fold knits rather than hanging them, because they stretch.

- Store silk blouses and other garments made of delicate fabric on padded hangers.

- Brush flannel and wool garments with a clothing brush to clean and restore the nap. Steam them to get rid of wrinkles rather than ironing them directly—unless you use a pressing cloth—because that makes the fabric look shiny and worn.

- Attend to stains immediately. Never store a soiled garment.

- Never store woolens in plastic during hot weather. Use fabric bags or containers so the humidity doesn't build up. Store garments in a cool place and use cedar chips or mothballs.

The above twenty-one points capture the principles of Italian style but at a distinct price advantage. They will enable you to look as elegant in your hometown as a well-heeled Milanese, Florentine, or Roman, with one notable difference. You will have enough in your savings account to take a trip to Italy and concoct your own fashion recipes firsthand.

TWO EMBODIMENTS OF THE
ROMAN FASHION ATTITUDE
AND APPROACH.

Conclusion

WHEN YOU THINK Italian style, the image that first comes to mind is a classic rather timeless one. The gorgeousness of the fabrics, the femininity of the silhouette, and the addition of just the right accessories—whether they be jewelry, sunglasses, a new hairstyle, or a sensuous shawl worn alone or in tandem with others—keep the look current and youthful, no matter what age the wearer. Another characteristic of this style is its appropriateness. It is more dressed-down than up; it always seems to suit the occasion as well as the woman's lifestyle.

Ultimately, Italian chic is as much an attitude as it is a fashion approach. The stylish Italian has a very clear vision of the woman she wants to be . . . then dresses for the role. There is a self-assuredness that comes from a long tradition of cultural beauty, quality, appreciation, even superiority. Naturally, where and how the wearer lives are also considerations just as they are for everyone, regardless of nationality. In Milan, the mind-set is business, in much the same way as it would be in a work-oriented American metropolis. Women think "industrialist, chairman of the board," so they dress in stylish suits and tailored dresses. These, however, have a characteristic soft rather than crisp edge. The result is power dressing without any stronghand tactics. In Florence, where city and country overlap, like so many suburban or rural American cities and towns, the look is easier, more casual and sporty, no matter what your profession. Earth-toned tweed jackets, velvet or corduroy skirts or trousers, silky shirts and sweaters worn with a parka and burnished leather boots, or a long flowered skirt with a pastel cardigan in warmer weather, is the wardrobe of choice for a doctor or lawyer as well as a secretary, saleswoman, or housewife. The atmosphere in Rome and points south seems to encourage a sexier, more curve-conscious look similar to that of Los Angeles and Miami. There, a fitted blazer over a simple short dress or leggings with giant gold earrings and an armful of bracelets looks natural. Everything is a little more exaggerated and trendier—without exceeding, however, the boundaries of the culturally prescribed good taste.

Role models also play an important part in the development of Italian style throughout history, from the Italian woman's glamorous, elegant, and aristocratic ancestors who are immortalized in the paintings and sculptures of the great masters to the

memorable movie stars of the Fifties, like Magnani, Loren, and Lollobrigida, to her own mother and grandmother who pass along the accumulated fashion knowledge of their families before them.

However, while style in Italy is segmented and regional, its different faces can work for the varied facets in your life: Milan style for your business hours, Florence style for weekends, and Rome style for those occasions when dazzle is "de rigueur"!

No matter what sources you draw on to explain the reasons for it, it remains clear that the Italian look is the result of a fantastic tradition of style that is very special and unique. As you have seen, it is also a chic that is easy to understand and adapt to *your* particular needs, budget, and lifestyle. Simply start with a shawl!

ABOUT THE AUTHOR

Top fashion/beauty journalist SUSAN SOMMERS is the author of the popular style book *French Chic: How to Dress Like a French-woman.* A former style director at the Condé Nast Publications as well as fashion and beauty director at *New Woman,* her byline has appeared in most of country's leading magazines. Other books she has authored include *How to Be Cellulite Free Forever* and *Beauty After 40: How to Put Time on Your Side.* She lives in New York City.